# NEW BERN
## AND THE
# CIVIL WAR

JAMES EDWARD WHITE III

THE
History
PRESS

Published by The History Press
Charleston, SC
www.historypress.net

Copyright © 2018 by James E. White III
All rights reserved

First published 2018

Manufactured in the United States

ISBN 9781625859921

Library of Congress Control Number: 2017958378

*Dedicated to the memory of Corporal Jesse Hyman Beacham, Company D, 40th Regiment NC, 3rd North Carolina Artillery*

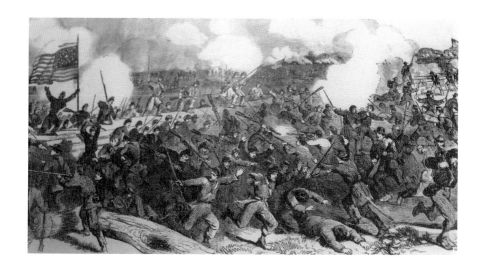

# CONTENTS

Foreword, by Steve Shaffer                                          7
Preface                                                             9

1. The Butler Expedition, 1861                                     13
2. The Burnside Expedition, 1862                                   27
3. The Battle of New Berne                                         39
4. The Best Fortified Town in America                             59
5. The Second Battle of New Berne                                 77
6. The Time Is Ripe: The Third Battle of New Berne                89
7. The Battle of Batchelder's Creek                              103
8. Hoke's Plan Comes Unraveled                                   115
9. The Battle of Newport Barracks                                123
10. The Kinston Hangings                                         131
11. The Battle of Plymouth                                       141
12. The Burning of Washington                                    159
13. The Fourth Battle of New Berne                               165

Notes                                                            179
Bibliography                                                     195
Index                                                            201
About the Author                                                 207

# FOREWORD

As author James White states at the outset of his book, there exists little knowledge, study and understanding of Burnside's joint expedition to North Carolina in general and the Battle of New Berne in particular. Certainly, Dr. Richard Sauers's 1996 work *"A Succession of Honorable Victories": The Burnside Expedition in North Carolina* exhaustively treats that expedition in great detail, but it pays little attention to the Confederate effort to retake New Bern. The author, a well-respected historian of the Civil War period of eastern North Carolina, has done an exemplary job in his dogged pursuit of the Confederate efforts to retake the second-oldest city, the second-largest population and the second-largest port.

White focuses his skilled, meticulous, in-depth research on those military actions pursued by the Confederates in their efforts to retake New Bern, foiled in every instance by a superior Federal presence—superior in men, weapons and material. The ineffectual command and control on the part of the Confederates were their undoing. Their planning was good, but their execution suffered, attributable to poor communications that negatively impacted their command and control system, such as it was.

However, it should be noted that the original orders issued by McClellan to Burnside in 1861 were to pursue the Rebels westward well beyond New Berne, if possible. However, to their credit, the Confederates were effective in containing the Yankee forces for the full period of the Federals' control and occupation for the duration of the war in North Carolina.

The period of the Federal holding of New Berne for the duration of the war is the period selected by White for discussion and analysis. And we are indebted to him, as this period has heretofore been largely avoided—and since Sauers's book, more information relevant to this period has come to light and is now brought forth by White in his effort to inform and educate.

This latter purpose of Mr. White, a scholarly analyst and educator of local origin, has resulted in a work of great value to Civil War scholars, buffs and those curious about their home areas here in coastal North Carolina where Civil War events of historical interest and significance have received all too little attention.

The modern community of New Bern must be grateful for Mr. White's devotion to his home state and his indefatigable efforts to brilliantly set down a thorough and accurate record of the struggle to re-retake the strategically important river port of New Berne.

STEVE SHAFFER

# PREFACE

T his is a book about the Confederate attempts to retake New Bern following the Battle of New Berne on March 14, 1862, which the Federals won. These are little-known battles but significant and very interesting. Three times the Confederates attempted to retake New Bern, and twice they almost succeeded. Twice they came within a hair's breadth of taking the town back from Federal hands. In both cases, the Confederates were on the verge of success but called to turn around and return to Richmond, yet very few know about these battles. Many people do not even know of the main Battle of New Berne of March 14, much less the other three battles. It is as if they never happened. It is as if they are hidden from view. There is one historical marker for the Battle of Batchelder's Creek, but even it is on a seldom-traveled road and says very little about what happened there. The thesis of this book is to reveal the various battles of the Civil War surrounding New Berne, how they were connected and their importance to the war effort in North Carolina. Throughout the book, the spelling of New Berne has been rendered with an *e* on the end because that was the way New Berne was spelled in the *Official Records of the War of the Rebellion*.

First of all, I am deeply indebted to John Klecker, who took the lithograph from 1862 and colored it, making it such that it was perfect for the cover of the book. Secondly, he took all the pictures in the book and worked with them, making them suitable for publication. Pictures are worth a thousand words, and he has done a tremendous job making them so.

Secondly, I want to thank Hal Jespersen, who painstakingly drew all the maps used in the book. He took the poor drawings that I sent him and turned them into works of art.

I am indebted to Richard Sauers for his excellent book, *"A Succession of Honorable Victories": The Burnside Expedition in North Carolina*. It is the best book on the Burnside Expedition there is, and I turned to it often for chapter 2 of the book and the Battle of New Berne.

John K. Burlingame's book *History of the Fifth Regiment of Rhode Island Heavy Artillery, During Three Years and a Half of Service in North Carolina, June of 1862–June 1865* was an excellent source on New Berne during that period as well as the Battle of Batchelder's Creek, the Battle of Plymouth and the Battle/Burning of Washington. I am deeply indebted to him for his work on the subjects.

Another helpful book was Daniel W. Barefoot's *General Robert F. Hoke: Lee's Modest Warrior*. I relied heavily on this book for information on General Hoke, his involvement in the three attempts to retake New Bern in 1863 and 1864 and involvement in the Battles of Plymouth and Washington. The book is well written and well documented.

For my section dealing with the Battle of Plymouth, which was a prelude to the Battle of New Berne in 1864, nothing could be written without mentioning the CSS *Albemarle*. Perhaps the expert on that subject is Robert G. Elliott, who wrote the definitive book on the subject, *Ironclad of the Roanoke*. This is a thorough book, well documented, well written and full of material of which I was able to make good use.

Another quality book on the Battle of Plymouth, well documented and more current, is Juanita Patience Mose's *Battle of Plymouth, North Carolina (April 17–20, 1864): The Last Confederate Victory*. Again it was well written and relied on for the Battle of Plymouth.

A more recent book is Eric A. Lindblade's work on the Newport Barracks, titled *Fight as Long as Possible: The Battle of Newport Barracks, North Carolina, February 2, 1864*. This is a little-known event of the Civil War that was connected to the Battle of New Berne of February 1–2, 1864. When looking at Hoke's attempt to retake New Berne in early February 1864, one must discuss the Battle of Newport Barracks, and Linblade's book is a must-have for that. It is well documented, well written and thoroughly researched.

One of the least understood and least known events of the Civil War in eastern North Carolina is the Kinston hangings. These hangings were a result of the 1864 Battle of Batchelder's Creek. Gerald A. Patterson wrote an excellent book on the subject, *Justice or Atrocity: General George E. Pickett*

*and the Kinston, N.C. Hangings.* He goes into deep research on the topic and covers the reasons for the hangings as well as each man involved and what happened to each one. It is a thorough work, and anyone who wants to know more about that subject should make this book part of his library.

Finally, I am deeply indebted to Lee W. Sherrill Jr. for his book *The 21st North Carolina Infantry: A Civil War History with a Roster of Officers.* It is a beautiful book with remarkable maps and illustrations. The research is beyond reproach, thorough and well documented. The writing is engaging and flows like a novel. His chapters on Batchelder's Creek, the hangings in Kinston and the Battle of Plymouth are excellent, and I relied heavily on them. In fact, without Lee's book and his help, I might not have been able to complete my chapters on Batchelder's Creek.

John G. Barrett's *The Civil War in North Carolina* was an excellent reference to check what was going on in eastern North Carolina with what was going on in the rest of the state. Plus, Barrett has a lot of information on eastern North Carolina. His overview is excellent.

The most important set of books I used was *The Records of the Rebellion,* listed as OR, and the *Official Naval Records of the Rebellion,* listed as ORN. These records, originally published in 1893, cover all the official records of both Confederate and Union troops and navies from 1861 to 1865. They are well indexed and tremendously full of reports, letters, memos, telegraph messages and more—it's nearly impossible to write a book about the Civil War without using the *Official Records.* Another major source for Civil War research in North Carolina is *North Carolina Troops, 1861–1865: A Roster,* published by the North Carolina Archives and History, volumes 1 through 20. These volumes tell about each regiment and company, list the members of each regiment from North Carolina and provide history of that regiment and each company.

No book could be written without the help of proofreaders who gave of their time to read each chapter, offering advice and positive criticism. I want to thank Travis Seymour, Dr. Phyllis Broughton, Skip Riddle, Steve Shaffer, Wade Sokolosky and Tim Norman for taking time out of their busy schedules to read the manuscript, edit it and offer very helpful suggestions. Of course, the most important critic and reader was my loving wife, Nancy, who read every page of the manuscript, offered excellent advice and was most helpful with grammar and punctuation. In addition, she put up with my late nights and early mornings working. I couldn't ask for a better helpmate.

# THE BUTLER EXPEDITION, 1861

S hortly after North Carolina seceded from the Union on May 20, 1861, and joined the Confederate States of America, orders went out from Governor Henry T. Clark in Raleigh to begin seizing Federal fortifications at Fort Macon at Beaufort Inlet, erect new fortifications along the barrier islands and protect the mainland. In 1861, the major inlet through those islands was located at Cape Hatteras. A second inlet was located at Ocracoke Inlet, between the islands of Ocracoke and Portsmouth; a third, Old Topsail, was protected by Fort Macon; and a fourth inlet, Cape Fear Inlet, was located south of and protected the port of Wilmington. If North Carolina was to be protected from Federal invasion, strong defense of these inlets was imperative. In addition, it was through these inlets that North Carolina blockade runners plied their trade during the early days of the war, bringing in necessary mercantile goods as well as important war materials. Were these inlets to fall to Federal forces, they would not only have a major foothold on North Carolina but also close the state to needed supplies.

Within the state were a number of ports, such as Wilmington, New Berne,[1] Beaufort, Edenton, Washington, Plymouth and Elizabeth City. In 1861, Wilmington served as the primary port in state shipping, but Hatteras Inlet came in second, through which more ships with a greater tonnage came into the state than that of Beaufort and almost equal that of Wilmington.[2] Hatteras served all the ports within the state except for Beaufort and Wilmington. Of the major inlets in North Carolina, Hatteras Inlet was the

only inlet in the Outer Banks[3] that could admit large oceangoing vessels.[4] Even so, the draft of incoming vessels could not exceed nine feet.

The state government in Raleigh immediately developed plans to build fortifications all along North Carolina's coast at Roanoke Island, Cape Hatteras, Ocracoke Inlet and Wrightsville Beach off of Wilmington, as well as other locales. Since Hatteras Inlet was of major importance, its principal fortification, Fort Hatteras, was located one-eighth of a mile from the inlet. Fort Hatteras was a dirt fort approximately 250 feet wide, made of sand and sheathed by planks driven into the ground in slanting position. The entire thing was covered with turfs of marsh grass. The fort was protected by twelve 32-pound smoothbore guns.[5]

In order to help with the fortification of North Carolina's coast, the Confederate government transferred twenty 13-pounder fieldpieces to North Carolina. While this seemed to indicate that Richmond was aware of the importance of North Carolina and its Outer Banks, it was the last such gesture until it was too late to protect the state's coastline.[6] By the end of the summer of 1861, there were no more than 580 Confederate troops guarding the entire coast of North Carolina. At Roanoke Island, there were 350 men, comprising the Seventh North Carolina Regiment and the Tenth North Carolina Artillery. The remainder was located at Oregon Inlet and Ocracoke Inlet. In addition, the State of North Carolina had mustered in 22 infantry regiments by August 1861, yet only 6 of those units were still in North Carolina, the rest having been ordered to Virginia. Local militia manned the forts at Fort Macon at Beaufort Inlet and at Fort Caswell below Wilmington until they were taken over by state troops.

Brigadier General Henry A. Wise, former governor of Virginia, was transferred to North Carolina in the fall of 1861. When he realized how sparsely manned the Outer Banks were, he made a quick appeal to Richmond and Judah P. Benjamin, secretary of war, and Jefferson Davis, president of the Confederacy, for additional troops. But he was refused.[7]

If the Confederate government in Richmond underestimated the worth and value of the North Carolina Outer Banks, the Federal government in Washington, D.C., did not. Lincoln's Anaconda Plan was designed to cut off the ports of the Confederacy with a blockade as well as split the Confederacy in two by controlling the Mississippi River. Flag officer Rear Admiral Silas H. Stringham was put in charge of the Atlantic Blockading Squadron, but his efforts were unsuccessful.[8] Confederate ships like the *Winslow* continued to raid Federal blockaders, keeping the Union navy from gaining a foothold on the Outer Banks or controlling the shipping through their inlets.[9] During

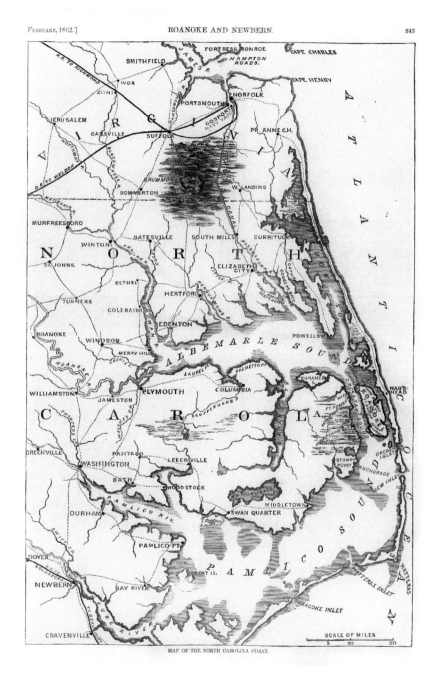

Coastal North Carolina. *Courtesy of* Harpers Pictorial History of the Civil War.

*Left*: Brigadier General Henry A. Wise. *Right*: Major General Benjamin F. Butler. *Courtesy of the Library of Congress.*

the summer of 1861, the *Winslow* captured at least sixteen ships off the coast of North Carolina.

At Fort Monroe, Virginia, Major General Benjamin F. Butler realized the importance of North Carolina's barrier islands and informed the U.S. War Department that North Carolina was building a number of fortifications along the coast. He recommended to the War Department that a small expedition to North Carolina be made to capture the forts. He suggested that "something should be done to break…up the depot for rebel privateers at Hatteras."[10] Butler continued to write that the "Importance of the [Cape] cannot be overrated."[11] Butler went on to express that the "whole coast of North Carolina, from Norfolk to Cape Lookout" was within the Federals' reach and should be a major objective. Once captured, the Federals would have a base of operation from which to attack inland to New Berne, Washington and Beaufort. Butler concluded by stating that in his judgment, "it is a station second in importance only to Fortress Monroe on this coast, [and] as a depot for coaling and supplies for the blockading squadron it is invaluable."[12]

Commodore Silas Stringham. *Courtesy of the Library of Congress.*

Surprisingly, the War Department saw no value in Major General Butler's recommendation and scuttled the idea. The Navy Department, however, saw tremendous merit in the idea and proposed a joint operation with the army. Commodore Silas Stringham would be in charge of the naval operations, and Butler would be in charge of the army maneuvers against eastern North Carolina. The Navy Department considered the North Carolina coast to be "the most dangerous stretch of shore in the whole Confederacy." Officials saw coastal North Carolina as "an immense watery bastion, with the sounds as moats, the Outer Banks as ramparts, and Hatteras Inlet as its chief sally port."[13]

Butler's expedition against the North Carolina coast left Fort Monroe on August 26, 1861, without the men having any idea where they were headed. They had been told to prepare ten days' rations and 140 rounds of ammunition. Stringham's squadron consisted of eight vessels of various sizes and guns. Commodore Stringham set his squadron to rendezvous with Butler's army at Hatteras Inlet, with the two of them arriving off the coast of Hatteras on August 27.

At the lower end of Hatteras Island, on the north side of Hatteras Inlet, the Confederates had constructed two forts, Fort Clark and Fort Hatteras. Fort Clark was smaller than Fort Hatteras and was a square redoubt made of reinforced sand,[14] mounted with five 32-pounders and two 8-inch howitzers and faced seaward. The much larger Fort Hatteras was an "octagonal fort, which occupied three quarters of an acre, constructed of sand with parapets rising to a height of ten feet" and mounted with twelve 32-pounders as well as a 10-inch Columbiad overlooking the sound.[15]

Colonel J.C. Lamb of the Roanoke Guards was in command of the garrison at Fort Clark. Midmorning on August 28, Federal forces under Commodore Stringham began to shell Fort Clark with an elliptical motion. The ships maneuvered in a circle while coming nearer to the fort, firing on it as they did so—their movement making them difficult targets for land-based artillery. They then continued past the fort, followed by another ship, which did likewise, creating a line of solid fire at the fort. By 10:00 a.m., the air was filled with smoke from the firing to the point where the navy gunners were unable to see the batteries on shore.[16] While Fort Clark was being shelled, Federal forces under Major General Benjamin F. Butler began to land on shore just north of the fort. The seas were so rough, however, that only 318 men were able to land on that day. The Rebel forces fired at the Federal ships, but most of the shots fell short of their targets. Very quickly, Colonel Lamb's men ran out of powder and had to evacuate Fort Clark. Orders were

Colonel J.C. Lamb. *From the* North Carolina Dictionary of Biography.

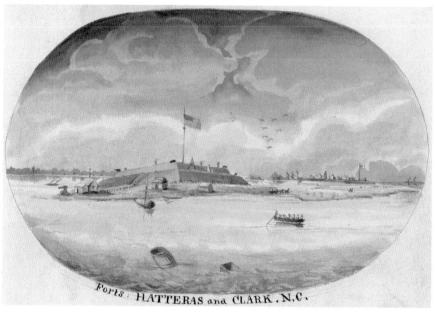

Forts Hatteras and Clark. *Courtesy of Bridgeport History Center, Bridgeport Public Library.*

issued to spike the guns with nails. Colonel Lamb and his men, "carrying the fort's colors," headed for Fort Hatteras, to the west of Fort Clark. Shortly thereafter, Colonel Max Weber of the Union navy led his land forces to the now-abandoned Fort Clark, where he became the first to hoist the Union flag over a captured Rebel fort.[17]

Fort Hatteras, like Fort Clark, was described as resembling "pigpens more than bastions."[18] In fact, Fort Hatteras was so small that only those men actually on duty could be within the fort, while the rest had to seek protection outside the fort facing the sound.[19] During the night, 257 Rebel reinforcements from Portsmouth Island arrived at a point between Fort Clark and Fort Hatteras, where they found the men "fatigued and careworn." With the added men, the Confederates probably could have retaken Fort Clark—but they didn't even make the attempt.

The next morning, seeing no flag flying over Fort Hatteras, Butler assumed that it had been taken during the night by the Federals on shore. When the Federal fleet began maneuvering into position, the Confederates opened fire. Steady firing ensued for an hour, after which the smoke was so thick that the fort was no longer visible from the ships. The gunners aboard the ships continued with their fire, with the shells landing in the murk, although the gunners were sure they were hitting their targets.[20]

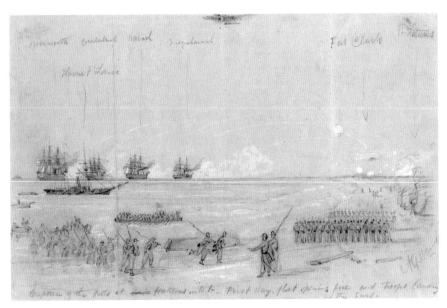

Capture of Cape Hatteras. *Courtesy of the Library of Congress.*

During the three hours of shelling, some three thousand projectiles were fired on the fort by the Federal ships. "As many as twenty-eight [shells] in one minute were known to fall within and about the fort. It was like a hail storm."[21] The shells "tore into the mud walls like some sort of brutal tilling machine, uprooting great fountains of muck and turf where particles hung in the humid air like liquid smears before raining back down over the sweating and frustrated Confederate gun crews."[22]

Inside the fort, most of the Confederates' powder was old, of poor quality or wet, and their fuses were damaged or defective. As a result, all their shots were detonating short of their targets.[23] About 11:00 a.m., a Federal shell hit its mark within Fort Hatteras, the ventilator, starting a fire in the bombproof, which started a fire in the adjacent magazine. Word went out that the magazine was on fire. Commodore Samuel Barron called for a council of officers, which unanimously agreed on the necessity of surrender. Holding out any longer would only result in a greater loss of life, with no chance of doing any damage to the Federals.[24] One of the soldiers found a white sheet and waved it from the parapet, but the Yankees did not see it flying above the ramparts of the fort. Finally, the Confederates took the white part of a second national Confederate flag and raised it over the fort's ramparts; the Federal forces saw it and ceased fire. The men in the fort reacted in various ways upon the raising of the white flag. Some had tears in their eyes, while others raved and some escaped to the ships.[25]

When the white flag was spotted, General Butler sent an aide ashore to accept the fort's surrender. Commodore Samuel Barron sought honorable terms for his men within the fort, requesting that his men be able to keep their side arms and be paroled. However, Butler was in no mood to be lenient and refused all terms other than full capitulation. Barron had no choice but to accept Butler's terms.[26]

Recognizing the importance of Hatteras Inlet, Butler disobeyed the original orders from his superiors to spike the guns, destroy Forts Hatteras and Clark and abandon the area. Instead, he left behind Colonel Rush C. Hawkins with the 9th and 20th New York Regiments to hold Fort Hatteras, thus keeping a major Federal foothold in eastern North Carolina.

With Butler-Stringham's success at Hatteras, the Confederates began to assess their forts at Oregon and Ocracoke Inlets. Captain Daniel McD. Lindsey of the Currituck Atlantic Rifles manned Fort Oregon at Oregon Inlet. He consulted his officers, and they decided to abandon the fort, removing their guns to Roanoke Island. Farther south at Ocracoke Inlet stood Fort Morgan, often referred to as Fort Ocracoke, on Beacon

Island. Fort Morgan consisted of two 8-inch Columbiads, two 10-inch Columbiads, three 8-inch howitzers and ten 32-pounders. In fact, Fort Morgan was better armed than either Fort Clark or Fort Hatteras had been. General Lawrence O'Bryan Branch in New Berne ordered the removal of the remainder of the 17th North Carolina Regiment at Camp Washington on Portsmouth Island as well as those at Fort Morgan. All men, cannons, powder and public property were to be transferred to Roanoke Island. The remaining nine cannons were to be spiked and left behind and the barracks and other buildings at the fort burned.[27]

Commodore Samuel Barron. *Courtesy of the Library of Congress.*

At Fort Morgan, efforts had been made to ready the fort for the impending invasion of Federal forces. Sergeant Baron von Eberstein had replaced Lieutenant Brantly as chief of battery and ordnance due to Brantly's drunkenness and unprofessional behavior. Von Eberstein worked hard to prepare the men for the impending assault.[28]

When Captains James J. Leith and Thomas Swindell heard of the fall of Forts Clark and Hatteras, they immediately called a conference of their officers in the big house on the island—formerly used as the officers' quarters and mess hall. One of those invited to that conference was Von Eberstein, from whom we know what was discussed.

According to Von Eberstein, Captains Leith and Swindell proposed that the men of Fort Morgan evacuate the fort in the morning—after all, they would be captured otherwise. Von Eberstein argued against evacuation of the fort, as there were no Federal ships anywhere in sight. He continued to argue that they could fight anything that the Federals could send against them.[29]

Von Eberstein was overruled by Captain Swindell and the balance of the other officers. Captain Swindell went to Portsmouth Island at once to get two small schooners to carry the men to New Berne. Von Eberstein described the evacuation of Fort Morgan as "the most cowardly evacuation ever known." Captain Swindell took down the company flag, which had

Colonel Rush C. Hawkins. *Courtesy of the Library of Congress.*

been presented to the company by the ladies of Washington, and stuck it down in the southeast corner of the bombproof. Swindell then told the men to leave the fort, leaving the flag behind in order to let the Federals believe they were still there. Von Eberstein said that there was no act more cowardly he had ever known.[30]

Evacuation and burning of Fort Morgan. *Private collection.*

Von Eberstein went on to explain that it was impossible to defend Fort Morgan without reinforcements. Therefore, he and the remaining men began to dismantle the fort. The guns were piled up, and they destroyed provisions and clothing. Everything in the battery that might be of use to the enemy was destroyed. After making the fort useless to the Federal forces, Von Eberstein and the remaining men left Fort Morgan and left for New Berne. Refusing to further disgrace the Confederate flag flying over the fort, Von Eberstein took the flag down and took it to New Berne with him.[31]

General Branch's headquarters, located in New Berne, ordered the complete evacuation of the soldiers left on Portsmouth Island. The CSS *Ellis*, towing a schooner, removed the camp guards and a few remaining ladies from Portsmouth Island. In a letter to the *Washington (NC) Dispatch*, one of the officers aboard the *Ellis* wrote, "After finding the fort [Morgan or Ocracoke] had surrendered and that we could be of no possible use, we left for Ocracoke to take on board the sad and weeping wives of the officers, now prisoners, and shall proceed to Washington, North Carolina."[32]

With the capture of Ocracoke Inlet, Butler's initial objective was complete. He had sealed up much of North Carolina's coast to shipping, especially the Albemarle and Pamlico Sounds. All the Confederate forts located on the

Outer Banks, from Fort Oregon to Fort Ocracoke, were in Federal hands. The only inlets in the state that remained open to shipping were Old Topsail Inlet at Beaufort, which was protected by Fort Macon, and Cape Fear Inlet, which was protected by Fort Fisher. The fall of the Outer Banks of North Carolina opened the door to the rest of the state, especially the inner banks, including New Berne. Butler's Expedition was the beginning of what would be the fall of New Berne in 1862.

# The Burnside Expedition, 1862

With the success of the Butler-Stringham expedition to seize and hold Hatteras Inlet, key to one-third of North Carolina, the Confederates took a greater interest in Roanoke Island. As part of Brigadier General D.H. Hill's evaluation of North Carolina's coastal defenses, the officer recommended that a continuous set of earthworks be built across the narrow neck of Roanoke Island.[33] North Carolina governor Henry T. Clark wrote to President Davis, saying that "the position of Hatteras affords the enemy a positon or nucleus to form expeditions, almost without observations, to radiate to different points, even in opposite directions....I must urge the fortification of Roanoke Island to defend one-half of the exposed territory."[34] Davis replied that "the enemy was making these coastal demonstrations precisely to lure the Confederacy into dissipating its strength in Virginia," and he "was not going to be fooled by the ruse."[35]

During the summer of 1861, Major General George B. McClellan assumed command of the Union's Army of the Potomac. He began to take a strong interest in the operations along the North Carolina coast, suggesting to Winfield Scott, the seventy-five-year-old general-in-chief of the Federal army, that a major expedition be sent to North Carolina. General Scott did not share McClellan's enthusiasm for such an expedition. McClellan saw the Outer Banks of North Carolina as a coaling station for the Federal fleet's blockade.[36] Following Scott's resignation as general-in-chief and McClellan's appointment to that position, McClellan convinced President Abraham Lincoln and his

cabinet of the importance of an operation against the North Carolina coast. McClellan appointed his good friend Major General Ambrose E. Burnside to begin preparing for such an expedition. Commodore Louis M. Goldsborough would command the navy gunboats, support and transport vessels along with Burnside in command of the army land force of some fifteen thousand men. Burnside was granted permission to raise fifteen regiments of military and given unlimited funds to operate the invasion.[37] McClellan's instructions to Major General Burnside were "detailed, ambitious, and rather sensitive orders," including:

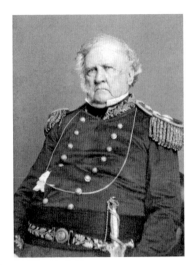

General Winfield Scott. *Courtesy of the Library of Congress.*

- Capture and hold Roanoke Island.
- Seize or block the Great Dismal Canal connecting North Carolina waters with Gosport, the Confederate naval base, Norfolk.
- Capture the active river port town of New Berne and Beaufort Harbor.
- Capture or neutralize Fort Macon.
- Destroy as much of the Wilmington & Weldon Railroad as possible, including the vital bridge near Goldsboro and several important railroads.
- A demonstration against Raleigh was permissible, as was a move against Wilmington, but only if the risks were not too great.[38]

In preparing for his expedition, Burnside recruited as many experienced former sailors and fishermen from the Mid-Atlantic and New England states as he could find. His fleet consisted of more than eighty ships carrying "twenty-one 8 and 9-inch smoothbore guns, twelve 32-pdr. (6.4 inch) guns, eleven rifled guns of 30 to 100 pounders, and ten smaller rifles from 12- to 20- pounders."[39]

Joseph Denny of 28th Massachusetts, on the USS *Highlander*, described the scene as Burnside left Annapolis on January 9, 1862:

*It was the grandest sight ever seen before upon this side of the Atlantic....*
*From all the vessels and steamers the most enthusiastic cheers were*
*heard, mingling with the music of a dozen or more regimental bands. It*
*was a beautiful morning and the fleet sailed so grandly into the waters*
*of the Chesapeake.*[40]

Burnside's expedition left Annapolis on January 11, 1862, and arrived
off the coast of North Carolina on January 18. By February 4, the entire
expedition had safely crossed the bar and swash at Hatteras Inlet and was
at anchor in Pamlico Sound awaiting instructions. The fleet immediately
began preparations to attack Roanoke Island and set sail northward toward
Roanoke. As the fleet sailed toward Roanoke Island, Private James Stone
of the 21st Massachusetts, on board the steamship *Northern*, wrote, "It was
a handsome sight, eighty ships in all...gunboats, and...other ships carrying
the troops, baggage, provisions, ammunition."[41]

On February 16, 1862, Major General Burnside issued a proclamation
to the people of North Carolina stating that his purpose was to reestablish
the rule of Federal law and that he meant no harm to the people who lived
there. He went on to say, "We are Christians as well as yourselves, and we
profess to know full well and to feel profoundly the sacred obligations of the
character." He concluded, "We invite you in the name of the Constitution
and in that of virtuous loyalty and civilization to separate yourselves at once
from their malign influence, and return to your allegiance, and not compel
us to resort further to the force under our control."

The Confederates had built three forts on Roanoke Island. At the northern
end of the island on Weir's Point was Fort Huger, which "mounted twelve
guns, principally 32-pounders, and was commanded by Major John Taylor,
formerly of the U.S. Navy."[42] Farther south, approximately 1.75 miles,
was located Fort Bartow, which "mounted seven guns, five of which were
32-pounders, and two were rifled 32- pounders."[43] Fort Bartow was under
the command of Lieutenant B.P. Loyall of the Confederate navy. Between
Fort Bartow and Fort Huger was Fort Blancard overlooking Croatan Sound,
which manned four guns and was the smallest of the three forts. On the
mainland opposite the island, at Redstone Point, was a battery called Fort
Forrest with 32-pounders that had been mounted on the deck of a canalboat
and placed so that the guns would have control of the channel.[44]

One road ran north–south in the center of the island. A redoubt had
been built about midway down this road and consisted of a three-gun
battery containing the only "mobile field artillery on the island: a heavy

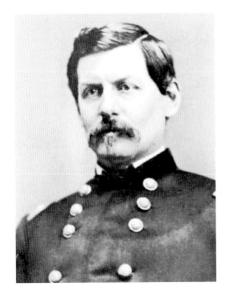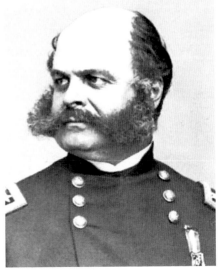

*Left*: General George McClellan. *Right*: Major General Ambrose Burnside. *Courtesy of the Library of Congress.*

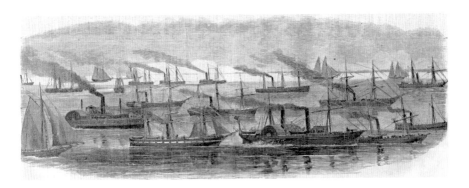

Burnside expedition. *From* Harper's Weekly.

brass 18-pounder, a Mexican War relic, a 24-pounder boat howitzer, and a 6-pounder boat gun. Only the 6-pounder had proper ammunition. The larger guns had to make do with 12-pounder ammunition."[45]

Brigadier General Henry A. Wise had a force of approximately 1,435 Confederates to man the various batteries on Roanoke Island. He complained that the men were "undrilled, unpaid, not sufficiently clothed and quartered, and were miserably armed with old flint muskets in bad order. In a word, the defenses were a sad force of ignorance and neglect combined, inexcusable

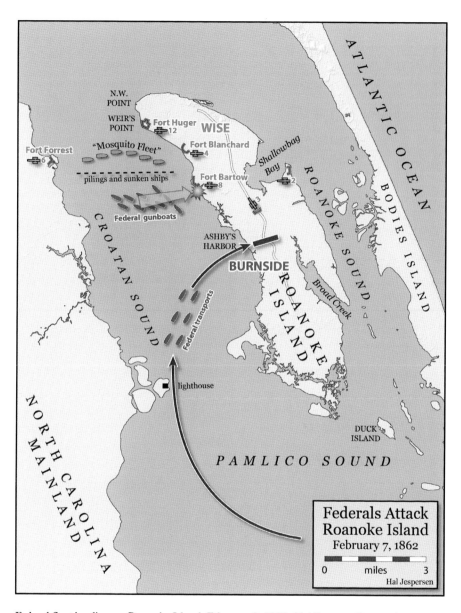

Federal fleet landing on Roanoke Island, February 8, 1862. *Hal Jespersen, Cartographer.*

in any or all who were responsible for them."[46] The men were further described as "in such weak physical condition and so poorly equipped that they failed to 'inspire' the general. The cold, damp, winter weather and lean diet kept a quarter of them on the sick list. Uniforms were inadequate. No

two men were dressed alike: clothing consisted of whatever a person could manage. The 'weapons were as varied as their owner's garb.'"[47] After Wise's departure from Roanoke Island, the command of the island was transferred to Colonel H.M. Shaw, a transplanted North Carolina congressman from Rhode Island, who was not held in high esteem by his men at the barracks.[48]

Early on the morning of February 7, 1862, Burnside's fleet entered Croatan Sound, headed for Ashbys Harbor, where the Federal landing was to take place. At 10:30 a.m., Fort Bartow began firing on the fleet. In addition to the attack on the Federal armada by Fort Bartow, the Confederate fleet, derisively nicknamed the "Mosquito

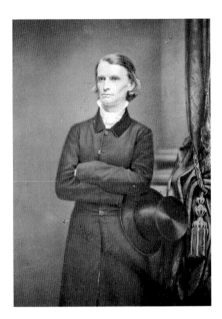

General Henry A. Wise. *Courtesy of the Library of Congress.*

Fleet," due to its small size, opened fire on the Federal ships. The battle raged throughout the day, with Federals beginning to land around four o'clock that afternoon. Within an hour, nearly 4,000 men had come ashore at Ashbys Harbor, and by midnight, nearly 7,500 had landed. Shaw had approximately 200 riflemen hidden in the bushes, yet when they were spotted by the Federals and fired upon, Colonel J.V. Jordan, commander of the 31st North Carolina Regiment, "pulled out his entire force, without having fired so much as one token volley."[49] By dark, many of the Federal ships had run low on ammunition and the Confederate ships were entirely out. The Mosquito Fleet returned to Elizabeth City, while the Federal ships withdrew to deeper waters.

Early the next morning, the Federals resumed their land attack. At daybreak, Brigadier General John G. Foster led the a brigade consisting of the 25th Massachusetts, 23rd Massachusetts, 27th Massachusetts, 24th Massachusetts, 10th Connecticut Volunteers and the 9th New York northward on the road toward Fort Bartow near the center of the island on the sound, driving the Confederate pickets before them.

Private Welch of the 23rd Massachusetts, described the first encounter with the Confederates that day:

*Right:* Colonel Henry M.
Shaw. *From the* North Carolina
Dictionary of Biography.

*Below:* Attack on Roanoke Island.
*Courtesy of Bridgeport History Center,
Bridgeport Public Library.*

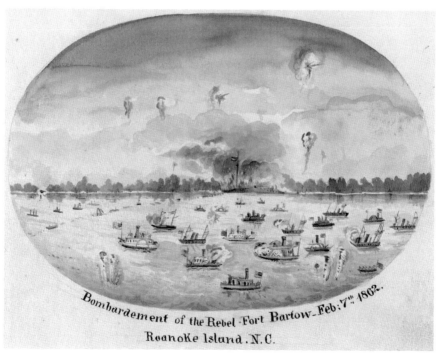

*We marched along about a mile or so when we heard firing. Soon we came to a clearing and saw the Twenty-fifth in action ahead of us, with skirmishers ahead. We fell into column, by division, behind them advanced when they did, and halted when they did. We were just in range of the bullets and their song was quite audible.*

*The enemy had a three gun battery at the further end of the road through…a swamp.…They had cut down trees…some sixty or eighty yards across, and five or six hundred yards down the road, making an oblong cleared space.…Then three guns completely covered the road…and were firing…all the time…their determination to keep the road clear at all events…and reckoned to hold the fort.*[50]

As the Federals marched forward through the thick mud, the Confederates opened fire, confident that they could prevent the Federals from taking the redoubt. On either side of the road was a swamp, which even the locals declared impassable. The Confederates under the leadership of Colonel Shaw kept a sharp fire on the Federals with grapeshot from their three cannons. The shot cleared the road "like a broom."[51]

Brigadier General Foster's 25th Massachusetts was in the front of the line and taking a beating by the Confederates. Foster ordered the 23rd and 27th Massachusetts to leave the road and try to make their way through the swamp and around to the rear of the Confederate redoubt. At the same time, Major General Jesse Reno saw what Foster was attempting and ordered his brigade to take to the swamp on his left and try to go around to the rear of the redoubt from the other side. Both Federal movements went bravely forward through waist-deep muck and tangles of briars.[52]

Back on the road leading to the redoubt, the Confederate fire was so heavy that Foster's men had to lie down to reload their rifles and then stand up to fire as they inched their way toward the redoubt. As the Federal forces slowly moved forward, it was tortuous going. They had no place to hide from the Confederate musket fire.[53]

About midmorning, Brigadier General Foster ordered the 9th New York Zouaves to charge ahead of the 10th Connecticut and into the guns of the enemy, driving them from their works. The 10th Connecticut laid down in the road as the Zouaves charged over their heads, yelling "Zou-zou-zou!" as they did so. Simultaneously, Major General Reno's men charged from the Confederate right and Brigadier General Foster's men charged from their left, creating a tremendous amount of confusion for the stunned Confederates.

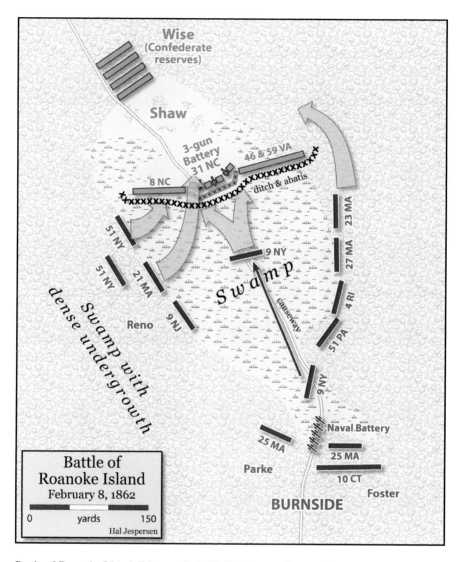

Battle of Roanoke Island, February 7, 1862. *Hal Jespersen, Cartographer.*

While Brigadier General Foster was keeping the Confederate redoubt busy on the road, the Federal fleet gave Fort Bartow a "seven-hour pounding from approximately 2,600 projectiles."[54] As the buildings within Fort Barrow burned furiously, the fort poured heavy fire on the Federal fleet in Croatan Sound.

Lieutenant Colonel Edmonds described the battle at this point:

> *The fight had now lasted three hours and a half.... The men...* [under] *a heavy fire of infantry and three field pieces in the battery had worked their way, inch by inch, wading at times, waist deep in bog, mud, and water, through the morass, and were getting to firmer ground on which they could secure footing for assaults on the flanks of the breastworks.... [When the 9th New York was ] ordered to charge the battery in front over the narrow causeway...the 9th New York...with a cheer rushed forward in column of fours—the road would admit no wider front—and made a gallant charge; the regiments from the right and left, rising on the firmer ground they had gained from the morass—deemed by the Confederates impassable—instantaneously charged with an answering cheer, and the battery was overwhelmed, front and flanks. Its defenders...broke and ran.*[55]

With the Federal takeover of the redoubt, Colonel Shaw realized that Roanoke Island was lost. Word quickly arrived at Fort Bartow that the Confederates at the redoubt were retreating and Colonel Shaw was going to surrender. "Cartridges were thrown in the sand, guns spiked, implements destroyed, and a quick march back to quarters was commenced."[56] Shaw ran up a white flag at Fort Bartow and sent Lieutenant Colonel Daniel G. Fowle under a flag of truce to the Federals to ask for terms of surrender. Fowle was directed to Brigadier General Foster, who stated that the only terms he would give was unconditional surrender, immediately.[57] Later that night, at nine o'clock, "the Federal fleet at anchor in the sound was signaled that Roanoke Island had fallen and that the Stars and Stripes floated over every battery."[58]

In only two days, Major General Burnside had accomplished the first part of his mission in North Carolina. In that time, he had taken the most important of his military objectives, "at a cost of 37 men killed and 214 wounded. Shaw's men suffered 23 killed and 58 wounded, along with a staggering 2,500 men taken prisoner."[59] Burnside's final report stated that he had complete possession of Roanoke Island, which contained five forts, thirty guns, small arms, building materials, tools, barracks and a large hospital building.[60]

While the island itself was secure, there was a lot more work to do. Out in the sound, the Confederate Mosquito Fleet was still at large. In order to continue pursuit of his objectives, Burnside had to eliminate the Confederate naval force. The Mosquito Fleet, commanded by Commodore

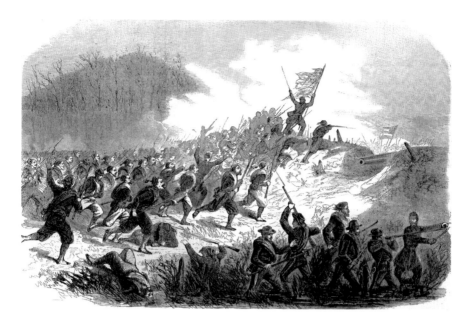

Attack on Fort Bartow. *Courtesy of* Leslies Weekly.

William F. Lynch, consisted of five ships: CSS *Winslow*, CSS *Oregon*, CSS *Ellis*, CSS *Beaufort* and CSS *Raleigh*. They were mostly "small, shallow-draft steamers that had originally been canal tugboats or intracoastal trading vessels."[61] After the fall of Roanoke Island, the Federal navy followed the Mosquito Fleet to Elizabeth City, where a major battle between the two ensued. Commodore Lynch could only stand by at the fort and watch as his ships were destroyed "before his eyes":

> *As the flotillas collided, the* [U.S.] Commodore Perry *rammed the* [Confederate] Seabird, *sinking her. The* Ellis *was boarded by bluejackets from the* Ceres. *Lieutenant J.W. Cooke of the* Ellis *ordered his crew over the side while he remained aboard with cutlass in hand to meet the enemy. The* Fanny, *aflame, was run aground by her crew and abandoned. Only the* Appomattox *and the* Beaufort, *which was not engaged, escaped up the river. The* Beaufort *made it safely to Norfolk but the* Appomattox *had to be destroyed by her captain when it was discovered that she was "about two inches too wide to enter the mouth" of the Dismal Swamp Canal. The* Forrest, *on the ways at Elizabeth City, was burned at Commodore Lynch's orders.*[62]

Even before the Battle of Roanoke Island was over, Major General Burnside was already making plans for his next offensive against New Berne, an important port and the second-largest city in North Carolina. Few people are aware of the Battle of Roanoke Island or Burnside's Expedition, much less their relationship to New Berne and the first Battle of New Berne on March 14, 1862. But in fact, New Berne was one of the Burnside's major goals, as it was New Berne was a major port city in eastern North Carolina.

# THE BATTLE OF NEW BERNE

After getting affairs in order on Roanoke Island, Burnside left for New Berne on March 11, 1862. The next day, he joined up with the naval vessels at Cape Hatteras and sailed inland toward the mouth of the Neuse River, arriving there in the early afternoon of March 12. Commodore Stephen C. Rowan was in charge of the ships while en route to New Berne. He was in command of fourteen ships of the line: *Philadelphia, Stars and Stripes, Louisiana, Hatzel, Underwriter, Delaware, Commodore Perry, Valley City, Commodore Barney, Hunchbank, Southfield, Morse, Lockwood* and *Henry Brinker.*

A member of the 27th Massachusetts described the arrival on the Neuse River on March 13:

> [A]*t 2pm we entered the Neuse River....Our approach was signaled* [to] *the enemy above, by means of fires along the northern bank, the black smoke rising upward like weird fingers of fate....As night set in, the sky was heavy with threatening storm...At nine o'clock we reached...Slocum's Creek fifteen miles below New Bern, and anchored for the night.*[63]

It rained all night, and the next morning wasn't much better. Colonel Rush Hawkins of the 9th New York described the situation that morning:

> *The next morning was as unpleasant as a cold penetrating rain and dark sky could make it, but not withstanding...at 6:30...the troops began to*

*disembark, the majority going in small boats, while others in their eagerness for the fray jumped from the transports, which were fast on the mud bottoms, and, holding their cartridge boxes, and muskets over their heads, waded to the land...13 regiments of infantry* [and] *8 pieces of artillery.*[64]

The Confederates anticipated Burnside's arrival and had begun making appropriate preparations. Major General Lawrence O'Bryan Branch, as the Confederate general in charge of eastern North Carolina, including New Berne, had spent time working on building fortifications along the Neuse River in preparation for the Federals' arrival. His fortifications might have been adequate if he had more than four thousand troops with which to man them. Colonel Charles C. Lee of the 37th North Carolina Infantry was given command of the left wing of the Confederate forces, and Colonel Reuben Campbell of the Seventh North Carolina Infantry was given command of the right wing.

The remainder of the Confederate Order of Battle included Lieutenant Colonel Edward Graham Haywood, 7th North Carolina Infantry; Colonel S.B. Spruill, 19th North Carolina Infantry; Colonel Zebulon B. Vance, 26th North Carolina Infantry; Major John A. Gilmer Jr., 27th North Carolina Infantry; Lieutenant Colonel Robert F. Hoke, 33rd North Carolina Infantry; Colonel James Sinclair, 35th North Carolina Infantry; Lieutenant Colonel William M. Barbour, 37th North Carolina Infantry; Colonel H.J.B. Clark, Special Battalion North Carolina Militia; and Lieutenant J.L. Hanghton, Macon Mounted Guards.

Branch had built seven forts along the Neuse River, which protected the town from a naval attack; however, no forts were established to guard the roads into New Berne or the railroad. The largest of the forts was Fort Thompson, named for Major W.B. Thompson and located about six miles below New Berne on the Neuse River. Fort Thompson mounted thirteen guns, most of which were smoothbore 32-pounders—two were 6-inch rifles. Of the thirteen guns, only three were

General Lawrence O'Bryan Branch. *From Mary Poke Branch, in* Memoirs of a Southern Woman, *"Within the Lines."*

emplaced to fire on the land side, none of which could shell the road or railroad.[65] In addition to Fort Thompson were six other forts: Fort Dixie with four guns, Fort Ellis with eight guns, an unnamed fort with two-gun case mated work and Fort Lane with four guns. Outside these, two batteries of two guns each guarded the river shore inside the town.[66] Fort Gaston guarded the bridge over the Trent River about four miles south of New Berne. About six miles below Fort Thompson was a line of entrenchments that ran from the Neuse River to the dense swamp just beyond the railroad known as the Croatan Works. The Croatan Works, or Croatan Line, ran across the Beaufort Road, which was the route most likely to be taken by the enemy and was considered to be the Confederate primary line of defense. On the western most end of the Croatan Works was a small fort that consisted of a large platform on which several artillery pieces were posted. The remains of this fort still exist today. General Branch considered this line of defense to be his strongest.[67] Even so, Branch abandoned the Croatan Works because he feared that the enemy would land above and behind the works and that with so few men he wouldn't be able to defend the river shore for that distance. Instead, Branch had rifle pits dug at Fisher's Landing—some four miles or so north of Croatan Line—about twenty-five feet high on the cliffs above the riverbank. He then built another fortified line anchored on Fort Thompson, which ran one mile to the railroad. He then decided to extend that line and improve it as his main line of defense. This line of defense, consisting of trench works, ran from Fort Thompson westward to Wood's Brickyard, which were owned and operated by Council Wood.[68] There,

*Branch turned a corner with his additional breastwork to conform to the contours of the ground. The line dropped back about 105 yards to cross a small branch, then turned again in the breastworks original direction, or away from the river. This extension was defended by a series of small redans, or fortlets. These were still under construction when the battle began. The corner at the brickyard, almost a salient, was a weak point in the line. Branch ordered his men to cut loopholes in the thick masonry walls of the kiln buildings for rifle firing, and ordered a battery of two 24-pounder field guns brought up to reinforce the position. He intended to make a strong point out of the dangerous salient. All along the line from the fort on the river to the railroad Branch's men felled the trees with the tops toward the direction the enemy would appear. The thickets thus formed would impede a charging enemy without offering him cover.[69]*

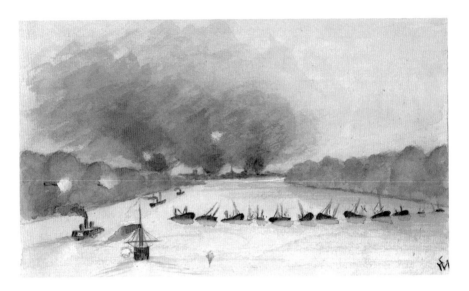

Original picture showing sunken ships in the Neuse River. *Herbert E. Valentine Collection, Southern Historical Collection, UNC–Chapel Hill.*

In addition to the forts below New Berne, the Confederates had placed a number of pilings and sunken ships in the river to prevent the enemy from coming up the river by ship. An enemy vessel entering the river would hit a number of pilings that had been cut off below the surface of the water. Behind these pilings were a row of sharpened pilings with iron caps that had been driven into the water at a forty-five-degree angle downstream. Beyond these were thirty torpedoes containing two hundred pounds of gunpowder fired by percussion locks and trigger lines fastened to the pointed pilings.[70]

Commodore Stephen C. Rowan halted his ships at the mouth of the Neuse River on March 12 in order to concentrate his ships on the advancement up the river. That night, the fleet advanced up the river and, about nine o'clock, anchored off of the mouth of Slocum Creek, about sixteen miles below New Berne. Major General Burnside organized his forces into three brigades, placing Brigadier General John G. Foster over the first, General Jesse L. Reno over the second and General John G. Parke over the third. Brigadier General Foster's brigade consisted of the 23rd Massachusetts, the 24th Massachusetts, the 25th Massachusetts, the 27th Massachusetts and the 10th Connecticut. Brigadier General Reno's consisted of the 21st Massachusetts, 51st New York, 9th New Jersey and 51st Pennsylvania. Brigadier General Parke's consisted of the 4th Rhode Island, 5th Rhode Island, 8th Connecticut and 11th Connecticut.

Orders were given to be prepared to land first thing the next morning. The men were to "land in light marching order." Rather than carry all of their equipment, they were to carry only rubber and woolen blankets, rolled and worn over their shoulders; haversack and canteens; and sixty rounds of cartridges, forty in their cartridge box and twenty distributed about their person.[71] At dawn the next morning, the Federal guns began bombarding the wooded area around Slocum Creek in preparation for landing.[72] The shelling of the creek was unnecessary, as there were no Confederates anywhere nearby. Burnside's men began to disembark, using the same method used at Roanoke Island, but with no opposition. As the men landed, a band began playing "Hail

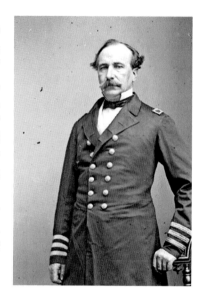

Commodore Stephen C. Rowan.
*Courtesy of the Library of Congress.*

Columbia."[73] Once on the mainland, the "soldiers burst into cheers and then started a miry journey toward New Berne." General Foster moved up the county road and attacked the enemy's front and left. General Reno moved up the railroad to turn the enemy's right, and General Parke moved up the county road as a reserve.[74] The ground was wet and mucky due to the heavy rain; the deep sand and thick clay were so bad that the soldiers had problems keeping their shoes on their feet. While the soldiers marched toward New Berne, the Federal gunboats kept up with them, moving toward New Berne as well. After marching some six miles in the mud and slush, the Federals came upon the Croatan Works, where they found the works deserted, much to their surprise.[75]

As the afternoon wore on, Burnside had his men make camp where they could get a good night's rest in preparation for the battle the next morning. While the rain came down in torrents, the men attempted to build fires and keep warm throughout the night.[76] That night, Burnside moved the rest of his troops, field guns and ordnance supplies into position for the next day.[77] At dawn, March 14, Burnside had his "men up and moving in preparation for advance on the rebel line."[78]

In preparation for the battle, Major General Branch organized his Confederates into a line of battle anchored on Fort Thompson. On the

Confederate left next to Fort Thompson stood the 27th North Carolina, then the 7th North Carolina and then the 35th North Carolina. Next to the 35th North Carolina was Wood's Brickyard. On the other side of the brickyard was Vance's 26th North Carolina, which was supported by an independent company and two dismounted cavalry companies. In reserve was the 33rd North Carolina, which Branch held in the rear. Two field pieces guarded the right side of the railroad, and ten supported the infantry on the left.[79] Between the kiln and Colonel Zebulon Vance's 26th North Carolina Regiment was a major gap in the line that was quite vulnerable. Branch plugged this hole in his line with a unit of inexperienced militia men who had only been in the service for two weeks. They did not even have uniforms, and most carried either shotguns or hunting rifles.[80]

Major General Branch sent out three of his regiments—the 35th North Carolina, 33rd North Carolina and 7th North Carolina—to fight a delaying action against the Federals.[81] Fighting began at 7:30 a.m. on March 14, but Burnside did not recognize it as such, thinking it only a feint. Burnside divided his force into three columns. He placed Brigadier General Foster on the Federal right nearest the fort, holding Major General John G. Parke's

Federal camping Near Slocum Creek. *Courtesy of Bridgeport History Center, Bridgeport Public Library.*

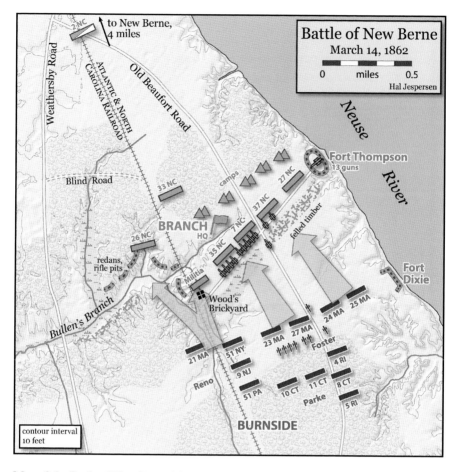

Map of the Battle of New Berne, March 14, 1862. *Hal Jespersen, Cartographer.*

brigade in the rear as a reserve unit, in the center along the railroad, so that he might be able to send Parke in whichever direction he was needed to support the other two brigades. Major General Reno was sent down the railroad toward the center of the Confederate line.

On the Federal right, Foster's brigade attacked the Confederate line first near Fort Thompson. Fort Thompson's three guns facing landward were most effective against Foster's men, "bowling over [the] bluecoats with virtually every discharge. Adding to the carnage were over shots from Commodore Rowan's Union gunboats firing from the Neuse River. Rowan's gunners were lustily shelling the whole area, without regard to the precise locations of friends or foes."[82] Foster's 27th Massachusetts Regiment, "suffering heavy

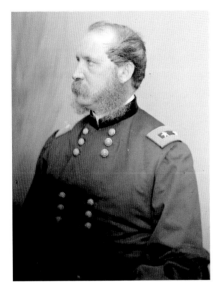
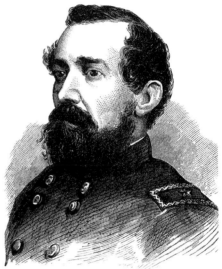

*Left*: Brigadier General John G. Foster. *Courtesy of the Library of Congress.*

*Right*: Major General Jesse Reno. *Courtesy of Frank Leslie's* Famous Leaders and Battle Scenes of the Civil War.

casualties, burned up all its ammunition without getting near the rebel entrenchments and had to be replaced by the 11th Connecticut. Another of Foster's spearhead units, the 23rd Massachusetts, eventually cracked under the heavy fire, and many of its men fled from the field."[83] The 23rd Massachusetts was replaced with the 10th Connecticut, "which dug in about 200 yards from the Confederate breastworks and fought an intense duel with the 27th and 37th North Carolina Regiments....The entire Federal right had been pummeled to a standstill."[84] The Confederate fire was incessant and severe. Simultaneously, the Rebel artillery raked the Union front. The three guns at Fort Thompson that faced the land "mowed gaps in the Yankee line at every discharge."[85] Confederate breastworks opened a hot fire on the enemy line. Each man fired "about three shots a minute....Instead of stopping to put the ramrod back in the gun after using it, the Federal soldiers would stick it in the ground in front of them. This withering fire still could not break the Confederate line. As a consequence, the Federal offensive on the right came to a standstill."[86]

Sensing that the Confederates were beginning to get into trouble ahead of him, Foster "ordered another frontal assault at Fort Thompson.... This time, Foster's maneuver succeeded and the Confederate line began

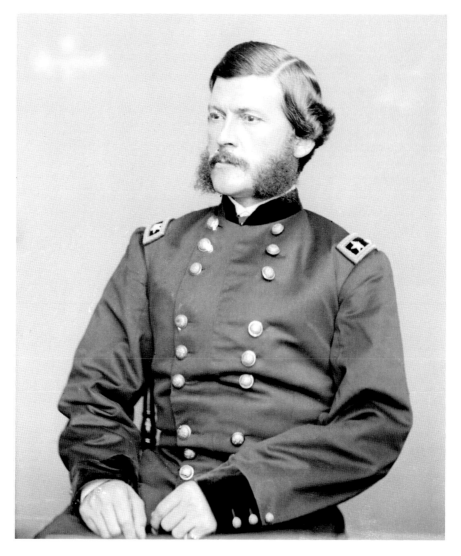

Major General John G. Parke. *Courtesy of the Library of Congress.*

to crumble. A pincer movement by Parke and Foster sent the rebels into a disorganized retreat."[87] Colonel Horace C. Lee, 27th Massachusetts Infantry, pushed the 27th and 37th North Carolina from the front line, sending them to the rear. He then went to push out the garrison of Fort Thompson himself, after the retreating soldiers had spiked the guns. There was no time to blow the powder magazine within the fort, as the Federals were advancing too quickly and were only forty yards away.[88]

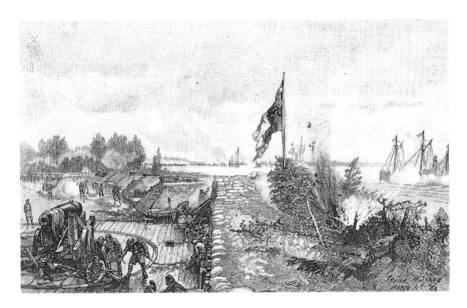

Fort Thompson. *Private collection.*

On the Federal left, General Reno moved his lead regiment, the 21st Massachusetts, forward, quickly discovering the weakness or break in the Confederate line at the brickyard. Reno found no Confederates to his immediate front, for Zeb Vance's line did not extend that far to the railroad. To his right, he could see the flank of the militia with no guns protecting it. Reno seized the opportunity and charged the militia to his right across the railroad: "Upon seeing the enemy on their flank, the militiamen were seized with panic…and part of them broke ranks."[89]

Believing it to be impossible to stop the Yankees, General Clark ordered a retreat, which turned out to be a "stampede." The fleeing militiamen exposed Colonel James Sinclair's 35th North Carolina Regiment. Colonel Campbell ordered the unit out of the breastworks and incited a bayonet charge on the advancing column, but Sinclair failed to form his men and left in confusion.[90]

Fred Osborne of the 23rd Massachusetts wrote to his mother about the Battle of New Berne, describing the hottest part of the combat:

> We commenced firing at once and the fire along the whole line was very sharp. The 23rd gun was the only artillery we had at first and none of the others came up until Capt. Dayton had used up all his ammunition. After our boys had fired a few rounds we had orders from the colonel to fall back.

*We were in a thin pine woods and the shells and balls from the battery made the splinters and bark fly and dropped the whole top of* [a] *small pine tree right on some of our heads.*[91]

Major General Branch made another attempt to close up the breach at the brickyard by sending in the 7th North Carolina, which rushed into the fray toward the gap in the line, as did Colonel Clark M. Avery's 33rd North Carolina, from the other side of the brickyard. Branch then asked Colonel Lee for help, to send in the 37th North Carolina,[92] but he was unable to do so because of Foster's heavy charge against his men, which occurred at approximately the same time. Seeing what was taking place to his left, General Foster then ordered his brigade to charge. General Foster's forces soon carried the whole line of breastworks between the river and the railroad. From behind the breastworks, General Branch saw that the enemy had the line—he was without a single man to place in the gap and decided that his best option was to secure the retreat.[93]

Branch immediately sent orders to retreat across the Trent River Bridge to all the defending troops, some of whom were still fighting. Several units never received the orders to retreat and were captured by the Federals. The retreat to New Berne was anything but orderly. Every man began to strike out for the bridge as fast as his legs would carry him. The three-mile route to the Trent River Bridge was filled with men running and bombs bursting

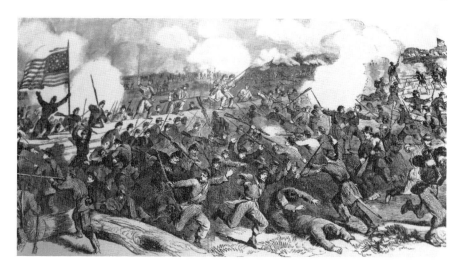

Storming Fort Thompson. *From* Leslie's Weekly.

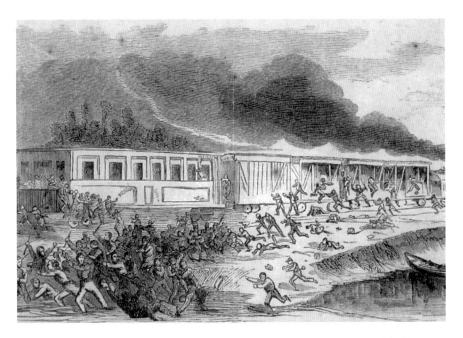

Confederate soldiers running to catch trains out of New Berne. *From* Harper's Weekly.

above and all around as the retreating soldiers rushed toward the bridge at top speed. Once they crossed the bridge, the soldiers did not stop running until they reached the depot, where they began to climb a westbound train that was pulling out of New Berne for Kinston.[94] Surging across the Trent River Bridge, the 7th North Carolina Regiment destroyed the draw. Branch had prepared a barge laden with turpentine-drenched cotton bales, which the retreating Rebels fired and jammed up against the railroad trestle, setting it alight. The railroad bridge, too, caught on fire and was destroyed.

On the Confederate right, Colonel Zebulon Vance and his 26th North Carolina were still fighting. For some reason, Colonel Campbell failed to tell Vance to retreat—thus, Vance continued to fight on while everyone else began to retreat. Some of the heaviest fighting of the entire battle took place here on the Confederate right. The commander of the 21st Massachusetts described the fighting with Vance's force:

> [They] *consisted of the Thirty-Third North Carolina and the Twenty-Sixth North Carolina Regiments, and were the best-armed and fought the most gallantly of any of the enemy's forces. Their position was almost impregnable so long as their left flank, resting on the railroad, was defended,*

*and they kept up an incessant fire for three hours, until their ammunition was exhausted and the remainder of the rebel forces had retreated from that position of their works lying between the river and the railroad.*[95]

As the rest of the Confederates made their escape from the battlefield across the Trent River Bridge, Vance's men were still fighting. By the time Vance discovered his men were fighting alone, it was too late to escape across the bridge, and he had to make his escape elsewhere. The only choice he had was across Brice's Creek, which was too wide and too deep for his men to cross without a bridge. Vance got on his horse and began to cross the creek, but his horse was unable to swim the entire steam, so Vance swam the rest of the creek to the other side. There he walked to a farm and found several boats, which he brought across the creek for his men to cross to the other side. Vance's men were able to make it to safety before the Federals caught up with them because the Federals were looting the Confederate camp located just behind the line of battle.

From New Berne, Confederate units made their way to Trenton, Kinston or Tuscarora. Some marched the distance over land, while others caught westbound trains out of New Berne. Panic ran throughout New Berne as the Confederates rapidly retreated through the town, closely followed by the Federal forces. Throughout the city, fires broke out, burning major buildings and some homes. Federal troops and freed slaves ran rampant throughout the day and most of the next day, plundering silver, china and anything of importance. It wasn't until late the next day that Brigadier General Burnside established strict control over New Berne and the fires put out and the plundering stopped. He ordered that all stolen property be returned to the rightful owners and sent soldiers to enforce martial law.[96]

Burnside's losses were small, especially considering his gains. According to official records, 90 men were killed, 380 men wounded and 1 captured, for a total casualty list of 471. On the other hand, the Confederates lost considerably. In addition to losing the second-largest city in the state and one of its most important ports, 64 of Branch's men were killed, 101 men were wounded and 413 men were captured or missing. Plus, he lost all of the forts below New Berne, the field guns, numerous small arms and the railroad. U.S. Secretary of War Edwin M. Stanton tendered Burnside the thanks and congratulations of the United States,[97] as well as a promotion to major general.[98]

After the Battle of New Berne, Burnside did not sit quietly and celebrate his victory. Instead, he immediately began looking for ways to expand his

base. He kept his men busy building forts and entrenchments around the perimeter of the town and constructing batteries and small forts to guard road junctions and bridges farther out. He set crews to work rebuilding the Trent River bridges. In addition, his troops fought a number of skirmishes in the nearby areas of Newport, Gillet's Farm, Haughton's Mill and Tranter's Creek. He sent a small expedition to nearby Washington on March 21–22, which his men found to have been deserted, the Confederates having retreated toward Greenville. Among the citizens left in New Berne, there was significant Union sentiment, and they persuaded Burnside to occupy the town with a company of the 24th Massachusetts Regiment and several gunboats to protect the inhabitants who professed loyalty to the United States.[99] Burnside's army then pressed on to Plymouth on the Roanoke River, which he found to be undefended by Confederate forces. His men left a copy of his proclamation and moved on up river toward Williamston, chasing after the Confederate steamer *Alice*. Burnside stopped in Windsor and then returned to Plymouth, where Commander Rowan ordered his men to remain in order to protect the Unionists there. Burnside had captured Elizabeth City, South Mills and Winton while stationed on Roanoke.

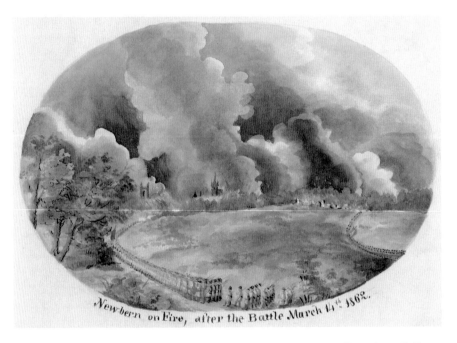

New Berne on fire after the Battle of New Berne. *Courtesy of Bridgeport History Center, Bridgeport Public Library.*

In the aftermath, North Carolina governor Vance wrote a letter to Confederate secretary of war James A. Seddon that read in part: "From Roanoke Island to the last siege of Washing[ton], the history of the War has been a succession of calamities in North Carolina....I shall not pretend to say that our defense is intentionally neglected, but that it is very poorly provided for is a fact too patent to deny."[100] His letter achieved no more than the many sent before. No additional help was to be sent to eastern North Carolina from Richmond.

Burnside began looking at his next major objective, Fort Macon. The fort guarded Beaufort Inlet, one of two inlets still open to Confederate shipping in North Carolina. Fort Macon was one of Burnside's major goals and a necessary prize before he could move against Wilmington to the south.[101]

Fort Macon had been completed in 1834 and was of the most modern design for that period. At a cost of $350,000, it was designed to protect Beaufort Harbor from an attack by sea. No soldiers had been stationed there since 1849, except for an ordnance sergeant, and the fort had fallen into a state of ill repair. On April 14, 1861, Confederates took over the fort and immediately began the process of repairing and rearming it. By the spring of 1862, the fort "was armed with fifty-four guns: two 10-inch columbiads, five 8-inch columbiads, four 32-pounder rifles, one 24-pounder rifle, eighteen 32-pounder smoothbore, and six 32-pounder carronades. The fort had 35,000 pounds of powder [of a very low quality, such as that at Fort Hatteras], which is not enough for a siege, too few shells, but did have a six-month supply of food for the garrison."[102] As for manpower, the fort had 22 officers and 419 men, 300 of whom were "effective soldiers with which to defend itself. Mumps and pneumonia had also weakened the garrison. Sand dunes remained all around the fort, never having been leveled, providing cover for an enemy assault."[103]

In order to begin preparations for an attack on Fort Macon, Burnside ordered Parke to Carteret County and to take the cities of Beaufort and Morehead City, from which he intended to launch the attack. After doing so, Parke began planning with the blockade squadron on the coast for the joint attack on Fort Macon. Parke placed his headquarters at Carolina City, just west of Morehead City, because it was directly opposite the nearest landing point on the banks on which Fort Macon was built. He then sent two of his officers to Fort Macon, requesting its surrender. Colonel Moses J. White, commander of the fort, politely declined Parke's offer of surrender, even though he realized the difficulty of successfully defending the fort.

Beginning on March 29, Union soldiers began crossing the Hoop Hole Creek to the banks opposite Carolina City, where they began to establish their camp. The soldiers worked around the clock transporting men and supplies to the camp.[104] Within a few days, the 8th Connecticut Infantry had established a firm beachhead eight miles from Fort Macon[105] and was joined by eight companies of the 4th Regiment Rhode Island Infantry; five companies of the 8th Connecticut; 5th Rhode Island, Company C; 1st Regiment U.S. Artillery; and Company I of the 3rd New York Light Artillery. Parke used various steamers, scows, schooners and rafts to transport men, supplies and artillery from Carolina City to Bogue Banks.[106]

Fort Macon had been designed to fight against enemy ships, not against a land attack. The Confederates failed to realize the plight of the men stationed at Fort Macon should it be attacked by a larger land force in coordination with a naval squadron. On the other side, General Burnside was well aware of the fort's vulnerability, which he planned to use to his advantage. Therefore, he began to land his troops on Bogue Banks behind the sand dunes beyond the fort.[107]

Early in April, General Parke's men began the process of digging trenches and emplacing guns just below the fort. Sand dunes, which lay all around and to the south of Fort Macon, worked perfectly for Parke. They afforded ample cover and concealment for the Federals' operations.[108] On April 11, work began on the trenches in earnest, both night and day, about 2,000 yards just south of the fort. The Federals worked under cover of darkness, placing three batteries—which were well hidden by the sand dunes—some 1,300 to 1,700 yards from Fort Macon. They dug rifle pits about 2,000 feet from the works but could go no farther due to the fort's fire.[109] The Federals completed their work after a week and a half, with batteries consisting of 8-inch mortars, 10-inch mortars and Parrott guns, all connected with zigzag trenches.[110]

With everything in place, all communication between the fort and the outside was cut off. On April 23, General Parke sent officers under a flag of truce to Fort Macon, presenting a second demand for the surrender of the fort, which Colonel White again refused, although he "probably had fewer than three hundred men fit for duty."[111] While Burnside was ready to begin the attack, Parke wanted one more day for preparation. The night of the twenty-fourth, Parke's men "dug out the embrasures and unmasked the Parrott rifles. At 5:30 a.m., on the twenty-fifth, Capt. Lewis O. Morris' Parrots fired the first shot, a shot on the parapet. The mortar batteries joined in, all firing rapidly. The fort returned the fire with

spirit."[112] Quickly, the battle developed into a full-scale battle between the Federals and the fort, even though the firing was wild and ineffective. "Bursting shells either filled the air with wreaths of smoke or tossed the sand and water in fountain-like columns. The solid shot from the Federal batteries ricocheted along the surface of the water beyond the fort, while Confederate shells glanced harmlessly from one sand hill to the other. Without mortars to lob the shells, Colonel White could hope to inflict little damage on the Federal emplacements."[113]

The Federal fleet had not been informed of the impending attack on Fort Macon and was not prepared for the battle. Approximately two hours after the conflict began, the Federal ships began to fire on the fort, which was designed for this type of battle. Fort Macon began to fire back at the Federal fleet, forcing it to retire after only one hour of firing on the fort.[114]

Back on the land side of the fort, the Federals' fire was rather ineffective. However, Foster had served as an engineer during the prewar period and had inspected the fort. Therefore, he knew the location of the fort's magazines and shell rooms. This gave the gunners an accurate target within the fort for their Parrott guns. Morris's Parrotts just skimmed over the outer walls and bored into the magazine's wall. In addition, the Parrotts began to dismount the guns on the parapets.[115] Throughout the day, the Federals continued their heavy shelling of the fort. "The accuracy of this fire…was amazing. It is estimated that out of 1,150 shots fired, about 560 hit the fort, and after mid-day, every shot fired from the batteries fell on or near the target. A total of nineteen Confederate guns were disabled."[116] The Confederate bombardment was not ineffective either. "Confederate projectiles from the fort flew in the embrasures of Morris's battery, damaging one gun which stayed in action. Most of the parapet of Flagler's mortar battery was blown away, so that the men had to shovel sand to rebuild it as the shelling allowed. More damage to the mortar batteries came from concussion of firing and the heavy downward recoil of the mortars."[117]

Having realized that there was no hope of winning the battle, about 4:30 p.m., Colonel White ordered a white flag to be raised over the fort, and immediately, all firing ceased. The colonel sent out two of his assistants under a white flag to ascertain the terms of surrender. General Parke informed the officers that only an unconditional surrender would be acceptable to the Federals, which White refused. Unable to agree on the terms of surrender, the two sides agreed to a ceasefire until the next day, when Major General Burnside could arrive and negotiate the terms of surrender. Early the next morning, Burnside sent two of his officers to the fort under a white flag with

new terms. Those terms "were that the fort and all its men and arms would surrender, and the captured officers and men would be released on their honor not to fight again until properly exchanged as prisoners of war and would return to their homes, taking with them their private property."[118] To these new articles of surrender, Colonel White agreed.

Later that morning, the Federals lined up outside the fort to take formal possession of it. Inside, the Rebel Stars and Bars still proudly flew over the ramparts. After the Federals entered the fort, the "officers gathered at the fort's flag pole. A detail lowered the Confederate flag, but they had no large United States garrison flag. With the help of a Confederate officer, one was found in the fort. As the new color guard hoisted it, bugler Joe Greene of the 4th Rhode Island played 'The Star Spangled Banner' 'as if his very soul was in each martial note.'"[119]

With the fall of Fort Macon, only the garrison at Fort Fisher, which guarded Wilmington, was left open in the state. Major General Burnside had now accomplished the first three of his objectives, establishing strong Federal positions all along eastern North Carolina. Confederate losses during the battle were seven killed and eighteen wounded, plus one who died of illness. On the Federal side, one was killed during the battle, two were wounded and six others died due to disease.

Before Burnside could begin the process of planning his next offensive, President Lincoln ordered him back to Virginia to reinforce Major General McClellan, who was fleeing from General Robert E. Lee during the Seven Days Battle on the Peninsula. On July 6, 1862, after a series of major successes, Major General Ambrose Burnside departed North Carolina and Major General John G. Foster, his right-hand man while in North Carolina, was appointed to replace Burnside as commander of the Department of North Carolina.

Following Burnside's Expedition, there was a permanent Federal occupation of New Berne, with the Federals using the city as a base of operations for attacks on surrounding areas. Forts and camps were built, surrounding New Berne, and soldiers began to settle in. One soldier wrote home of Federal soldiers desecrating the grave of Richard Dobbs Spaight, a signer of the U.S. Constitution. He described the tomb as "a large marble slab with inscriptions covered his remains set in a beautiful tomb overarched by some trees and vines of southern growth. When cared for by loving hands it must have been a lovely spot."[120] The author of the letter went on to add: "When the 10th Connecticut were quartered here they tore open the tomb and opening the coffin in which the General had been embalmed with

his equipment they plundered the sword and left the coffin with nothing to veil it but the blue sky."[121] The soldier went on to say that when the 43rd Massachusetts came in, "men were detailed immediately to repair the tomb, but they could not restore the sword or wipe out the eternal insult to the dead and stain upon our arms."[122]

# The Best Fortified Town in America

Following the defeat of the Confederates on March 14, the town of New Berne looked different than it did before the battle. Most of the white citizens left town, and their houses were occupied by Federal troops. While there is no true idea as to how many white citizens left New Berne after the battle, Federal soldiers estimated that "only about two hundred out of a total population of seven or eight thousand white people, remained at their homes."[123] A good deal of western Craven County between New Berne and Kinston was a "no-man's land" where neither Confederate nor Federal forces controlled the area. Guerrilla forces roamed the area, attacking Federal forces that went out on small expeditions from heavily fortified New Berne.

Immediately following the fall of New Berne, mobs of blacks and some Federal troops ran through the streets stealing and looting. Major General Burnside put an end to the plundering and stealing by imposing martial law on the town and demanding that all stolen goods be returned. One officer noted that many still stole souvenirs on the sly.[124] Major General Foster was appointed provost marshal of the city of New Berne and the vicinity, and he "established a most perfect system of guard and police."[125]

General Foster was a trained engineer and began completing fortifications in and around New Berne.[126] Foster quickly began settling in, building forts, digging trenches and establishing strong fortifications to defend the town from Confederate forces. The town was naturally defended by two major rivers at the confluence of the Neuse and the Trent, which guarded three

sides of New Berne. As the Federal occupation grew, soldiers from fifteen regiments from Massachusetts plus others from Pennsylvania, Rhode Island, Connecticut, New York and New Jersey served in New Berne to help protect the town from Confederate attack.[127]

Thousands of Federal soldiers made their camps outside the city of New Berne, while the higher-ranking officers established their headquarters in the finer homes within the town. Public buildings, such as St. John's Masonic Lodge, were turned into hospitals. Churches found that their pulpits were now occupied by the Union army chaplains. The streets were filled with Federal soldiers and guarded by the Federal provost guard.[128]

New Berne was the citadel of Federal forces in eastern North Carolina, and as such, the Federals were determined to protect the town at any cost. They began to complete and repair Confederate forts and put them to use. Then the military began to build new forts in and around New Berne, especially along the Neuse and Trent Rivers. These new forts included Fort Stevenson on the Neuse, Fort Rowan on the railroad and Fort Totten, the major fort on the Upper Trent Road. In addition, there were other forts and blockhouses built outside of the city.

While New Berne was naturally defended by the Neuse and Trent Rivers on the north, east and south, on the west there were two natural waterways as well, which were useful as defensive works. The land in between those two waterways was protected by a large swamp called the Yates Pocosin and other marshy areas. The first of the two waterways was Deep Gully, which "trickled southeast for five miles before emptying into the Trent."[129] The other waterway was Batchelder's Creek, which at its widest part is fifteen to twenty yards across, and it snakes its way toward the Neuse River for nine miles.[130] The Federals dug a major canal between the Trent River to the Neuse River connecting Forts Totten, Rowan and Dutton. This served as a type of moat between the Federal-controlled New Berne and the Confederate side of Craven County.

In and around New Berne, the Federal forces constructed and manned nine forts—each was formidable in its own right. Altogether, the forts gave New Berne in late 1862 the reputation of one of the "best fortified towns in the United States."[131] Those nine major forts were Fort Totten, Fort Rowan, Fort Stevenson, Fort Spinola, Fort Amory, Fort Gaston, Fort Anderson, Fort Chase and Fort Reno. There were a number of other forts, including Forts Dutton, Chase and Union. In addition, the Federals built a number of blockhouses on the outskirts of town and established pickets around the city.

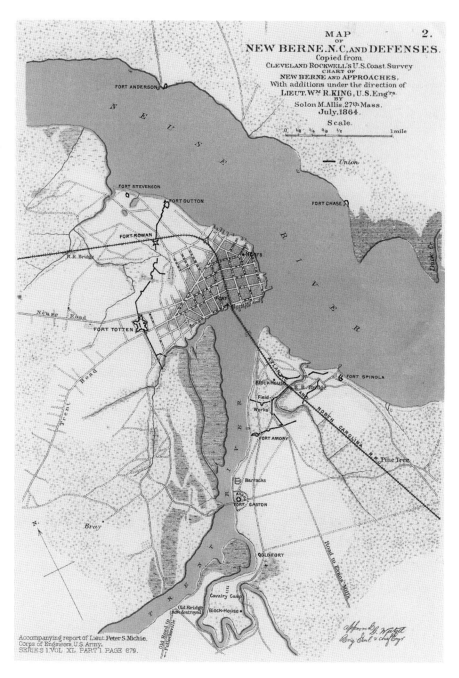

Map showing Federal forts in and around New Berne after the battle. *From* Official Records, *series I, vol. 40, part I, p. 679.*

The largest and most important of the forts was Fort Totten, which was located on the edge of town between Trent and Neuse Roads. Fort Totten

*was a five-pointed work with bastions at four of the angles, while the salient, at the fifth one, was to the rear. The work enclosed from six to eight acres, and was surrounded with a wide and deep, but dry ditch. Each bastion mounted five guns; one at the salient, one on each face, and two as "flankers," to sweep the ditch. It also had on the front curtain embrasures for four thirty-two-pounder howitzers. There were four eight-inch mortars in rear of the howitzer platforms. The guns were thirty-two's, with the exception of one eight-inch Columbiad, one rifled thirty-two-pounder in bastion number three, and the flankers, which were thirty-two-pounder carronades on ships' carriages and were to throw grape or canister. Extending across the entire length of the fort, parallel with the front and about forty feet behind the front curtain was a high traverse. It was made of faced timbers, about forty feet long. A trench about three feet deep was traced around the space the traverse was to cover. These timbers were placed on end in the ditch, and the earth was firmly tamped around them. They were then drawn in at the top, and the whole bolted and braced together from the top to bottom. At each end of this frame-work magazines were constructed, each one opening to the rear. Then the whole of this frame was filled with well-tamped earth which covered the magazines and made them shell and bomb-proof. The whole was surmounted with a breastwork sodded and riveted, affording a splendid place for sharpshooters in case of attack. The rampart on the traverse was reached by stairways from the rear. This great traverse was a landmark to the country for miles around. The quarters for the garrison and the parade ground were in rear of this traverse. It was supplemented by other and smaller traverses at different points to protect the several faces of the work from an enfilading or reverse fire. If properly armed and manned it could not have been taken with any force the enemy could bring against it.* [132]

Fort Totten was commanded by Major Samuel G. Oliver of the 2nd Massachusetts Heavy Artillery, while Captain James Moran, 5th Rhode Island Heavy Artillery, was in charge of bastion number three and Captain Elijah D. Taft, New York Light, 5th Battery, was in charge of bastion number two.[133] The fort was manned by Company D, 5th Rhode Island Volunteer Artillery, with forty-three men and Company I of the 5th Rhode Island Volunteer Artillery with thirty-four men.[134]

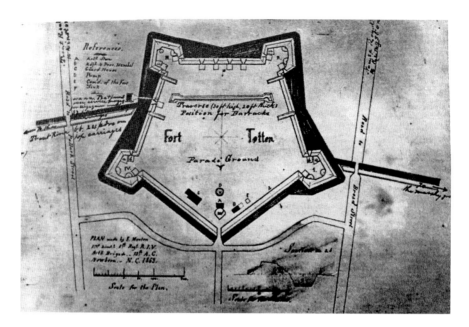

Diagram of Fort Totten. *Original in possession of Pat McCullough, New Bern.*

Fort Rowan was not nearly as large as Fort Totten. It had large guns placed at the four corners with bombproofs and was surrounded with high earthen walls and a deep moat. It was located adjacent to the Atlantic and North Carolina Railroad on the north side of New Berne and was often referred to as the "Star Fort" because its shape was that of a four-pointed star. Fort Rowan and Fort Totten were considered to be the "linchpin of New Berne's defenses."[135] Lieutenant C.F. Gladding of Company F, 5th Regiment of Rhode Island, commanded Fort Rowan. The fort was named for Commodore Stephen C. Rowan, the U.S. Navy officer who replaced Admiral Louis M. Goldsborough, when the latter was called by General McClellan to assist him in the Peninsula Campaign. Fort Rowan was manned by fifty-three men of Company F, 5th Rhode Island Volunteer Artillery, with Colonel Henry T. Sisson commanding. It had one 100-pounder Parrott; two 32-pounders, long; one 3-inch rifle, brass; one 3-inch rifle, steel; and two 8-inch mortars.[136]

Fort Stevenson, named after Brigadier General Thomas G. Stevenson, 1st Division, 9th Army, was located north of town and along Smith Creek and was commanded by Captain H.B. Landers of Company H, of the 5th Regiment Rhode Island Heavy Artillery. Fort Stevenson was

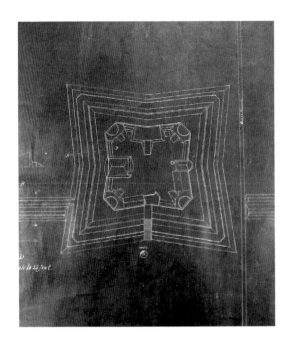

*Left*: Diagram of Fort Rowan. *Below*: Diagram of Fort Stevenson. *Originals in possession of Pat McCullough, New Bern.*

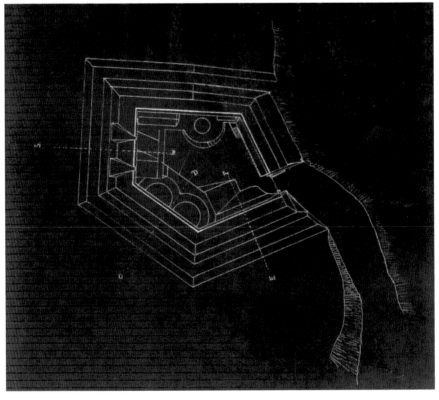

surrounded by a high wall and a deep moat and manned by thirty-nine men of Company H, 5th Rhode Island Volunteer Artillery, with Colonel Henry T. Sisson, commanding. It had one 32-pounder rifle and four 32-pounders, long.[137]

Fort Spinola was named after Francis Barretto Spinola, who probably built the fort, and located along the Neuse River just south of New Berne. Captain I.M. Potter of Company B, 5th Regiment of Rhode Island Heavy Artillery, commanded the fort. Fort Spinola jutted out into the Neuse River and had seven large guns on a high earthen wall that surrounded the fort and included a deep moat on the land side. Fort Spinola was manned by sixty-four men of Company B, 5th Rhode Island Volunteer Artillery, Colonel Henry T. Sisson commanding and one company of the 19th Regiment Wisconsin Volunteer Infantry consisting of forty-two men with Lieutenant Colonel R.M. Strong, commanding. The fort had six 32-pounders, long and two-32-pounders rifles.[138]

Fort Amory was located south of New Berne along the Trent River. Captain Robinson of Company G, 5th Regiment of Rhode Island Heavy Artillery, was its commander. It was most likely built by and named for Colonel Thomas J.C. Amory. Fort Amory had three 32-pounders overlooking the Trent River and was surrounded by a high wall and a deep moat. It was

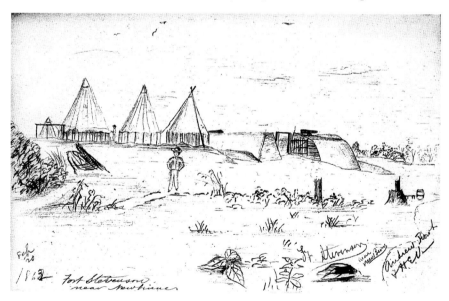

Fort Stevenson print. *Herbert E. Valentine Collection, Southern Historical Collection, UNC–Chapel Hill.*

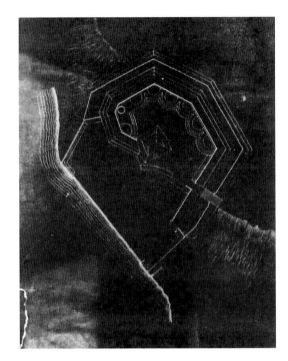

*Left*: Diagram of Fort Spinola.
*Original in possession of Pat
McCullough, New Bern.*

*Below*: Fort Spinola print. *Herbert E.
Valentine Collection, Southern Historical
Collection, UNC–Chapel Hill.*

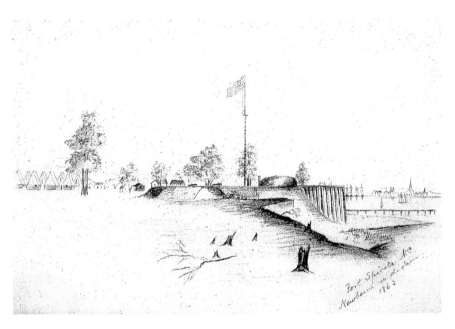

manned by forty-seven men of Company G, 5th Rhode Island Volunteer Artillery, with Colonel Henry T. Sisson commanding.[139]

Fort Gaston was located on the Trent River south of Fort Amory and was originally a Confederate fort. It was located at the bridge over the Trent River and used to guard that crossing. After the Federals took over New Berne, they also took over Fort Gaston. It was commanded by Captain De Meulin of Company K, 5th Regiment of Rhode Island Heavy Artillery. Fort Gaston had seven guns overlooking the Trent River and was surrounded by a high earthen wall with a deep moat. Fort Gaston was manned by thirty-three men of Company K, 5th Rhode Island Volunteer Artillery, with Colonel Henry T. Sisson commanding and one company of thirty-seven men of the 19th Regiment Wisconsin Volunteer Infantry with Lieutenant Colonel R.M. Strong, commanding. Fort Gaston had four 32-pounders, long, and three 32-pounders, short.

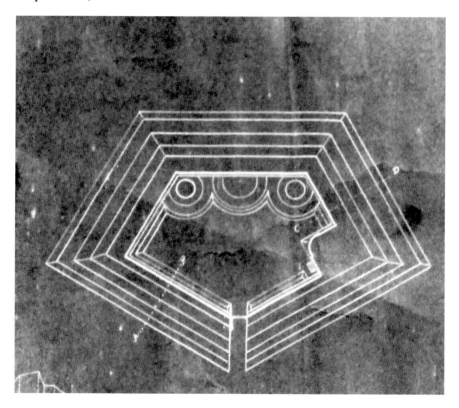

Diagram of Fort Amory. *Original in possession of Pat McCullough, New Bern.*

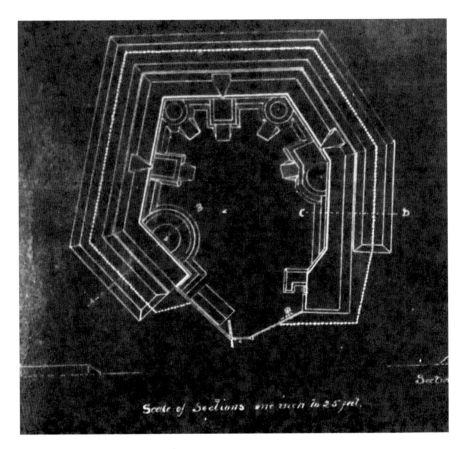

Diagram of Fort Gaston. *Original in possession of Pat McCullough, New Bern.*

Forts Amory and Gaston guarded the Trent River along with several small gunboats. The forts were "located upon the high ground where the banks form a high bluff, permitting a flotilla of small boats or a column of infantry to pass with comparative security in dark and stormy weather."[140] Colonel Arthur R. Dutton, "one of the most accomplished engineers in the service and of great experience, has looked after this work. It will command the Trent, and have a cross-fire upon all the approaches to Fort Totten, besides making us independent of gun-boats in that quarter."[141]

Fort Chase was located along the east side of the Neuse River, south of and across from New Berne. Fort Chase had three guns facing the river side and had a high wall on the land side and a deep moat as well.[142]

Fort Anderson was located on the north side of the Neuse River, opposite the town of New Berne. It was situated on a slight elevation, the height of

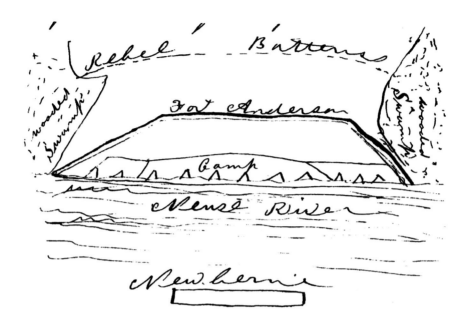

Diagram of Fort Anderson. *Courtesy of the North Carolina Department of Archives, Raleigh.*

the interior crest being eight or nine feet and the ditch in front six by eight feet. It was flanked by a swamp of three or four miles on the right and a swampy creek on the left so that it could only be approached in front. The road ran down to its center and then along the ditch of the left half. The garrison was composed of regiments of between 250 to 300 men who served for only two years.[143] Fort Anderson was manned by ten companies of the 92nd Regiment, New York Volunteer Infantry. Lieutenant Colonel Hiram Anderson Jr. commanded ten companies of 244 men. It had one 32-pounder rifle; three 32-pounders, smooth; one 32-pounder carronade; one 24-pounder howitzers; and one 12-pounder howitzer.[144]

The fort was surrounded on three sides by dirt walls about ten feet high and twenty feet thick at the base. "Inside at one end are wooden buildings used for the officers' quarters. Then there two long rows of tents. At the other end is the powder magazine. Near the entrance is another building used for a guard house. No grass but barren sand inside and outside."[145]

About two miles southeast of New Berne stood Foster's Barracks along the Trent River. This was the major Federal military barracks in the New Berne area. Their general plan was "two long buildings parallel to each other distant about fifteen rods, each divided into 5 compartments, thus

accommodating the 10 companies with separate rooms. The officers will have barracks also as soon as they are completed, but for the present we are obliged to be content with tents."[146]

Fort Chew's location is unknown, but it was manned by the 92nd Regiment New York Volunteer Infantry with Lieutenant Hiram Anderson Jr. commanding a detachment of fifty-two men. It had three 24-pounders.[147] Fort Union had one 100-pounder Parrott; one 32-pounder, long; and one 32-pounder, short.[148] The last Federal fort was Fort Reno, which has not been located.

Colonel Henry T. Sisson, 5th Regiment Rhode Island Heavy Artillery, was in charge of the forts around New Berne.[149] In addition to the Federal forts, there were a number of Federal encampments surrounding New Berne, heavily manned.

Farther south was Evan's Mill garrisoned by one company of the 19th Regiment Wisconsin Volunteer Infantry, sixty men commanded by Lieutenant Colonel R.M. Strong.[150] In the general vicinity was an encampment near Brice's Creek, where a company of thirty-five men of the 19th Regiment Wisconsin Volunteer Infantry, commanded by Lieutenant Colonel R.M. Strong, manned the camp. Forty-one men of the 12th Regiment New York Volunteer Cavalry also manned the area of Brice's Creek.[151]

In the area of New Berne, at the New Berne Fair Grounds, ten companies consisting of 564 men of the 15th Regiment of the Connecticut Volunteers, commanded by Lieutenant Colonel Samuel Tolles, were encamped.[152]

At Batchelder's Creek, west of New Berne, sixty-seven men of the 12th Regiment New York Volunteer Cavalry, commanded by Colonel James W. Savage, manned the camp. Located at Batchelder's Creek was the iron rail Monitor Car, consisting of two Wiard and two 6-inch guns.[153] It traveled twice a day to and from New Berne.

Camp Palmer was manned by the 12th Regiment New York Volunteer Cavalry, with Colonel James W. Savage commanding a contingent of 263 men.[154] It manned two mountain howitzers for defense.[155]

Lieutenant Colonel George W. Lewis commanded Camp Peck, which was manned by the 3rd Regiment New York Volunteer Cavalry. He manned Companies A, B, C, E, F, G, I, K, L and M, 417 men. They had ten 3-inch guns, four 3.67-inch guns and six 4.62-inch guns.[156]

About eight miles west of New Berne on Trent Road was Rocky Run, where seventy-eight men of Companies D and H of the 3rd Regiment New York Volunteer Cavalry were posted under the command of Lieutenant Colonel George W. Lewis.

In addition to the forts, there were blockhouses scattered all over the outskirts of town with small contingents of men at various outposts. One of those was located at Batchelder's Creek about eight miles west of town. It consisted of a blockhouse and trenches along with a contingent of men protecting the road coming into New Berne.

A second blockhouse was established at Evans' Mill along Brice's Creek, south of New Berne, not far from the Trent River.

There were other blockhouses as well. One was located just south of New Berne across the river and another near Havelock along the railroad. There were probably a dozen such blockhouses around New Berne. In addition, there was one in Havelock.

Along the Croatan Line eight miles or so south of New Berne there are the ruins of a fort on the western end of the railroad. That line runs from the fort all the way east to the Neuse River. While many people call this a blockhouse, it is clearly a fort, as it is mentioned in the records and featured a high platform for the artillery. Much of this platform remains intact today. In fact, much of the Croatan Line remains intact.

Batchelder's Creek Blockhouse. *Courtesy of East Carolina University, Joyner Library, Greenville, North Carolina.*

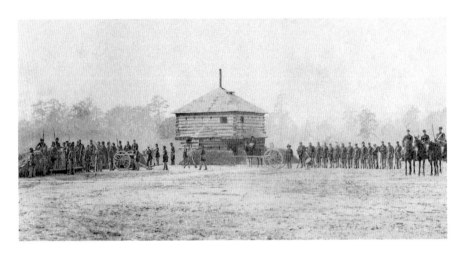

Evan's Mill Blockhouse. *Courtesy of Wisconsin Public Library, Reedsburg, Wisconsin.*

Blockhouse near New Berne. *Courtesy of Tryon Palace, New Bern.*

Blockhouse near New Berne. *Herbert E. Valentine Collection, Southern Historical Collection, UNC–Chapel Hill.*

Blockhouse near New Berne. *Courtesy of New Bern–Craven County Library.*

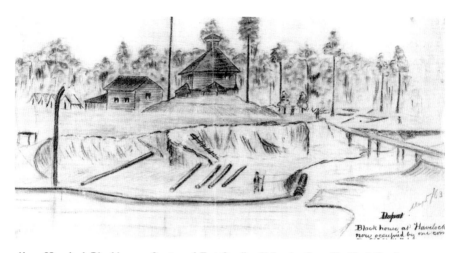

Block house at Havelock now occupied by one com

*Above*: Havelock Blockhouse. *Courtesy of East Carolina University, Greenville, North Carolina.*

*Opposite*: Signal tower, similar to those built west of New Berne near Batchelder's Creek. *From* Atlas to Accompany the Official Records.

In addition to the forts and blockhouses, the Federals had a string of watchtowers or signal towers built about eight miles west of New Berne. There were a number of them stringing from the Neuse River to the Trent River to enable communication.

Before the battle on March 14, 1862, the Confederates had erected their defenses of New Berne primarily south of the city along the Neuse River in order to prevent the enemy from coming into the city. If a battle was to occur, they wanted it to take place several miles from the town to protect it and its citizens.

The Federals took a different approach to defending the town. They built their defenses close to the city, creating a ring around it as a protection from the raiding Confederates just beyond the town limits. Surrounding New Berne was a large network of Rebel guerrillas in all directions whom the Federals wanted to keep at bay—plus, they wanted to be able to return to their forts quickly when on reconnaissance.

Most of these forts are still in existence in and around New Bern, as are the foundations of the blockhouses, yet only a small handful of people know they even exist. Some of the forts have houses built in the middle of them or on them and the people living there have no idea their houses are situated on a Civil War–era fort. Many of these forts are clearly out in the open, and no one recognizes what they are. Part of the Croatan Line still exists, as does the Fort Thompson Line, located at the county fairgrounds. Fort Gaston is

remarkable for how much of it is still in existence, as is Fort Dixie. The Evans Mill Blockhouse, Havelock Blockhouse and Batchelder Creek Blockhouse foundations are still extant, and the foundation of the fort at Croatan still survive. It is remarkable that these still stand, especially considering that very few know of their existence.

# THE SECOND BATTLE OF NEW BERNE

When New Berne was captured and occupied in March 1862, Confederates immediately began planning strategies to retake the city and evict the Federal menace located on their doorsteps. The first opportunity came just a year later in the spring of 1863, when Brigadier General Daniel H. Hill, newly appointed commander of Confederate forces in North Carolina, initiated a plan to liberate New Berne through a military strike from Kinston. This was considered timely due to the "reduced Federal forces at New Berne," which had been so diminished "by the reinforcements that General Foster had sent to South Carolina."[157]

General James J. Pettigrew, working under D.H. Hill, moved out from Goldsborough with a portion of the reserve artillery, traveled twenty-six miles east to Falling Creek, eight miles west of Kinston, where he bivouacked for the night. There he received orders to report the following day to Major General George Pickett, who ordered him to Kinston with the four 20-pounder Parrott guns of the Macon Light Artillery, under command of Lieutenant C.W. Slaten, and one 3-inch rifle of the Montgomery Light Artillery, under command of Lieutenant James E. Davis.[158] Their appearance in Kinston provided a total of nine guns ready for action.[159]

All of the artillery was transported by rail twenty-one miles from Kinston and halted for the night, where they "were delayed for over three hours by a portion of the brigade wagon train" when one of their guns, "a 3-inch rifle, broke through a corduroy bridge, letting the piece down into the water."[160]

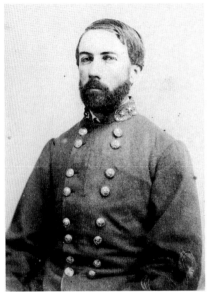
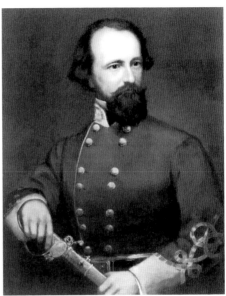

*Left*: Brigadier General D.H. Hill. *Courtesy of the Library of Congress.*

*Right*: Brigadier General James J. Pettigrew. *From the* North Carolina Dictionary of Biography.

Brigadier General Beverly Robertson's cavalry brigade consisting of the 4th and 5th North Carolina regiments was located on the south side of the Trent River, but he moved his forces, including three squadrons from the 4th North Carolina Cavalry and three from the 5th North Carolina Cavalry, consisting of approximately five hundred men, toward Jacksonville when he received word of enemy sightings in the area.[161] As he proceeded toward Pollocksville, where the Federals had their pickets stationed and were strongly fortified, he determined that the Yankees had crossed Mill Creek several days before and destroyed the bridge over that stream, which he found impassable. He returned to McDaniel's Mill, where encamped, leaving Andrew McIntire's squadron behind on picket duty at Pollocksville and Mill Creek. He gave them orders to hold those places at all costs.[162]

Robertson then ordered part of his company forward to cut the railroad and telegraph line between Sheppardsville (Newport today) and New Berne. He took the rest of his force to Pelletier's Mill some twenty miles distant, where he arranged for them to attack early the next day, Sunday, March 8, 1863. They were to at least occupy the enemy's attention if not attack. At the same time, Colonel D.D. Ferebee, 4th North Carolina Cavalry, was to

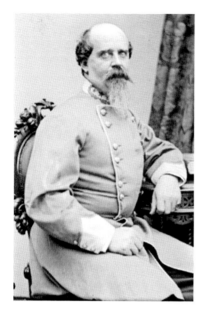

Brigadier General Beverly Robertson. *Courtesy of the Library of Congress.*

destroy the Atlantic and North Carolina Railroad above Newport Creek, taking the road beyond Kennedy's Mill.[163]

While Brigadier General Robertson was traveling in lower Jones and Onslow Counties, James J. Pettigrew left Goldsboro on March 9 and arrived in Kinston the next afternoon. There Pettigrew received orders to proceed to Barrington Ferry across from New Berne, get his guns in position and "open a concentrated fire upon the enemy's work."[164] The heavy concentration of fire from Pettigrew's guns was to demoralize the enemy to the point of a "bloodless surrender."[165] Therefore, it was most important that the bombardment begin on Thursday, March 12.[166]

Pettigrew had to travel fifty-seven miles in heavy rains, which had put the roads in poor condition. He hoped to carry out the work by moonlight on Friday morning, entrenching the guns before the gunboats could attack.[167]

The infantry arrived at the camp, which was eight miles from Barrington's Ferry, at dark. It was Pettigrew's intent to start at midnight for the ferry, but the swamp under the train changed to quicksand and damaged the bridge. All through the night, the men worked to repair the bridge in freezing water. It finally became necessary to ford the swamp in another area. The infantry arrived at the ferry early that night, but the 20-pounders had mired in the swamp, so the artillery did not arrive until the next morning.[168] Based on reconnaissance, Pettigrew determined that Pettiford's Ferry was the perfect place for attacking the gunboats. Then, he placed a rifled gun with the 26th North Carolina under Colonel Henry K. Burgwyn Jr. and planned to dig entrenchments.[169]

At approximately the same time, Federal forces began to advance toward Mill Creek, a tributary of the Trent River in Jones County, expecting to find the creek occupied by Confederate forces. The Federals took possession of the opposite bank at 8:00 a.m. with no opposition. At once they moved on to Pollocksville, where they learned that Robertson and his cavalry had left there earlier, headed for Kinston.[170]

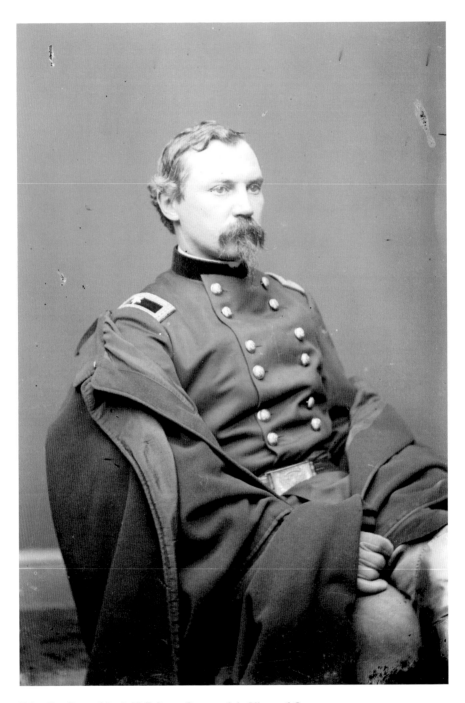

Brigadier General Innis N. Palmer. *Courtesy of the Library of Congress.*

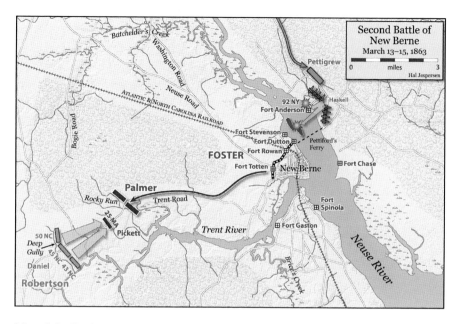

Map of the Battle of New Berne and Deep Gully. *Hal Jespersen, Cartographer.*

The Federal forces communicated with their pickets located along Mill Creek and with the gunboat *North Star*, located in the Trent River near Mill Creek. The captain of the *North Star* placed himself under the command of the Federal forces in the area and proceeded to Pollocksville to support the arriving Federal troops there. The 158th Pennsylvania Militia was then detailed toward Pollocksville, just up the road from Mill Creek.[171]

Confederate Brigadier General Junius Daniel took his brigade down the lower Trent Road, where he encountered Federal pickets at Deep Gully. Daniel charged the Federals with four companies and drove them out, but darkness halted further action.[172]

Upon receiving word that the Confederates were advancing in large numbers, Brigadier General Innis N. Palmer sent out three regiments from New Berne, the 5th Massachusetts Volunteer Militia, 25th Massachusetts Volunteers and the 46th Massachusetts Volunteer Militia, to Deep Gully on the Trent Road.[173]

When the Federal forces arrived at Deep Gully, they found that the Confederates had crossed and were strongly entrenched in the area. The Federals bivouacked for the night and made preparations for a morning attack.

On Saturday, March 14, the Federals made a feeble attempt to recapture Deep Gully. At daybreak, Colonel Josiah Pickett of the 25th Massachusetts moved skirmishers forward, and they immediately engaged the Confederates' line. Brigadier General Palmer took command and was ordered forward with his regiment, supported by the 5th and 46th Regiments Massachusetts Volunteers, plus a section of William J. Riggs and one of Captain James Belger's battery.[174]

Musket fire was kept up for nearly three hours. As the city was being attacked in the rear, the regiments supporting Josiah Pickett were withdrawn from its defense and he was left, with his regiment and two pieces of artillery, to take care of the enemy as best he could. Having special orders from Brigadier General Palmer not to expose the pieces, Pickett blockaded the road and fell back to a better position at the Jackson House and awaited the Confederate advance. The Rebels soon began to shell the woods around them and kept it up at intervals during the day but did not advance.[175] While General Pettigrew pushed the Federals back from Deep Gully, he failed to push them any farther. He should have pursued them to their next stronghold, which was located three miles down the road toward New Berne at Rocky Run. There the Federals were able to reform and hold on to their position.[176] Pettigrew fell back to a point opposite Trenton, where he remained until noon on Monday, March 16.[177]

The Confederates had destroyed the bridge at Deep Gully and placed a large pine tree across the road on the New Berne side of the gully. Sixteen Federal volunteers went to the front, where they found the enemy's campfires still burning but no Rebels. Before they could leave, two or three companies of Rebel cavalry came dashing past them, headed in the direction of New Berne. As the Federals left for New Berne, they ran into Colonel Thomas J.C. Amory with his brigade and artillery, which were moving out. This force encamped about three miles from Deep Gully. The next morning, Amory's brigade ventured some four miles farther toward Kinston and formed a line of battle, sending some cavalry ahead. They found no Confederate enemy but discovered that twenty thousand Confederates had passed that way earlier.[178]

On Sunday, March 15, Colonel J. Richter Jones,[179] 58th Pennsylvania Infantry, made a reconnaissance mission to Deep Gully and found there were no Confederates there or within three miles of the area. He reported that "the main body of their force moved away last evening and the residue early this morning, in full retreat."[180] Jones went on to report that the Confederate force had "eight pieces in the battery in the field behind the Gully, and had a

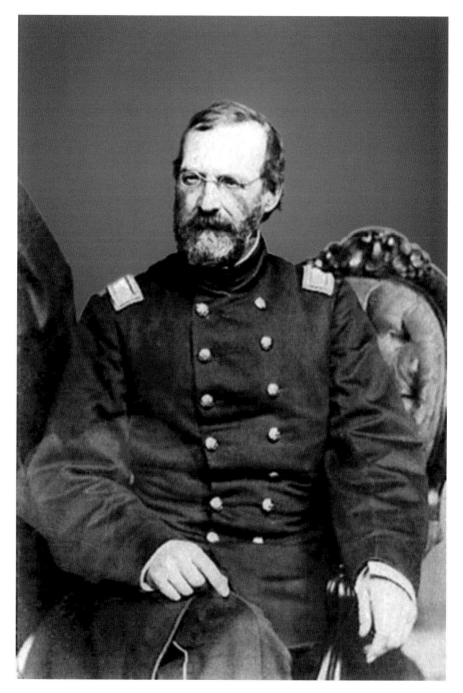

Colonel J. Richter Jones. *Courtesy of the Library of Congress.*

front of about 1,200 yards deployed, enveloping and turning…Deep Gully position on both flanks. From the signs on the ground made by the recoil of pieces, &c., they fired but little."[181]

On Saturday, March 14, Brigadier General Pettigrew, commanding a force of seven thousand men and seventeen pieces of artillery, had advanced on the north side of the Neuse River and attacked a small fort known as Fort Anderson, occupied by the three hundred men[182] of the 92nd New York Volunteers, commanded by Lieutenant Colonel Hiram J. Anderson.[183] Fort Anderson, opposite New Berne, was an unfinished earthwork with no mounted cannon held by a regiment of volunteers.[184] Supporting Fort Anderson were four gunboats in the Neuse River: *Hetzel*, *Hunchback*, *Shawsheen* and *Ceres*. The *Hetzel* was particularly effective in protecting Fort Anderson and repulsed the Confederates. Had it not been for the four gunboats in the river, there would have been a serious assault on the fort.[185]

The interior of Fort Anderson was eight or nine feet high, and the ditch surrounding the fort was six feet by eight feet. The fort was flanked by a large swamp of three or four miles on the right and a swampy creek on the left. Thus, the enemy could only approach from the front.[186] The post consisted of 250 to 300 men who were there on a two-year assignment.

The Federals were taken completely by surprise by the Rebels appearing in force with artillery when not even a single scout had shown himself in the past twelve months. The town was soon in a turmoil.[187]

The Confederates opened fire on Fort Anderson, holding their infantry in reserve for an assault on the fort. Lieutenant Colonel Hiram Anderson Jr., within the fort, was summoned to surrender several times, but each time he refused. Anderson referred the matter to his superior, General Foster, for orders and was told to defend the fort at all costs. The gunboats were on the other side of the Neuse River and in a situation where they were of no help at first. One was aground, and two were damaged. It took a while, but tugs towed them into position, and with a battery of rifled guns on the other side of the river, the Federals compelled General Pettigrew to withdraw his artillery and infantry. He remained only as a threat until morning, when he retired from the field.[188]

The Confederates expected the Federals to fire one round and surrender, which would cost the Confederates fifty to one hundred men. The Confederates therefore decided to display their force by giving them heavy fire from their artillery and demanded their surrender. The artillery deployed their shells into the fort, opening with rapid and well-directed fire. Lieutenant Louis G. Young, aide-de-camp, then demanded

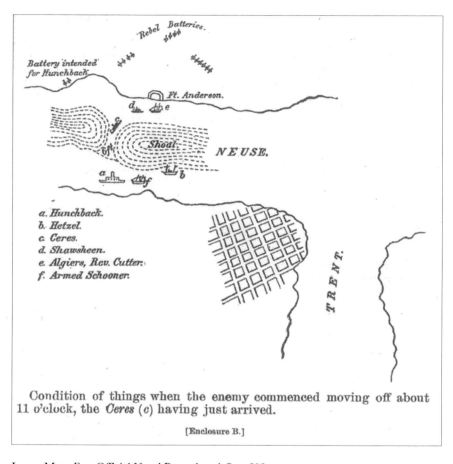

a. Hunchback.
b. Hetzel.
c. Ceres.
d. Shawsheen.
e. Algiers, Rev. Cutter.
f. Armed Schooner.

Condition of things when the enemy commenced moving off about 11 o'clock, the Ceres (c) having just arrived.

[Enclosure B.]

Loyuo Map. *From* Official Naval Records, *vol. 7, p. 605.*

the surrender of the fort. The Federals declined to surrender without consulting General Foster, so the firing on the fort recommenced. The Confederates devoted their attention to the 20-pounders, inflicting as much damage as they could on the fort. "A gunboat lay opposite at the wharf in New Berne, about 1½ miles distant, getting up steam and firing upon us, in which she was aided by field guns, probably Whitworths from the sound of the missiles. Half of the shells from the 20-pounders burst just outside of the guns. At length the axle of one of these guns broke and it became unserviceable. Then another burst, wounding 3 men, 1 of them mortally. These four 20-pounders were our sole agents for accomplishing the object of the expedition."[189] The ammunition was no better than the guns. "The light guns would have been effective against gunboats in an

Lieutenant John L. Barstow Jr.
*Courtesy of the Library of Congress.*

ordinary-size river, but the Neuse at New Berne is so wide as to enable them to remove a mile or two distant."[190]

One member of the garrison at Fort Anderson described the attack on the fort: "About daybreak of the 14th we were roused from our sleep by the roar of musketry on our picket lines and soon the men were seen falling back on the fort in quick time, but in good order firing as they came and then the rumbling of artillery wagons broke on the rear and we knew full well that the 'Philistines were upon us.'"[191]

The Confederate attack on Fort Anderson was deadly, and the position occupied by Lieutenant Colonel Hiram Anderson Jr. and Lieutenant John L. Barstow Jr. "was one of extreme danger." The Confederates' success seemed inevitable. All of a sudden, the firing ceased and a flag of truce came down. Colonel Anderson went down to meet Pettigrew and was told that New Berne was to be taken that day, and that the Federals had better surrender for they could not hold out against the Rebels.

> *Look at our position. Not a single piece of artillery in our fort. Every gunboat gone but one, and she aground over Newbern. No chance of reinforcements under two hours and we with only 300 men. While the Rebs with Pettigrew's Brigade of 3000 men and 18 pieces of artillery were ready to attack. The enemy before us, the river behind us, there was no retreating, no falling back. The 92nd was fairly cornered. Our fort is built of logs and sand, with a deep ditch around it, we tore up the bridge over the ditch, barricaded the gateway and when the flag of truce came for an answer, the Col. told him "he couldn't see the point."[192]*

The Confederate attack quickly resumed. Spent pieces of shell hit both Lieutenant Barstow and his flagman Timothy B. Marsh, both of whom were not seriously wounded. Second Lieutenant Henry T. Merrill, 17th Massachusetts, with Lieutenant Barstow, saved the day by taking a position in

the paddle box, and together they directed the fire of the gunboat *Hunchback* and shore batteries on the south side of the Neuse.[193]

Other gunboats began coming around from the Trent River. The principal goal of the expedition had already failed—now the question was to finish the work begun before withdrawing or not. The advantage of continuing with the attack was the capture of some three hundred men with arms. But it was a fort that the Confederates would not be able to hold afterward. The disadvantage would be the possible loss of a certain number of men sixty miles from their hospitals. Therefore, Pettigrew decided against the attack, explaining:

> *I decided against it. It cost me a struggle, after so much labor and endurance, to give up the éclat, but I felt that my duty to the country required me to save my men for some operation in which sacrifices would be followed by consequences, not in capturing…men and holding temporary possession of breastworks, however brilliant the operation might be. I therefore withdrew the whole command except the Twenty-sixth regiment, which remained within about 500 yards of the place in order to cover the withdrawal of Captain John D. Whitford's men.*[194]

The gunboats kept up their shelling all day, and by midafternoon, more reinforcements were brought into Fort Anderson, making it even less likely that the Confederates would be able to take the fort. By late afternoon of March 15, Major General John Foster had reported that the Confederates were retiring from an attack on New Berne. At that point, the Confederates opened a brisk artillery fire from seventeen pieces, which continued for about three hours. The Confederates then retreated a short distance, where they continued to threaten Fort Anderson until morning, when they retired. The Federals sent out parties following the Rebels in order to harass their retreat.[195]

Captain John D. Whitford. *Courtesy of St. John's Masonic Lodge, no. 3, New Bern, North Carolina.*

Pettigrew suggested that the failure of the expedition was the result of "the

enemy having received reinforcements." He went on to say that he thought that the Yankees might sally out, so he drew up a parallel line to the fire of the gunboats. While this position was perceived by the enemy as their advancing, they disappeared as soon as the Confederate skirmishers appeared. "The shelling of the gunboats continued all day. The two rifled guns at Pettiford's Ferry replied, and I [Pettigrew] had every reason to think disabled one."[196]

After the Rebels withdrew, every tent and house was

> *riddled with shot and shell. Two large tents were knocked down and taking fire burnt up with all their contents. Ever and anon a shell would explode in a tent or house tearing everything to pieces. The Col.'s house had 114 holes through it, large and small. Whole charges of grape crashed through the trees bringing down their limbs as the frost does the leaves. A tall pine was cut down by a solid shot and fell with a tremendous crash on the tents. Two horses in the stable were killed and the Dr.'s saddle smashed up. A solid shot struck the chimney of my tent and knocked it endways. A charge of grape came into out tent, tore my knapsack and cut our blankets badly and took them partly out of the tent. Our shirts and drawers hanging on the line in the tent were wonderfully cut up. We found grape shot in our bed, and pieces of shell all around, while our tent was admirably adapted for the Daugarian business, from the number of skylights and sidelights in it. Some had their knapsacks burnt up. Others were struck by shells and completely empties of everything. In fact it was laughable to see how things were smashed up. Dishes, cups, Dr.'s stores, supplies all gone to ruin. It was a perfect rain of shot and shell and why there were not more killed I cannot tell.[197]*

Pettigrew could have and should have taken Fort Anderson that day. He had enough men to storm the fort, and the Federals had no hope of reinforcements. The Confederates were in a strong position at Deep Gully as well. Even so, that would have been as far as they would have gotten, as the total strength of the Federal forces and Fort Totten was such to prevent the Confederates from taking the town.

## 6

# THE TIME IS RIPE

## *The Third Battle of New Berne*

s 1863 drew to a close, New Berne was quiet. There was little military action taking place in or around the town. The Federal soldiers were becoming bored with this inactivity and somewhat complacent in their safety. Eastern North Carolina was plagued with undisciplined squads of Union soldiers who roamed the countryside looting homes and terrorizing the residents. At the same time, Confederate deserters formed small bands raiding the Federal sympathizers and Federal scouting parties and defied authorities who approached their camps.[198] Most of North Carolina's Confederate troops were located in Virginia, where they had been sent to fight and were unable to do anything to help control the lawlessness that was running rampant throughout the eastern part of the state. The Federal troops stationed in the area were too few in number and too demoralized to do anything; they cared little about the plight of the local citizens and did nothing to stop the lawlessness. As a result, the situation kept deteriorating. The Federal troops in New Berne were concerned with what took place in New Berne but not too concerned with what took place outside of the town limits.

On the part of the local Rebels, there was much disaffection with the Confederate government, which was doing little to stop the depredations. The many local Confederate troops, who had been promised they would be able to stay in North Carolina, had been sent to Virginia to fight, which left North Carolina unprotected and ripe for attack. In addition, the right of Richmond to conscript individuals, the Conscription Act of 1862, into the

Confederate service was heavily argued throughout eastern North Carolina by people who believed they were fighting the war for "states' rights." North Carolina's Chief Justice Mumford Pearson ruled that the Confederate conscription law was unconstitutional and honored every request for a writ of habeas corpus for every member of the Confederate army who had deserted. This made it difficult for the military to deal with a major desertion problem that was only getting worse.[199]

Back in Virginia where the North Carolina troops were fighting, they began to hear of the dissatisfaction with the Confederate government in eastern North Carolina as well as the stories of the Federal soldiers' atrocities against the locals. They received letters from home telling them of what was going on as well as encouraging them to come home to protect their families, harvest the crops or plant for spring. As babies were born, the soldiers wanted to be there for the birth or at least go home to see their new offspring. All of these factors caused major disaffection within the already demoralized Confederate army. Thus, more and more North Carolina soldiers began to desert—simply walking off the field and heading home to take care of their loved ones. By the end of 1863 and the beginning of 1864, they were deserting "by squads and companies."[200]

To take advantage of the deteriorating situation within the Confederate army, Federal officers began to recruit local citizens in the occupied portions of North Carolina, including deserters from the Confederate army, especially those who were poor who would join up for the Federal bounty that was paid to join up.[201]

Winter was a time when soldiers tended to go into their winter camps. There was usually little to no fighting during the winter months due to the snow and inclement weather. In addition, the roads were nearly impassable and became mostly ribbons of mud and slosh connecting one town with another. Soldiers got bogged down in the mud, ankle or knee deep, and often lost their boots. It was difficult moving artillery, cook wagons and other equipment over the muddy roads. So, both armies shut down operations from late October or early November until the spring thaw in late March or April. Of course, this situation was much worse in Virginia than it was in North Carolina, with the winter weather there being much more severe.

As a result of the winter lull in fighting, General Robert E. Lee had a large number of Confederate troops he could release for an expedition in North Carolina, where the climate was warmer. This would enable the Confederate forces to actually deal with the situation in eastern North Carolina.[202]

General Robert E. Lee. *Courtesy of the Library of Congress.*

On January 2, 1864, General Lee wrote to President Jefferson Davis that "the time is at hand when, if an attempt can be made to capture the enemy's forces at New Berne, it should be done. I can spare troops for the purpose, which will not be the case as spring approaches."[203] He went on to argue: "If I have been correctly informed, a brigade from this army, with [Brigadier General Seth] Barton's brigade, now near Kinston, will be sufficient, if the attack can be secretly and suddenly made."[204]

Lee explained that New Berne was heavily defended by a line of entrenchments from the Neuse River to the Trent River:

[A] *redoubt* [Fort Totten] *near the Trent protects that flank, while three or four gun-boats are relied upon to defend the flank over the Neuse. The garrison has been so long unmolested, and experiences such a feeling of security, that it is represented as careless. The gunboats are small and indifferent, and do not keep up a head of steam. A bold party could descend the Neuse in boats at night, capture the gun-boats, and drive the enemy by their aid from the works on that side of the river, while a force should attack them in front.*[205]

In addition to boosting eastern North Carolina's morale with a victory as well as freeing the city of New Berne from Federal clutches, there was a large amount of provisions and supplies there, which the Confederacy wanted for its army. Plus, taking New Berne back from the Federal forces would give eastern North Carolina a boost, which it badly needed.[206]

Lee went on to argue that ironclads being built on the Roanoke and Neuse Rivers would be available to help with the expedition by clearing the waters of the enemy and capturing Federal transports, which could be used by the Confederates for transportation.[207] Lee suggested to Davis that in addition to a strong military leader, a strong naval officer would be needed for the boat expedition, with appropriate numbers of men and officers to man the boats and serve the gunboats that were captured.[208]

President Jefferson Davis studied Lee's proposal and realized "a series of military successes in the region would have a positive effect on the morale of North Carolina citizens, along with reducing the pillaging and plundering taking place."[209] In addition, President Davis had to take into consideration the political situation as well. Opposition to the Confederate government was strong throughout North Carolina and becoming more and more flagrant. This was turning into a genuine threat—seeking a negotiated peace with the government in Washington would pull the state out of the Confederacy.[210] General Lee wrote on January 20, 1864, that "military successes in eastern North Carolina will have 'the happiest effect in North Carolina and inspire the people.'"[211]

The supply routes from North Carolina into Virginia, which carried much of the needed supplies for Lee's Army of Northern Virginia, especially the Wilmington and Weldon Railroad and the Atlantic and North Carolina Railroad, were being harassed by the Federal forces in the area. The Atlantic and North Carolina Railroad was closed to Confederate rail traffic in Craven County. These railroads and supply routes were "critical to military operations in Virginia and elsewhere."[212] Since 1862,

Jefferson Davis, president of the Confederacy. *Courtesy of the Library of Congress.*

when the Federals defeated the Confederates in the Battle of New Berne and began their occupation of eastern North Carolina, they had disrupted all supply routes to Virginia with their constant raids, as they were left without adequate defenses.[213]

General Robert Hoke. *Courtesy of the Library of Congress.*

Lee's proposal for an expedition in eastern North Carolina was well received by President Davis, and he immediately sent for Brigadier General Robert F. Hoke, a North Carolinian who had just returned from special services in the state. Davis wanted more information of the conditions in North Carolina and questioned General Hoke about his thoughts of what could be done to reduce the problems.[214] After his conference with President Davis, General Hoke began to prepare a plan for the capture of New Berne and freeing the area of Federal troops.

President Davis proposed to General Lee that he lead the expedition himself into North Carolina, thinking that it was of that level of importance and that someone of Lee's abilities needed to lead it. Lee counter-proposed that Brigadier General Hoke be assigned to the expedition, but President Davis wanted a major general to lead the expedition and Hoke did not have the rank or experience in Davis's view. Finally, Lee gave in and assigned Major General George Pickett to the expedition, "giving him all the discretionary authority he usually granted his subordinates."[215] Since Brigadier General Hoke was the primary author of the plan of attack on New Berne, Lee assigned him and his brigade of North Carolinians to join Major General Pickett on the expedition, acting as second in command.[216]

In Lee's letter to Major General Pickett, he stressed the importance of taking back the city: "I think the garrison at New Bern can be captured, and I wish it tried, unless upon close examination you find it impracticable."[217] This leeway may have in the end cost Pickett the final prize of the city of New Berne. Lee went on in his letter to assign Pickett around thirteen thousand infantrymen from the brigades of Hoke, Seth Barton, Montgomery Corse, Thomas Clingman, Matt Ransom and James Kemper, as well as artillery under the command of Major James Dearing, who was given the temporary rank of colonel for the operation.[218] In addition to the infantrymen, Lee realized that the navy would be an important part of this expedition, as well as a strong group of sailors who would be able to take over the Federal gunboats

Major General George Pickett. *Courtesy of the Library of Congress.*

in the Neuse River. A handpicked detachment of sailors and marines was chosen to serve under Commander John Taylor Wood, nephew of President Jefferson Davis, to join this offensive. When the expedition's commander received his orders from Lee for the proposed plan of attack, "Pickett was less than enthusiastic about Hoke's strategy....Later, in the wake of the

Brigadier General Seth Barton. *Courtesy of the Library of Congress.*

failure to capture New Berne, Pickett reported, 'the present operations I was afraid of from the first, as there were too many contingencies.'"[219]

Hoke's plan, as presented to Major General Pickett, was simple but well thought out by someone who knew the area well. The plan called for a four-pronged attack aimed at New Berne with a numerical superiority over the Yankees.[220] Pickett's force would employ some thirteen thousand men[221] against the Federal forces held up in New Berne, about seven thousand men.[222] The four-pronged attack was to be led by Brigadier General Seth Barton, Brigadier General Robert Hoke, Lieutenant Colonel James Dearing and John Taylor Wood.

Brigadier General Barton would lead his column in the first prong of the attack by marching toward New Berne from Kinston on the Dover Road and then proceeding south, crossing the Trent River, where it would approach New Berne from the south or from the rear. Barton's forces included Barton's Brigade, Kemper's Brigade and half of Matt Ransom's Brigade, plus six hundred cavalry and six Napoleons. All together, these forces totaled approximately three-fourths of the entire expedition. Barton was to attack the south of the Trent River and attack Federal forces behind Brice's Creek. He was to get control of the railroad between New Berne and Beaufort, cut off reinforcements from that area and attack the town from the back.[223] Barton's troops would present a decoy for the western defenses while he attacked New Berne from the southern side of the town.[224]

The second prong of the assault was to be led by Brigadier General Hoke, who would leave Kinston and move between the Trent and Neuse, endeavoring to "surprise the troops at Batchelder's Creek, silence the guns in the Star Fort and batteries near the Neuse, and penetrate the town in that direction."[225] Thus he would safely bypass the guns at Fort Totten.

The third prong of the expedition against New Berne was to be led by Lieutenant Colonel James Dearing. Whitford's battalion was to move north

*Left*: Lieutenant Colonel James Dearing. *Right*: Commander John Taylor Wood. *Courtesy of the Library of Congress.*

of the Neuse River, capture Fort Anderson at Barrington Ferry and flank the batteries north of the river so as to lighten Hoke's work.[226] Taking Fort Anderson would give Dearing a direct fire upon the town and enfilading fire on the works in front.[227] The infantry consisted of Colonel John Whitford's 67th North Carolina and the 15th and 17th Virginia Regiments from Corse's Brigade.[228]

Commander John Taylor Wood, a nephew of President Jefferson Davis, would lead the fourth prong of the attack by leading a commando raid down the Neuse River to attack the Federal gunboats at anchor in the river overlooking the forts protecting New Berne. The night prior to the land attack, Colonel Wood, with two hundred men in boats, would descend the Neuse and endeavor to surprise and capture the gunboats in that river and, by their aid, drive the enemy from their guns.[229]

Finally, Major General William Henry Chase Whiting from Wilmington was to send a force up from Wilmington to Onslow and Carteret Counties and threaten the Swansboro area in order to draw the attention of the Federal forces located at Morehead City.

Paramount for the success of the expedition, Lee stressed the need for secrecy and boldness in the expedition. Lee emphasized that Pickett put

nothing to telegraph that might tell his purpose. He must deceive the enemy of his purpose and conceal it from the citizens of the area. "General Hoke will give you orders that you are to hunt down deserters and round them up."[230] It was very important to keep the entire operation secret for the element of surprise, for without the advantage of secrecy, the Federals would call in reinforcements, increasing the difficulty in capturing the city. It was important to not use the telegraph and also provide deliberate misinformation to reduce the possibility of Union commanders from being made aware as to the real plans that Pickett had.[231]

Major General W.H.C. Whiting. *Courtesy of the Library of Congress.*

After the final plan for the expedition against New Berne was approved, events began to happen rather quickly. On January 19, 1864, Lee announced that he was sending Hoke's Brigade to North Carolina to retake New Berne. In his announcement, Lee said, "I design sending General Hoke to North Carolina on special service with his brigade."[232] In addition, he needed to increase the size of Hoke's Brigade so he attached the 21st Georgia, the 43rd North Carolina Regiment, Dole's Brigade and Daniel's Brigade to Hoke.[233] He stated then that he would send Hoke to Petersburg on January 21, where his brigade would be prepared for the field and then march to Gordonsville; from there, they would take the train to Richmond.[234]

On the night of January 20, 1864, the troops received orders to be ready to leave the next morning. One sharpshooter recalled, "At 3 this morning we were aroused by the rattle of the drums, and 4 o'clock found us taking up our line of march for Gordonsville."[235]

Lee wrote President Davis a letter in which he expressed regret that the CSS *Neuse* and the CSS *Albemarle*, which were being built on the Neuse and Roanoke Rivers, respectively, were not completed. He went on to say that "with their aid I think success would be certain. Without them, though the place may be captured, the fruits of the expedition will be lessened and our maintenance of the command of the waters in North

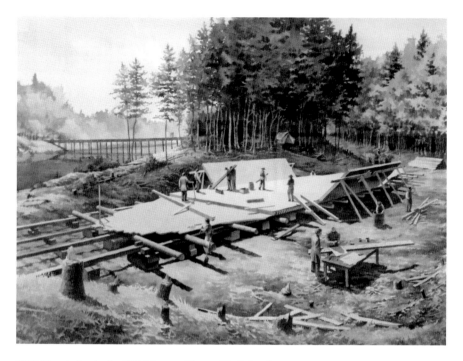

CSS *Neuse* being built. *CSS Museum, Kinston, North Carolina.*

Carolina uncertain. I think every effort should be made to get them into service as soon as possible."[236] On January 23, as freight cars became available, Confederate soldiers began traveling from Virginia to North Carolina. The soldiers had little idea of where they were going and no idea of their mission.

On January 28, the first of the Confederate troops were entrained at Weldon for the final leg of the trip to Goldsboro, where the expeditionary force was to be gathered together.[237] Hoke and his battalion arrived at Goldsboro on January 29, when finally it was revealed to the troops the object of the expedition. There, Hoke found most of the task force already in place and immediately sent the first group by rail to arrive at Kinston that same day. He continued pouring regiments, guns and horses into Kinston throughout the day and into Friday night. The pontoon train arrived in Kinston and, as soon as it could detrain, left town, marching down the Dover Road to get a head start.[238]

By Saturday, January 30, Pickett's army had fully assembled in Kinston. Many people in Kinston were puzzled about the soldiers' presence, but when asked, the soldiers announced they were there to round up deserters

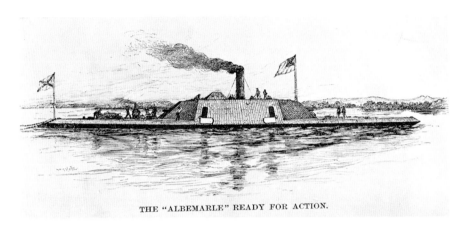

THE "ALBEMARLE" READY FOR ACTION.

CSS *Albemarle. Courtesy of Plymouth Museum, Plymouth, North Carolina.*

in the area. Even so, the size of the force and the presence of artillery made that unlikely and provided even more questions. In addition, there were very few deserters in the Kinston area except for a group of partisan rangers belonging to John Nethercutt's Battalion. Most of Nethercutt's Battalion had left earlier after joining the 66th North Carolina and had moved north to Virginia. When pressed for more information, the officers said they heard that the Federals were going to move inland and they were there to help prevent that.[239]

The column made camp for the night about six miles south of Kinston without tents near Sandy Ridge on the Dover Road. In order to maintain the element of surprise, Hoke arrested all with whom his men came in contact during the twenty-three-mile march from Kinston.[240] While Hoke and his men marched down Dover Road and camped about eight miles south or east of Kinston, General Barton marched fifteen miles from Kinston. Brigadier General James Dearing was also progressing well on the north side of the Neuse River, and Brigadier General James Martin (from Wilmington) was en route from Wilmington toward Morehead City. Colonel Wood began to proceed down the Neuse River with his two hundred sailors but had to turn back due to dense fog on the river, which made going impossible. Sunday morning, Commander Wood and his marines and sailors began to descend the Neuse River on a flotilla of fourteen vessels with the intention of making their attack that night. By Sunday, January 31, 1864, General Pickett had all fifteen men at his disposal and on the move toward New Berne.

The beginning of the new year was indeed ripe for an assault on New Berne. The Federal contingent was complacent, and the Confederates would be able to surprise and overwhelm them. As January rolled in, Major General George Pickett reluctantly began preparations in Goldsboro and Kinston to lead a major attack on New Berne to wrestle the town from Federal occupation.

# THE BATTLE OF BATCHELDER'S CREEK

A t the end of January, 1864, rumors were rampant throughout New Berne of Confederate troop movements, but the only Federal reaction to those rumors was increased vigilance at the various scattered outposts. Approximately seven miles west of New Berne was the westernmost outpost at Batchelder's Creek,[241] garrisoned by the 132nd New York. The 12th New York Cavalry picketed and scouted the country in the area west of the city and along the Trent River.[242]

The morning of February 1, 1864, broke with a light drizzle and a dense fog covering the ground. Federal forces were asleep in their camp with a number of Federal pickets scattered about serving on watch. On the eastern side of Batchelder's Creek was a large blockhouse with elaborate trench works. The Atlantic and North Carolina Railroad Bridge was located on the left of the Federal line, with the majority of the troops located in the blockhouse. The blockhouse and trenches had been garrisoned long enough that by 1864, it was considered to be a permanent garrison, which included the main camp located between the Railroad Bridge and Clark's station, slightly east of the creek. The Federal line of defense incorporated the creek and provided a strong defense from forces coming from Kinston.[243] The camp included cabins with "carpeting with real doors and fireplaces. There was an 'elegant' hospital and a theater neared completion in the main camp."[244]

Colonel Peter J. Claassen of the 132nd New York commanded the Batchelder's Creek line. Claassen boosted the line of defense by adding layers

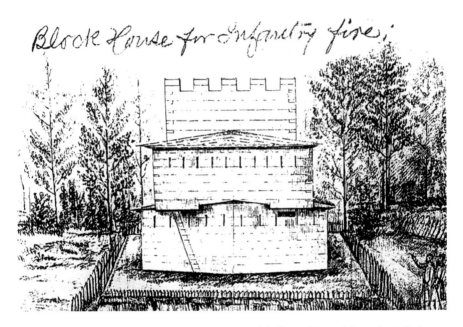

Blockhouse at Batchelder's Creek, by Cornelius Cusick. *Joyner Library, Manuscript Collection, East Carolina University, Greenville, North Carolina.*

of pickets west of the creek, a battery from the 3rd New York Light Artillery, a cavalry detachment from the 12th New York Cavalry and regular infantry from his regiment, plus half of the 99th New York. Claassen's total infantry consisted of approximately 750 men spread among the strong points along Batchelder's Creek.[245]

On Sunday, January 31, 1864, Confederate forces marched down Dover Road toward New Berne, arresting every person they saw. They marched toward Stevens' Fork, about ten miles above New Berne and two miles from the Federal outpost at Batchelder's Creek. The Confederates camped there without fires until one o'clock Monday morning when Hoke ordered his men up to begin the first prong of the assault on New Berne. Chaplain Paris recorded, "The Army marched at 2:00 o'clock a.m. It was very dark. At 15 minutes before 3 the vanguard fell in with the enemy's pickets and firing began."[246] The first Federal picket post encountered by the Confederate forces fled, causing no delay in their march. The silent battalion easily captured the next two posts, and the line of battle moved forward until it reached the fourth tier of the Federal outposts, which was located at the seventy-five-foot-long Neuse Bridge across Batchelder's

Creek. The Confederates fell in with the enemy around 2:45 a.m.[247] As the Confederate forces began to arrive in the area, Colonel Claassen directed his general outpost officer, Captain Charles G. Smith, to "proceed to the bridge with cavalry escort to ascertain if possible what force and how strong was attacking."[248] Captain Smith reported back to Colonel Claassen that "the enemy was in great force."[249] A few prisoners, taken very early in the attack, gave information of the strength of the enemy, their commanding general and so forth, and this was communicated by telegraph.[250]

Lieutenant Cornelius Cusick drew pictures of Batchelder's Creek. *From* The Iroquois in the Civil War, *p. 100.*

Colonel Claassen reported that the fog made it impossible to use signals. Instead, he dispatched Company D, 132nd New York, under Captain Thomas Green to report double-quick to the Neuse Road Bridge.[251] When the Confederate forces arrived at the bridge where the Neuse Road crossed Batchelder's Creek, they found that it was heavily defended by Federal troops. As the enemy approached, this force was on alert and defended the bridge over Batchelder's Creek. The Federals defended the bridge gallantly. After stripping the boards, leaving only the main supports, they stationed themselves behind a small breastwork. Every attempt of the Rebels to cross the bridge was repelled for several hours.[252] First Lieutenant Abram P. Haring of Company G, 132nd New York Infantry, was posted in command at the bridge that morning when the Confederates first attempted to cross. "The location of our small reserve," Lieutenant Abram P. Haring recounted, "was in a naturally strong position. The creek was fifty feet wide in front, with breastworks on each side about fifty feet long. During the preceding night we had taken up the bridge, and with the timbers and planks we constructed a small but strong breastwork, behind which we stationed ourselves."[253]

Haring continued: "About 3:30 o'clock in the morning during a heavy fog, the Confederates attacked us in force, but were unable to dislodge us. I immediately dispatched a messenger to headquarters informing the commanding officer of the situation. In the meantime the enemy, feeling conscious of their strength, made a second attack, which like the first proved

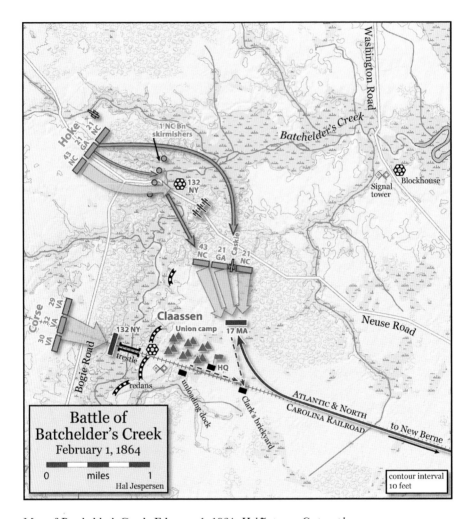

Map of Batchelder's Creek, February 1, 1864. *Hal Jespersen, Cartographer.*

futile. We were keeping up a steady fire during this attack, and now our ammunition was pretty well exhausted, but the little we had left we used to good advantage."[254]

Captain John A. Cooper, 21st North Carolina, was ordered to organize a voluntary twenty-man detail to secure the bridge. As they attempted to do so, the Federals pelted the Rebels with heavy gunfire, lighting up the night sky. The Confederates returned the fire, wounding one Federal and sending the others scurrying back across the disabled bridge, "firing as they retreated, until they reached the blockhouse at the Neuse Bridge."

*Left*: Colonel Peter Claassen. *Courtesy of the Library of Congress.*

*Below*: Map of Batchelder's Creek. *From the Official Records, series I, volume 47.*

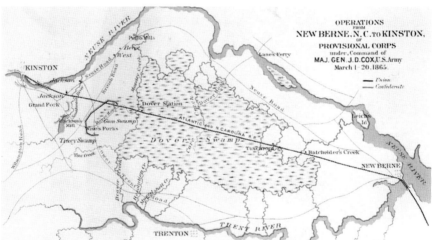

Cooper and his men followed with a rebel yell, only to find that "the rascals had torn up a portion of the bridge" and the Federal pickets escaped.[255] "The shot and shell now went screaming and shrieking through the air over our heads. The aim of the enemy was pretty good, many of their shells bursting and scattering their destructive contents and fragments in liberal profusion and in rather unpleasant proximity to our position."[256]

The Federals received word of the firing between the Confederate forces and the Federal pickets about 2:30 a.m. Captain Ira Winans, 99th New York Volunteer Infantry, was informed right after reveille that firing had been heard in the direction of Batchelder's Creek beginning at about 2:00 a.m. "The discharges of artillery were heard for about a half an hour."[257]

Abram P. Haring. *Courtesy of the Library of Congress.*

Lieutenant Haring and the eleven other men of his command held the Confederates for several hours at the bridge, while all attempts to dislodge the Federal band failed. Even after the Confederates brought up their artillery, the small Federal band held on in determination to not let the Rebels cross the creek, even though outnumbered 11 to 150. Finally, the Rebels, seeing no chance to cross the bridge, began cutting down small trees and using them to cross the stream to get to the other side. In that manner, they were able to attack Lieutenant Haring's "little force from the rear, thus driving them out of their stronghold."[258] For his bravery shown at Batchelder's Creek that day, February 1, 1864, Abram P. Haring was awarded the Medal of Honor.

A heavy fog engulfed the field of battle, making it difficult for one army to see the other. Claassen described the field of battle: "Although our lines were but 25 yards apart, the moving was far advanced before we could distinguish objects across the line....By degrees we were able to distinguish the strong line of fortification along the edge of the creek on both flanks of a powerful blockhouse which commanded the approach to the bridge."[259] The blockhouse "sat on lower ground and Cashie's gunners on the dominant west bank overshot them in the inky night and did little harm."[260] As the fog began to lift, Pickett and Hoke could distinguish fortifications ahead of them and ascertain the best and safest route ahead. As a result, they determined that a flanking attack would be safer than a forced crossing of the creek at the bridge.[261]

The officers and men stationed at Fort Totten were awakened at 5:00 a.m. to the sound of the long roll as well as the sounds of desperate fighting from Batchelder's Creek and other stations located along the Trent River. The attack at Batchelder's Creek was a threat to New Berne under circumstances more favorable to the Rebel army than ever before.[262] Federal reinforcements were sent to Batchelder's Creek, "only to find themselves in the presence of large forces of the enemy."[263] Major John B. Honstain, 132nd New York Infantry, was ordered to the Neuse Bridge to assume command of what forces were there.

At Batchelder's Creek, the Confederates advanced four Napoleons to within one hundred yards of the bridge, behind the protection of the ruins of the Rigdon Richardson House. One Rebel remembered, "Suddenly the whole heavens seemed on fire, and the thunder of cannon almost uprooted the stump which alone stood between me and the Yankee fortification."[264]

As the fog began to dissipate, the fire from both sides began to pick up, causing immense damage. While the Confederates at the bridge were taking heavy fire, Colonel John Mercer, commanding Hoke's Brigade, ordered trees cut to fall across the creek. By 9:00 a.m., the unconventional bridge had been dropped, and the moment the trees fell, Colonel Thomas C. Glover, 21st Georgia, mounted it and called to his regiment to follow. Major William Jacob Pfohl, 21st North Carolina, ordered the men of the 21st across the trees, right behind their Georgia friends.[265] "They attacked the enemy on the rear and flank as other Confederate soldiers, exposed to heavy fire, effected repairs on the bridge."[266]

The Confederate artillery again "belched forth and was again met with volleys of minies and during the shower of shot and shell…[the Confederate line] succeeded in pushing forward and effected a crossing, flanking the enemy. The fighting was continuous until 9 a.m. when all positions were taken."[267]

The Federal reinforcements began to arrive at Batchelder's Creek, only to find "themselves in the presence of large forces of the enemy, and struggle as they might, they were soon borne from the field by the mere weight of overwhelming numbers. They either had to retire on New Berne or be captured."[268]

At about 10:00 a.m., Colonel Claassen directed William L. Whealton, aide-de-camp to Innis N. Palmer, commander of the District of North Carolina, and his men to fall back with his entire force to the line of his camp, leaving videttes to give him information of an approach.[269] Second Lieutenant Lewis Cann, of the 17th Massachusetts Infantry, was directed to go to Colonel Claassen's camp and "destroy it, and lower [the] camp colors. [He] directed all commissary stores still left to be destroyed, which was effectively done by setting fire to everything."[270]

At about 12:30 p.m., Lieutenant Linskey reported that the right had been driven into New Berne and the enemy was crossing the Neuse Road and the railroad.[271] The wagons had already been loaded, so fire was set to the rest of the camp.[272]

The ironclad train car, the Monitor, was brought in for the purpose of support. As it came into the camp at Batchelder's Creek, it was firing

Example of a Monitor rail car. *Personal collection.*

shells into the woods on the left and right of the track, as well as down the track toward the oncoming Confederates.[273] The Federal forces began to retire and boarded the Monitor to be transported back to New Berne and the safety of Fort Totten. At 9:20, as the Monitor began to pull out of Batchelder's Creek, it gave the Confederates one last parting shot. The train reached New Berne in safety, although it was attacked at the Neuse Road crossing.[274] It backed up the infantry on its march toward New Berne, allowing the men to arrive safely. General Hoke had planned to use the captured Monitor himself to enter New Berne with his troops, "Yankee flags flying!"[275]

Brigadier General Hoke rushed his army six miles "in a desperate race to capture the train. The lead elements of the column, primarily soldiers from the 43rd North Carolina and the 56th North Carolina, were within twenty yards of the armored train when it pulled away."[276] Hoke's desperate push came up just five minutes short.[277]

The Confederate forces under Major General Pickett followed the Federal infantry as it retreated toward New Berne. The Confederates approached New Berne with approximately five thousand men and sixteen pieces of artillery. They advanced directly down the Neuse Road, with the Federal forces retreating slowly. After crossing Batchelder's Creek, the enemy was hotly pursued, but as the Rebels had no cavalry and marched all night, they were unable to press their advantage as they would have had

they been fresh troops. It was 3:00 p.m. before General Montgomery D. Corse of the Virginia Brigade crossed the Neuse Road with the railroad, some two and a half miles from town. There was, unfortunately, no cooperation, the other parties having parted during the attack, and the Rebels found they were making the fight single-handed.[278]

Claassen's retreat quickly turned into a desperate footrace. His "New Yorkers would turn and fire until the pursuing Confederates pressed them into further flight....Position after position was selected, but after a few shots each was abandoned, and onward dashed [the] artillery after them."[279]

Claassen notified the outposts of the approach of the Rebels, and the Federals retired, with the exception of the command on the Washington Road. This force, with a section of artillery and infantry, remained at its post until the enemy had passed below the junction of Neuse and Washington Roads. There the men were cut off, and there was no way of them retiring to the city. They were captured by the Rebels.[280]

By the middle of the afternoon, the situation in New Berne was chaotic and gloomy. "Everything moveable, cavalry, artillery, infantry, contrabands and stores, were within the lines of defenses. Detailed men and convalescents were hurried to their respective companies, the fire companies were ordered out and armed, and all able-bodied civilians, white and black, were soon added to the pieces in the works. The gunboats were now moved into position in both the Trent and Neuse rivers, so as to assist the forts in repelling an assault."[281] After a long, dangerous and fatiguing march from Batchelder's Creek, under the protection of the rear guard composed of Company B of the 132nd New York, which had a number of engagements with the Confederate forces in order to provide cover for the Federals' escape, the retreating Federals began to arrive at the Trent Road at about 1:00 p.m., three miles west of New Berne.[282] They were not heavily bothered by the Rebel forces until within the sight of Fort Totten itself. The route the Federals took was from Batchelder's Creek along the road to Pine Tree until they came to the Trent Road about a half a mile short of Pine Tree. "Upon arriving at Rocky Run, finding everyone gone and the camp on fire, an orderly was sent back to Red House and ordered the men left there to follow the infantry into New Berne, which they did, arriving about one and a half hours after the main body."[283]

Pickett and Hoke continued their advance toward New Berne, but halted their approach about midafternoon. Hoke's forces made it to within a mile of the city. A reporter for the *New York Herald* described the scene in

the Union lines: "The rebels [were] in sight of the city, and can be seen from Fort Totten by the naked eye. [Their] forces are resting on their arms day and night, waiting for the assault, on the city."[284]

The showdown at Batchelder's Creek was over by midmorning, despite stiff resistance. Then the Federals gave way in confusion, thereby allowing the Confederate soldiers to capture the Federal outpost and some prisoners. Pickett noted in his official report that Hoke forced passage across the bridge "in neat gallant style."[285]

One 21st North Carolina soldier wrote, "As soon as their position was forced, the Yankees ran like sheep for New Berne."[286] Chaplain John Paris called the battle "furious." Colonel P.J. Claassen recalled that captured Confederate veterans said that the

Henry Shaw's pistol taken at the Battle of Batchelder's Creek. *Courtesy of the Museum of the Albemarle.*

Batchelder's Creek fight was "as about as hot as they ever had it from the damned Yankees."[287]

Federal forces lost a number of stores that day, between 50 and 100 men, and one section of light artillery.[288] Confederate losses included approximately 35 killed and wounded at the Battle of Batchelder's Creek.[289] On the other hand, the Confederates "killed and wounded about 100 in all; captured 13 officers and 280 prisoners, 14 negroes, 2 rifled pieces and caissons, 300 stands of small-arms, a quantity of clothing, camp and garrison equipage, and 2 flags."[290]

In the early afternoon of February 1, Confederate forces pulled up to just a mile from the city. They were just outside the city limits but "close enough to have a full view of it, & the Stars and Stripes floating from the different works erected for the fortifications of the town."[291]

In the fighting of the early morning of February 1, Colonel Henry Shaw, defender of the Battle of Roanoke Island, was shot from his horse. The bullet entered his cheek and traversed his head, killing him instantly. His body was recovered and interred in the cemetery at Shawboro, North Carolina—the town that was named in his honor.

Brigadier General Hoke accomplished a lot in his attack on New Berne. His attack at Batchelder's Creek was a complete surprise to the Federals

and a major success, routing the defenders and sending them scurrying back to New Berne. Hoke followed, stopping just one mile short of his goal, close enough to see the flags flying over the ramparts of Fort Totten. With the number of men Hoke had and the small number within Fort Totten, he had a good possibility of actually capturing the fort.

# HOKE'S PLAN COMES UNRAVELED

Brigadier General Robert F. Hoke's plan to attack New Berne was a four-pronged attack—the first part of which was Hoke's direct attack on New Berne down the Neuse Road, which took place at Batchelder's Creek, seven to eight miles west of New Berne. The second part was to be led by Colonel James Dearing, commander of the 8th Confederate, or Dearing's Cavalry, composed of the 12th North Carolina Cavalry Battalion and several other companies and light artillery. Dearing was promoted to the rank of colonel on a temporary basis by General Pickett just for this assignment and placed in charge of the artillery for the expedition. He was to go around the northern part of Neuse River and attack Fort Anderson. The third part of the expedition was assigned to General Seth Barton. His men were assigned the task of taking the southern route around New Berne and attacking from the south, or the Trent River side of the city. The fourth and final prong of the attack was to be led by John Taylor Wood, who was to lead an expedition of approximately 250 men down the Neuse River and capture a number of Federal gunboats, turning their guns on New Berne.

Colonel Dearing was to lead the second prong of the attack. He was to travel north of the Neuse River with his regiment toward Fort Anderson, located at Barrington Ferry, opposite the city of New Berne. His objective was to capture that fort and its garrison. This action would take pressure off of Hoke's attack.

Dearing had three infantry regiments, the 15th and 17th Virginia (of Montgomery D. Corse's Brigade of the Army of Northern Virginia) and

67th North Carolina (John D. Whitford's), "four pieces of artillery, and some 300 cavalry positioned about 2 miles from Fort Anderson (across the Neuse). This force was to capture the Federal forces when Fort Totten should fall."[292]

Colonel Dearing soon arrived on the north bank of the Neuse, where he was to make demonstrations against Washington or surprise Fort Anderson and, if he could, go in and take the fort.[293] The Official Records note that another column led by Colonel John D. Whitford of the 67th North Carolina Infantry was ordered to Fort Anderson, but he did not make an appearance.[294]

Dearing's regiment left camp at 2:00 a.m. and marched without stopping until it arrived within a mile of Fort Anderson.[295] Dearing crossed the creek and marched his forces within shelling distance of New Berne and Fort Anderson.[296] The 67th North Carolina had already patrolled north of the Neuse River, and other units joined him there. Dearing had approximately 2,500 men and proceeded to the north of New Berne toward Fort Anderson[297] By capturing the fort, Dearing's forces would be able to fire on the town and the Union works therein.[298]

Colonel Anderson, commanding Forts Anderson and Chase, was closely watched by three regiments of Confederate infantry, four pieces of artillery and a regiment of cavalry, all under the command of Colonel Dearing.[299]

Anderson reported to Brigadier General Innis N. Palmer, who commanded the District of North Carolina, that Fort Anderson "is now besieged and our communication with the coast cut off. The besieging force is large, but I have no idea of being concerned about this place. The river communication is liable to be cut off now by batteries erected on the river and there are no longer gun-boats here to patrol the river."[300]

Even with such large forces facing Fort Anderson, the fort "remained defiant and bristling with guns."[301] Finally, several Federal gunboats from the Trent River began to come around the bend in the Neuse River toward Fort Anderson, adding to the defense of the fort. Even with as large a force as Colonel Dearing had, he finally decided that Fort Anderson was too strong to attack. That night, Colonel Dearing's band serenaded Fort Anderson, and then the regimental band at Fort Totten responded by playing some patriotic music from the top of the traverse there.[302]

The next day, Dearing felt he could not take the fort and withdrew from the area toward Kinston. The assault had failed, and Fort Anderson was relieved.

The third component of the expedition was assigned to General Seth Barton. His men were given the task of taking the southern route around

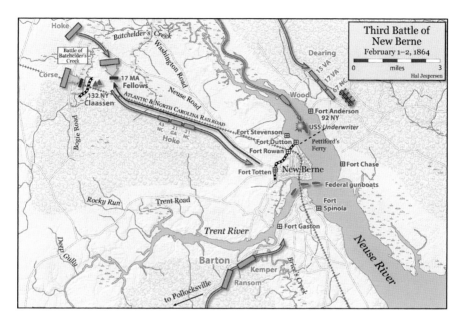

Hoke's attack on New Berne, February 1864. *Hal Jespersen, Cartographer.*

New Berne and attacking from the south, or from the Trent River side of the city. His column of approximately five thousand men left Kinston on January 30 with his brigade, Kemper's Brigade, most of Ramson's and cavalry and artillery detachments headed toward New Berne. They made a rapid twenty-one-mile march to a backdoor attack on New Berne. Barton's men crossed the Trent River at Trenton and camped for the night about twelve miles below New Berne. At this point in the campaign, he was playing his part brilliantly.[303]

By taking the route south of the Trent River, Barton would be able to cut the Atlantic and North Carolina Railroad, cross the river and go into New Berne over the railroad bridge.[304] Barton was to prevent either land or sea reinforcement of the town. By attacking the lighter defenses on the southern side of town, Barton would enter the city first.

On the edge of town, Brigadier General Hoke waited patiently for the sound of General Barton's guns, signaling his arrival and for an "all-out attack." But all was quiet as Barton advanced toward the city. Almost immediately, anything that possibly could go wrong did. Barton repeatedly sent out his cavalry to cut the railroad and the telegraph lines to Morehead City to isolate the New Berne garrison, but each time, the men returned only to report that they had run into serious resistance and were unsuccessful

in cutting the lines.[305] In addition, Barton's movement was slowed down by a grass fire that had carelessly been set, which seriously threatened his ammunition.[306] As General Dearing's forces moved closer to New Berne, his men could see the apples and housetops of New Berne. Captain Henry Chambers of the 49th North Carolina noted in his diary, "We all knew that Newbern was just before us."[307] At the back door of the city, Brigadier General Seth Barton halted and "sent couriers to Pickett for further orders."[308]

While Pickett waited for a report from Brigadier General Barton, he received reports from Colonel Dearing that the attack on Fort Anderson had failed. Barton was reluctant to attack the Federal defensive works, and his courier delivered Pickett a message stating that Barton had found the defensives too strong to attack. Hoke was livid with Barton's failure, and Pickett was incensed with Barton's reticence to attack.[309]

Commander John Taylor Wood was to lead the fourth component of the attack. He brought twelve boats and a number of barges to Kinston by rail from Virginia, and in Kinston, they were placed on the Neuse River.[310] Wood's men were to wait until about midnight and under cover of fog—which usually covers the river at night during that time of the year—were to silently move down the river toward New Berne and attack or capture one or more of the Federal gunboats for the fourth prong of the attack on New Berne.[311]

After capturing the Federal gunboat or boats, the Confederate forces were to "man her and open fire from the rear on the forts and breastworks defending the city. In the confusion that would ensue, Pickett's columns were to sweep forward to the assault, carry the works, and New Berne would be theirs again."[312]

On Sunday night, January 31, Wood and his men went down the Neuse River in search of Federal gunboats in order to destroy them. But the fog was so thick on the river that the flotilla had to turn around and return to Kinston.[313] They sat back and waited for a better night to do their work against the Federal gunboats.

The following night, Monday, February 1, Wood and his 250 sailors and marines boarded their small boats and headed downriver again in search of Federal gunboats on the Neuse at New Berne. Again the fog was thick, but they were able to make it all the way to New Berne. That night, one lone Federal gunboat was moored on the Neuse, the USS *Underwriter*, which appeared north of town, out of place, just below Fort Stevenson. The *Underwriter* was a side-wheel steamer with six guns weighing 325 tons and measuring 186 feet in length. It was one of the largest warships operating

in the North Carolina sounds,[314] "commissioned in New York in September, 1861, and mounted two 8-inch shell guns, one 30-pound rifle, and one 12-inch pound howitzer and had a crew of 12 officers and 72 men."[315]

As Wood's men approached the *Underwriter*, five bells rang out, "followed by the watchman's nervous shout on board the steamer: 'Boat ahoy! Boat ahoy!'[316] Wood did not respond but instead continued to advance on the steamer, gaining precious seconds. Aboard the steamer came sounds of the crew stirring about, followed by men hurrying above deck, preparing for battle. The ship would now have to be boarded with a prepared crew armed and at quarters.[317]

Quickly the Federals opened up on the raiders with a "destructive rifle fire." Wood's marines, three or four in each boat, stood and returned the fire, swaying on their feet with the motion of the boats.[318] Wood's marines and sailors boarded the *Underwriter*, and fierce hand-to-hand combat ensued between the Confederates and Federals. The captain of the *Underwriter* was killed in the first part of the action, as were two of the Confederate officers. The boarding party slowly gained the upper hand as the Federal crewmen headed to the hurricane deck for protection. "It seemed the very jaws of death," Lieutenant Benjamin P. Loyall, Wood's second in command, said later. "Wood, sword in hand, battled his way to the quarterdeck as more squirrel-like raiders scrambled over the side of the gunboat. The report of firearms and rattle of cutlasses made a deafening dim, increased by the frenzied cackling of hens in a coop on deck."[319] The raiders emerged forcing the ship's crew into the ward room, storage, and coal bunkers, after which Wood shouted, "She's ours! She's ours!' to stop the fighting.[320] Soon thereafter, the Federals cried, 'We surrender!'"[321] After a brief resistance by the Federal crew, many jumped overboard and swam to safety.[322] Even so, all of the officers of the *Underwriter* were captured except for the captain, who had been killed.[323]

The Rebel men went at once to their assigned quarters. Some of them went to the fire room, some to the engine room, others to the guns. They let out the anchor cable so that the guns of Fort Stevenson would not be able to reach the ship as it began to build up steam. The ship began to swing toward shore and promptly went aground.[324]

As soon as the firing ceased, Wood ordered the *Underwriter* underway. "Since she was the largest gunboat at New Berne, he would have temporary command of the waters."[325] Quickly, the engineers reported to Wood that steam was low and the fires were banked. It would take several hours before sufficient steam could be built to move on. Wood ordered

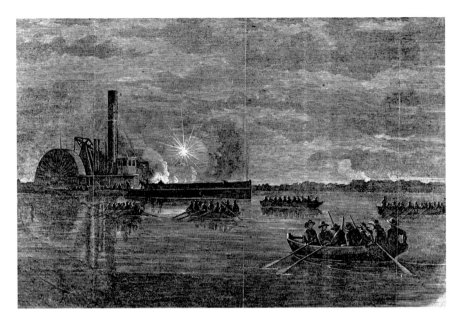

Confederates leaving, burning the *Underwriter. From the* North Carolina Dictionary of Biography.

Lieutenant George W. Gift to try to tow the ship with launches, but that proved to be impossible.[326]

Wood's position quickly worsened when an explosion rocked the ship through the upper works. It was caused by a shell fired by Fort Stevenson. During the battle, a crewman had slipped over the side of the ship and swam ashore. In turn, he informed the commanding officer at Fort Stevenson what was going on aboard the *Underwriter*. As soon as the crew reached shore, word spread to Fort Stevenson of what had happened. Fort Stevenson trained its guns on the *Underwriter* and its attackers and began to immediately fire on them.[327] The fort poured shot and shell into the *Underwriter*, even though Federal men were still on board the ship.[328]

The heavy fire from Fort Stevenson gave Wood no choice but to set the *Underwriter* on fire and abandon the ship. But before he did so, he ordered the prisoners and wounded into the boats, which was accomplished under heavy fire.[329] In the rush to leave the burning ship, some of the Federal prisoners realized that there were only two raiders in the boat and they lagged behind the others, led by engineer George E. Allen, who grabbed a cutlass, overpowered the two guards and escaped to shore.[330] About half a mile from the ship, the raiders saw flames leap up out of the windows of the

wheelhouse where the engineer's supplies were stored. About 5:00 a.m., "a tremendous flare-up followed by a dull, heavy boom assured Wood that the magazine had blown."[331]

The Confederates lost "five killed, fifteen wounded, and four missing. The enemy's losses consisted of about nine killed aboard the *Underwriter*, their bodies burning with the ship, some twenty wounded, and twenty-six carried off as prisoners, many of them without shoes or trousers against the February cold."[332]

While Wood's expedition was not a complete success, neither was it a failure. Wood was not discouraged and was "eager to continue the assault of New Bern."[333] His plan was to attack the forts from the water side while pressure was continued on the Federal installations from the land approaches.[334]

Wood's plan would not work. On Tuesday, February 2, Colonel Dearing was assigned to Wood, and thus far, Dearing had not accomplished his prong of the assault. Thus, Wood realized that Dearing's role in the expedition would be "impracticable." As for General Barton, he had been uncooperative, and as a result, Pickett's "enthusiasm for the entire project" had cooled.[335] There was the probability of enemy reinforcement, and since Wood had been forced to burn the *Underwriter*, Picket would not risk an amphibious assault. The element of surprise was lost as well, so Pickett ordered his troops to return to Kinston, saying there was no cooperation with the other parties having failed to attack. He found that he would have to make the attack single-handed.[336]

When Hoke and Pickett realized that they would be attacking New Berne alone, "Hoke ordered his 2,000 men back two miles to the junction of the railroad with the Neuse Road and told them to wait. [General Montgomery] Corse joined them there at three p.m. and it became more and more apparent that the assault had fizzled out."[337]

By February 4, all the Confederate forces were on the roads back to Kinston, the expedition a complete failure. General Seth Barton was considered to have "bungled the New Berne operation," and thus the blame was placed on him. However, in his memoirs, George Pickett stated that he had doubts of the success of the venture all along.[338]

The Confederates had killed or wounded "100 of the enemy, captured 300 men and rifles, 2 pieces of artillery, 4 ambulances, 3 wagons, 100 animals, a quantity of clothing, camp and garrison equipment and 2 flags."[339] Among the Union prisoners taken by General Pickett outside New Berne were several North Carolinians who were found to be deserters

from the Confederate army. They were later court-martialed as deserters, and twenty-three of them were hanged in Kinston "to discourage Federal loyalty in the state."[340]

Pickett's four-pronged attack on New Berne was a brilliant idea, but it failed for several reasons. Barton's attack from the south failed due to various mishaps along the way as well as Barton's unwillingness to attack New Berne when he had the town so near. Dearing's mission was also a failure, particularly because he too was timid. He was close to Fort Anderson and possibly could have overrun the fort but decided it was too strong and turned around. Finally, while Wood's mission had limited success, it did not accomplish the goal of capturing several gunboats and turning them on New Berne and the Federal forts located there. Thus, his mission, too, was a failure.

General Pickett blamed Barton for the failure of the mission, but it was not all Barton's fault. Pickett even went so far as to call a court-martial for Barton in the matter, but it was never held. It also must be remembered that Pickett was not in favor of the expedition in the first place, and one can only wonder if another general had been in charge if that leader would have pushed his subordinates a little harder.

Remains of the *Underwriter* are on display at the Academy Museum in New Bern today, yet few people in New Bern have any idea of the vessel's exploits. As for the rest of the Confederate attack on New Bern, again, it is an unknown event.

# THE BATTLE OF NEWPORT BARRACKS

In support of the attack on New Berne, Major General W.H. Whiting, who had been assigned command of the Military District of Wilmington, was to come up to Onslow and Carteret Counties and cause a diversion to keep the Federal forces at Morehead City busy, preventing them from sending support to the besieged Federal forces at New Berne. Major General Whiting selected Brigadier General James Martin to head the expedition into Carteret County to accomplish this mission. Martin was a highly capable and dependable officer with a glowing track record of experience. Martin would once again prove his abilities as an officer in the upcoming attack on the Newport Barracks.[341]

The bulk of his force would be made of the 17th and 42nd North Carolina as well as Company A of the 3rd Battalion North Carolina Light Artillery, known as the Northampton Artillery. Captain Andrew Jackson Ellis was in command and carried with his force "three six-pound guns and a three-inch ordnance rifle."[342]

Brigadier General Martin left Wilmington for Carteret County on Thursday, January 28, with parts of the 17th and 42nd North Carolina Regiments. The next day, the command was increased by a company of Captain Harlan's cavalry, a battery of six guns under Captain Paris, two companies of the 17th North Carolina who served as a picket at Topsail and the remainder of the 42nd, which had been at work on the fortifications at Virginia Creek.[343]

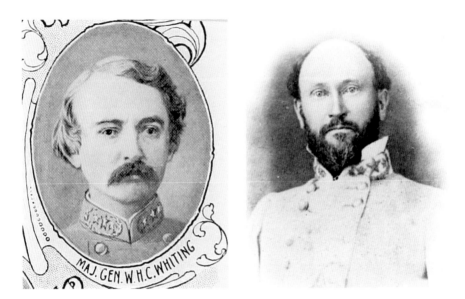

*Left*: Major General W.H.C. Whiting. *Right*: Brigadier General James G. Martin. *Courtesy of the Library of Congress.*

The detachment reached Jacksonville on Saturday, January 30, crossing New River with wagons, guns and men moving onward toward White Oak River. On Monday morning, February 1, Martin and his men began crossing the White Oak River. He ordered "pickets to move out on each side of the White Oak River with orders to 'arrest every person moving about.' No chances would be taken to allow the Union forces in the area to be made aware of the presence of Martin and his forces."[344]

On February 2, Martin and his men arrived at Cedar Point in Carteret County, where they encountered the Federal forces stationed at Gales Creek. Gales Creek was a small but prosperous community in western Carteret County off of the Cedar Point Road. Located nearby was the landing at Gales Creek, where small boats loaded and unloaded goods. From there, roads headed west and northwest toward Swansboro, White Oak and Pollocksville and east to Carolina City and Morehead City. Another road veered off in the direction of Shepardsville (Newport) and the main Union force located at Newport Barracks, four miles away.[345]

The Rebels were twice repulsed at Gales Creek, but they compelled the withdrawal of Federal forces with their superior forces back to the blockhouse at Bogue Sound. The Federal forces were quickly followed by the Rebels to the blockhouse where the 9th Vermont Volunteers were stationed.

The blockhouse was carried by assault, with its garrison falling back to the fortress at Morehead City.[346]

Martin and his men moved on to the nearby Bogue Sound blockhouse. "It offered a stronger defensive position than the Gale Creek blockhouse, with its rifle pits and a howitzer mounted on a naval carriage in the blockhouse itself."[347] The Bogue Sound blockhouse was manned by companies H and B of the 9th Vermont Infantry. The force there was small and consisted mostly of the new recruits who had lately been sent to the regiment and "who had received their arms that same morning."[348] The day had been most successful for Brigadier General Martin and his men. "With the capture and destruction of the Gales Creek and Bogue Sound blockhouses, the men in the ranks were flush with victory, but 'the principal work of the day was still to be done.'"[349] Martin moved on toward Newport Barracks at Shepardsville.

Upon nearing the first set of pickets, Martin's cavalry charged forward, forcing the Yankee pickets to retreat "as fast as their horses would carry them." The road was deep mud and pitted with holes, but onward the Yankees fled "some of the Yankee horses and their riders turning somersaults in the mud." Martin's cavalry followed the Yankees down the muddy road, "running over them, and tumbling headlong into the deep

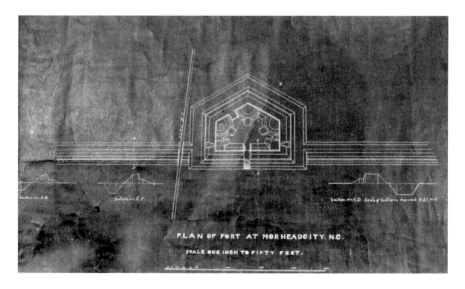

Diagram of the Federal fort at Morehead City. *Original in possession of Pat McCullough, New Bern.*

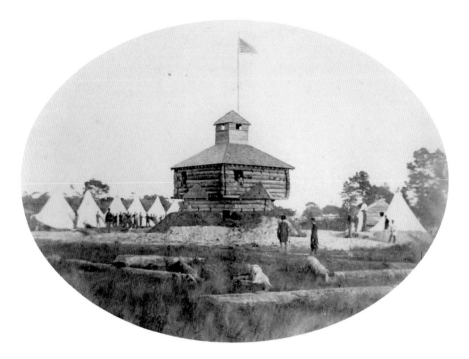

Bogue Sound Blockhouse. *From Jean Bruyere Kell,* North Carolina's Coastal Carteret County During the Civil War, *p. 171.*

mire after them, inflicting many bruises upon men and horses, breaking the neck of one of the latter, but doing no serious damage to the riders."[350]

Around noon, Martin's forces came in contact with Federal pickets outside of Newport Barracks. His men charged the pickets, killing or capturing all of them.[351] They moved forward to the first blockhouse, which was just as quickly abandoned by the Federals. About four miles down the road, they came upon the second blockhouse, in which the Yankees showed no attempt to give up. The blockhouse was well defended by artillery, which had begun opening fire when Martin's men came up. A company of the 17th, well instructed as skirmishers, was at once thrown forward under the fire of artillery, with orders to take it if practicable.[352]

Newport Barracks was located outside of the small village of Shepardsville, along the Newport River in Carteret County. In 1864, Shepardsville, known today as Newport, contained only about fifteen homes, stores and a church. While the community itself held little value to either the Confederates or Yankees, the Atlantic and North Carolina Railroad, running from New Berne to Morehead City, crossed the Newport River at this point. The railroad

provided an efficient means to transport supplies and troops between the coast and New Berne, along with other Union-controlled areas. Aware of the importance of the Newport River crossing, Union commanders moved quickly to fortify and protect the railroad trestle.[353]

Barney had two companies of cavalry numbering around 150 troopers and 450 infantrymen to meet the advance of around 2,500 Confederates.[354] The force consisted of the 9th Vermont Infantry, the 23rd New York Cavalry and Company 2, Massachusetts Heavy Artillery.[355] The actual fortifications of Newport Barracks consisted of a "redoubt armed with a 32-pound gun and three 12-pounders. On the coast road, leading along the short of Bogue Sound, at a point about three miles from the barracks, was a blockhouse, and a picket line extended from this to the swamps bordering the river—a circuit of twelve or fifteen miles."[356]

The defenses at Newport Barracks included the main earthworks, an earthen redoubt at Shepardsville and the outposts at Canady's Mill.[357] The fortifications "around Newport Barracks were built of earth about twelve feet tall. In addition abatises were constructed."[358]

The Confederate forces, on the other hand, consisted of fourteen pieces of artillery and four hundred cavalrymen. They came with the expectation of capturing the entire barracks with the full regiment within and had confidence in their ability to do so.

The Rebels quickly marched on Newport Barracks. The 9th Vermont Volunteers, stationed at the barracks, met the advancing Rebels with volleys of musketry, continued fighting and gradually retired toward the barracks.[359] The 9th Vermont Volunteers had been placed on the edge of the woods because there were not enough men to form a line of battle for the front, which had to be covered with skirmishers.[360] The Federal forces had already sent their "sick and part of the quartermaster's stores on board the train to Morehead City, [and left word that]…to prevent falling into the enemy's hands, all public stores then remaining should be burnt."[361]

The Confederates pushed the Federals back toward the barracks all morning long. Colonel Valentine G. Barney and his troops prepared to defend the barracks against the coming Confederate attack, knowing that the odds were greatly against them.[362] They resolved to do their duty and would not give up the barracks without a fight.[363] The 9th Vermont Volunteers were to make a stand at the barracks behind the earthworks and rifle pits with the support of artillery. Barney felt that between the strong artillery and fortifications, his force had a good chance of defending the barracks, and he could hold off the attacking Confederate forces. "Around 2:45 that

afternoon the main body of the 9th Vermont opened with a volley on the 17th and 42nd North Carolina infantry regiments and fighting raged for 30 minutes before the 9th Vermont fell back."[364]

After about thirty minutes of intense fighting, Brigadier General Martin ordered the infantry to move forward and charge the Federal forces to dislodge the 9th Vermont from its position. The 42nd and 17th North Carolina charged forward in a rush that North Carolina soldier described as "every gun was loaded, every bayonet fixed, and every heart filled with patriotic devotion to his Sunny South."[365]

For the next two hours or so, the fighting was intense, and the men of the 9th Vermont demonstrated bravery and determination in the face of tremendous odds. Yet the Confederate push against the Federal defenses at the barracks was more than the Union troops could withstand. Sergeant Charles Branch of the 9th Vermont wrote, "[O]ur line was compelled to give way and falling back a short distance a new line was formed which after a continuation of the firing was again charged and forced to fall back."[366] While the Federals had to fall back, they "made the attacking North Carolinians fight hard for every inch of ground gained."[367]

Finally, at 5:30 p.m., Lieutenant Colonel Barney ordered "the color guard of the 9th Vermont to place the regimental colors on the crest of a low hill overlooking Newport Barracks. This is where the eleventh and final stand of the day was made."[368] At this point, all the Federals could do was slow the Confederate forces down; they could not stop them from taking over the barracks. The Federals had no chance of winning this battle, and they knew it. During the fighting, the men of Company D, 2nd Massachusetts Heavy Artillery, spiked the artillery at Newport Barracks, rendering the guns useless. The men then crossed Newport River over the County Road Bridge and spiked the artillery there.[369] Without the functioning artillery, the earthworks at the Newport Barracks were rendered useless.

In addition, both the routes to Morehead City were cut off by the 17th and 42nd North Carolina Infantry, and thus Lieutenant Colonel Barney's mission changed from defending Newport Barracks to saving his entire command from capture.[370] Barney ordered a detail to set fire to the barracks, hospital and military stores to keep them out of the hands of the oncoming Confederate forces. Dense smoke began to rise above Newport Barracks as the 9th Vermont Volunteers fired one more volley and moved quickly across the Newport River, setting fire to the railroad trestle and the County Road Bridge as they did so.[371] The Federals then set fire to the government stores of turpentine in Shepardsville and

"began the twenty-three mile march through swamps and around the inlets to Beaufort."[372]

As Lieutenant Colonel Barney and his men left Newport and crossed the Newport River, Brigadier General James Martin and his men entered Newport Barracks, only to find it in flames. As they rode into the compound, they could not help but focus their attention on the U.S. flag still flying over the post. "Over the deserted stronghold waved that emblem of oppression the 'Stars and Stripes.' This was soon hauled down….[The flag] was trampled in the dust and torn into a thousand fragments."[373]

In the end, General Martin was completely successful, "driving the enemy from strong positions fortified, destroying their barracks and the railroad bridge at Newport River, and forcing the enemy with considerable loss to retreat to Beaufort."[374] The results of the expedition were

> *4 heavy dirt forts captured, 3 block-houses, with 1 flag, 10 pieces of artillery, 20 barrels of powder, several hundred small-arms, 200 boxes fixed ammunition for artillery, a considerable quantity of forage and other stores, 1,000 barrels of turpentine belonging to the United States, the quarters, stables, store-houses, called Newport Barracks, for 1,000 infantry, two companies of cavalry, and one of artillery; 3 railroad bridges, some trestle-work, some of the track at Croatan, and 2 large county bridges, all burnt or destroyed except one valuable piece of artillery brought away. About 30 horses and 2 wagons were also brought off and the telegraphy wire was cut. The men saved from the burning buildings many overcoats, blankets, and other articles of clothing. My officers report about 20 of the enemy killed and from 40 to 50 wounded. One hundred wounded as to be unable to bear the journey; also 6 negroes brought here.[375]*

Brigadier General Martin's actions at Newport Barracks accomplished his part of the goal that General Hoke set out for the expedition: he cut off the telegraph and railroad communication between Morehead City and New Berne, prevented the Morehead City garrison from sending much-needed reinforcements into New Bern by trains and, perhaps most importantly, captured the Federal outpost at Newport Barracks. While it was primarily an outpost, it was still a victory just the same, one the Confederates desperately needed.

While Martin was attacking and capturing Newport Barracks, Brigadier General Seth Barton was supposed to be setting the stage to enter New Berne from the south across the Trent River. However,

Brigadier General Barton had determined that the enemy was too strong for his men to defeat, and he declined to attack New Berne, even though he was on the city's doorstep and had a larger number of men than the Federals with which to fight. James Martin's successes on the battlefield were just a few of the wins that General Hoke could put under his belt on this expedition, but it seemed that the main objectives of the expedition were doomed to failure.

One of the Confederate soldiers at the Battle of Newport Barracks and later at the Battle of Wise's Forks was Thomas C. Dula of Company K, 42nd Regiment. After the war, Dula returned home to Wilks County, North Carolina, where he killed his girlfriend, Laura Foster. There was tremendous publicity about the murder and trial, turning Dula's story into a folk legend. On May 1, 1868, Dula was hanged in Statesville, North Carolina, for Laura's murder. In later years, a folk song was written about Tom Dula and Laura Foster, and in 1958, the Kingston Trio recorded a hit version of the murder ballad.

# THE KINSTON HANGINGS

General George Pickett's primary objective in 1864 was to capture New Berne and its vast stores and to reap the political success from the victory. However, he had a secondary objective: to seize a band of North Carolina deserters in eastern North Carolina who were serving with the Federal army in the 2nd North Carolina Regiment.

Desertion was rampant in North Carolina, as it was throughout the South. By 1864, the South was losing the war, the men were discouraged and many were leaving the army to go home to take care of their families and help plant crops. Even the chief justice of the North Carolina Supreme Court was against the North Carolina conscript law and filed writs of habeas corpus to help soldiers get out of the army.

It was bad enough to desert the Confederate army, but for the soldiers to join the Union army was an abomination in the sight of most Confederate officers. Why would former Confederates join the Union army? First of all, most of those who did, did so for the large bounty that was offered to recruits. Bounties as much as $200 and $300 were offered for signing up for the Federal army. In a period when the average man earned $50 a year, $200 was a lot of money. In addition, most families in the South were facing starvation, and that money could go a long way to feed and clothe one's family. The Federal army promised these new recruits that the army would protect them and their families from harm from the local Confederates and Confederate sympathizers. So, they signed up for the bounty. Many of these turncoats were not loyal Confederates in the first place and had supported the Federal government all along.

Pickett was bitter over his defeat during the attempt to retake New Berne and angry with Brigadier General Seth Barton over bungling his part in the plan. He ended up taking out his frustrations and anger on the band of prisoners that was captured at Beech Grove. These captives, who were members of the 2nd North Carolina (Union) Volunteers, had been identified by former comrades as deserters from local defense units taken into Confederate service. Twenty-two turncoats were unmasked and separated from the other prisoners.[376]

These men had been fighting at the Battle of Batchelder's Creek and were located at the blockhouse there. As the battle raged and began to turn against the Federals, the men of the 2nd North Carolina realized that they would be captured—having once been members of the Confederate army, they realized their situation would be rather precarious to say the least. Therefore, they retreated to the rear of the battle and sought the safety of the swamps, where they found their way back to Beech Grove. There they were found out by a scouting party of the 30th Virginia who "herded them back to join the other prisoners."[377]

Major Walter Harrison, Pickett's inspector general, described these accusers as "wretches who were well known, not only as deserters, but as the worst of marauders and depredators upon the borders after their desertion."[378] All of these men had been members of a home guard unit, Nethercutt's Battalion, which had operated in the area of western Craven and Jones Counties and eastern Lenoir County. At least two of the men belonged to the 10th North Carolina Regiment.

These men were simply considered to be prisoners of war until en route to Kinston, when two were recognized as former members of the Confederate army. They were camped at Dover when King Blunt saw several of the men and recognized them, thinking that they looked familiar. H.M. Whitehead confirmed that two men, Joe Haskett and David Jones, were men formerly from Whitehead's company. Joseph L. Haskett was a farmer from Craven County and only twenty-six when he enrolled in the Confederate service. He had enrolled in Company B of the 10th North Carolina or the 1st North Carolina Artillery and mustered in on June 12, 1861, for the duration of the war. He was captured at Fort Macon and later paroled, until he was exchanged on August 1862. He deserted on November 15, 1863.[379]

David Jones was born in Craven County and enrolled in the army at the age of twenty-one in Company B, of the 10th Regiment (1st North Carolina Artillery.) He enlisted in Lenoir County on November 15, 1862, for the duration of the war and deserted on November 15, 1863.[380]

Reverend John Paris. *Courtesy of the Library of Congress.*

These two men were hustled to Kinston, where they were placed in the Lenoir County Courthouse under arrest, where they would be court-martialed. The next day, Haskett and Jones were court-martialed in a military trial before a crowded courtroom and found guilty of desertion.

The following day, Reverend John Paris met with the two men. He said that "they were the most unfeeling and hardened men I have ever encountered. They had been raised up in ignorance and vice. They manifested but little, if any, concern about eternity" as they "marched to the gallows with apparent indifference." Jones, "though quite a young man, never shed a tear." In his last minutes with them, the chaplain said the men insisted "that the Yankees compelled them to take the oath and enlist" in their service.[381]

Joe Haskett was captured on April 26, 1862, and exchanged in August of that year. He deserted the Confederate army on November 15, 1863, and joined the 2nd North Carolina Union Volunteers within two weeks. He was captured at Beech Grove on February 2, 1864, court-martialed the following day and hanged on February 5. "The body of Private Haskett dropped beneath the scaffold beam about two weeks before the first anniversary of his wife's death,"[382] which may explain some of his melancholy at that time.

David Jones enlisted in the 10th Regiment on November 15, 1862, and deserted a year later on the same day as Joseph Haskett. He was captured at Bellair on February 2, 1864, court-martialed on February 3, 1864, and then hanged on February 5.[383]

The troops had been rounded up to observe the formal execution of the two men. They formed a large gray square around the scaffold to watch the hanging of the two deserters so that they might learn from the unfortunates' mistakes. John G. Justice read as loudly as he could the charges against the two men—desertion and taking up arms for the enemy. He also read the execution issued by Major General George E. Pickett:

*The condemned men's heads were covered with rough corn sacks in lieu of the customary black hoods that could not be procured. As the traps were sprung on the crude mechanism that had been erected in the sand,*

*the builders, new to such work, hoped nervously that their devices would function properly and that the agony of the condemned men would not be prolonged. They performed to grim perfection and in an instant the pair was limply suspended. The troops, long accustomed to seeing bodies torn apart by grape and canister, gasped open-mouthed at the sight of bound men having to surrender to death so unstrugglingly.*[384]

Now that the first two men were disposed of, the court turned to the next thirteen defendants who had been captured as traitors to be brought before the board. These men looked unkempt and disheveled from days of miserably close confinement, despite their new blue uniforms.[385] They were tried by the same court, but even so, it was not a fair trial by any means. These men had no chance of being acquitted of the crime charged. The reality was there was no argument on behalf of these prisoners that could be successful before the panel. The prevailing argument was that the leadership was already convinced that some harsh action was necessary in order to put down the problem of desertion, which was endemic to the area. The officers of the court-martial knew why they were there and planned on doing their duty.[386]

If two men hanging was a spectacle, then thirteen men hanging was even more so. These men were A.J. Britton, John J. Brock, Joel Brock, Charles Cuthrell, W.C. Daugherty, John Freeman, Lewis Freeman, William O. Haddock, Calvin Huffman, Stephen Jones, William Jones, Jesse Summerlin and Lewis Taylor. One witness described the scene: "A huge scaffold with an extended overhead beam was erected to hang all 13 of the condemned men simultaneously![387]

Andrew J. Britton enlisted as a member of Company A of the 8th Battalion of the North Carolina Partisan Rangers out of Jones County.[388] He first enrolled for service on June 12, 1861, with the 27th Regiment but was sick for most of the period of enlistment. Then he enlisted in Jones County on May 15, 1862, and was detailed as a musician from March 1, 1863, until sometime in June 1863. He was transferred to Company F of the 66th Regiment on October 2, 1863.[389] J.H. Nethercutt testified that he believed that A.J. Britton was the leading man in the desertion of the men but did not know if Britton ever enlisted in the Rebel army himself. Prior to his hanging, Britton sent word to his wife for her to meet him in heaven.

John J. Brock enlisted in Jones County in the 8th Battalion of the North Carolina Partisan Rangers on May 15, 1862, and mustered in as a corporal. In December 1862, he was listed as a prisoner and absent without leave. He

was captured January 28, 1863, and paroled on February 5, 1863. He was transferred to Company F, 66th North Carolina, on October 2, 1863.[390] His wife, Cecilia Jane Brock, saw her husband on the Saturday before he was executed when he was confined in the dungeon of the county jail. He told her that he only got one cracker per day to eat, and all the other prisoners said the same thing. She said that she fed her husband or he would have starved to death in jail. After his execution, Cecilia took his body to her home and buried it. He had been stripped of most of his clothes when she received his body. He was baptized at his own request in the Neuse River by Reverend Paris on the morning of his execution.[391]

Joel, John Brock's brother, was taken down to the Neuse River and baptized along with his brother just prior to his hanging.

Charles Cuthrell was born in Craven County and enlisted in the 3rd Regiment, North Carolina Artillery. He was a farmer and enlisted at the age of twenty-three on January 20, 1862, for the duration of the war. Cuthrell was captured at the Battle of New Berne on March 14, 1862,[392] pardoned and transferred to the 40th Regiment in November 1863. He apparently deserted at that time. On December 22, 1863, he joined the 2nd North Carolina Union Volunteers and was with the men captured at Beech Grove on February 2, 1864.[393]

William C. Doyety (Daugherty) enlisted in the Confederate service in Jones County on July 16, 1862, as a substitute for Joel A. Heath. He entered Company A, 8th Battalion Partisan Rangers, in Jones County. In October 1862, he was transferred to Company C of the 8th Battalion, and on October 2, 1863, he was transferred to Company D of the 66th Regiment. He had decided not to join the 67th North Carolina and was either willing or coerced to re-enroll in the 2nd North Carolina Union Volunteers on November 24, 1863. As a result, he was eligible for the $100 bounty.[394]

John Freeman enlisted in Company A of the 8th Battalion of North Carolina Partisan Rangers in Jones County on January 20, 1863, for the duration of the war. He was transferred to Company F of the 66th Regiment of the North Carolina State Troops on October 2, 1863. He enlisted in the 2nd North Carolina Union Volunteers on December 23, 1863.[395]

Lewis Freeman enlisted in Company A of the 8th Battalion of North Carolina Partisan Rangers in Jones County on January 20, 1863, for duration of the war as well. He was transferred to Company F of the 66th Regiment on October 2, 1863.[396]

William O. Haddock enlisted in Jones County on July 15, 1862, in Company A, 8th Battalion, North Carolina Partisan Rangers, for the

duration of the war. In October 1862, he was transferred to Company C. On December 14, 1862, he was captured by the Federals and later paroled. He rejoined his command but deserted after being paid on April 30, 1863. He was transferred to the 66th but had not returned to duty by that time and remained a Confederate deserter for seven months. He then joined the 2nd North Carolina Union Volunteers on November 27, 1863. At his trial, his sister, Mrs. Bryan McCullum, requested to testify at his court-martial, but that request was denied. She then asked the judge if she could take possession of and bury his body. General Hoke asked her if she planned to bury him in a Yankee uniform, and she said she would bury him as she received him from the hangman's rope. Even then, the hangman callously attempted to steal the shoes from the still-warm corpse.[397]

After Haddock was executed, Bryan McCullum, blacksmith, approached the general for an order to get William Haddock's body. He remembered being asked "if I wanted my wife's brother buried in a Yankee uniform."[398] When McCullum went to actually get the body, the executioner was taking Haddock's shoes off of him as he lay there in his crude coffin. McCullum stepped in and stopped him and told him that the body should not be molested, which the executioner duly respected.[399]

Calvin J. Huffman enlisted in Company A of the 8th Battalion North Carolina Partisan Rangers, on February 11, 1863, in Jones County. In May–June 1863, he was listed as wounded and on leave. On October 2, 1863, he was transferred to Company F, 66th North Carolina. He was listed as a deserter on October 10, and on December 22, he joined the 2nd North Carolina Union Volunteers.[400]

Stephen H. Jones was born in Lenoir County, but by the time of the Civil War, he was residing in Jones County as a farmer, where he enlisted on May 15, 1862, for the duration of the war. He was twenty-seven years old. He was listed on the rolls through July 23, 1862. Later, he deserted from the Confederate army and joined the Federal army.[401]

While he was in jail, his wife, Elizabeth Jones, took him a quilt to sleep on to keep him from lying on the floor. She visited her husband every day, offering him hope and encouragement. One observer stated, "When hope was exhausted, she said farewell to him and then clustered with the other kinfolk to await their deprivation. When the moment came she admitted turning away, saying, 'I could not stay to see it.' When it was over, she said, 'I carried my husband's body home with me that same day,' the manner and place of interment having become a matter of total indifference to the Confederate officials."[402]

William Jones resided in Camden County, where he enlisted in the Confederate army at the age of forty on May 30, 1861. He enlisted in Company M, 12th Regiment, and was enrolled as a corporal. He was transferred to 2nd Company B, 32nd Regiment, in October 1861 and deserted on May 10, 1862.[403]

After Jones's death, his wife, Nancy, went to retrieve his body but wasn't able to carry it home due to the lack of a conveyance. She stated that at first the Federal men were afraid to help her. The Rebels cursed her and said that burial was too good for him. On Wednesday, her fifteen-year-old son and seventeen-year-old nephew went to bring the body back home for burial, but the sergeant refused to give the body up. Finally, the doctor released the body, and she was able to take it home for burial. Mrs. Jones found the body "in a shameful state with 'nothing on but his socks.'"[404] She was obliged to walk the twelve miles home.

Jesse Summerlin enlisted for the duration of the war in Company A, 8th Battalion, North Carolina Partisan Rangers, on July 7, 1862, in Jones County, where he resided. He was transferred to Company C in November 1862 and transferred to Company D of the 66th North Carolina Regiment on October 2, 1863.[405] When Catherine Summerlin went to retrieve her husband's body, she found that the soldiers had stripped the body of all but his pants. She got her husband's body the next morning and carried it home for burial. Afterward, Colonel Baker of the Confederate army visited her and took her horse and all her provisions, leaving her with five small children and in destitute circumstances. After her husband's death, she was left under armed guard for three days and nights at her own house in Jones County.

Lewis Taylor enlisted in Jones County on January 24, 1863, for the duration of the war in Company A of the 8th Battalion of North Carolina Partisan Rangers. He was transferred to Company F, 66th Regiment on October 2, 1863. He did not report for duty with that regiment but instead enrolled with the 2nd North Carolina Union Volunteers on December 23.[406] If he had just waited a few days, his bounty would have tripled.

It had been difficult enough to watch the first two men hang, but the following thirteen was even more difficult. The roll of drums sounded, and then an officer of the court read aloud the sentences—with the formal phrasing somewhat irrelevant to what was going to take place. With abruptness, the trap doors were sprung and the ropes stiffened. Left swaying side by side, heads unnaturally tilted to the side, were the thirteen men.[407] The day was very cold. Captain Smith of the 8th Georgia Cavalry remembered the hanging by saying that "the sight was an awful one to behold."[408]

Finally, in late February, seven more deserters were hanged. They were Amos Armyett, Lewis Bryan, Mitchell Busick, William J. Hill, William Irving, Elijah Kellum and John Stanley. With the execution of these seven men, the jail was finally empty. The empty cells stood as silent witness to the brutality of what had taken place over the past few months in Kinston. The final seven men's lives and deaths were no less dramatic than the first two groups.

Amos Armyett considered himself to be a Methodist and was pointed out as the ringleader of the deserters. He was called a "bad man of no ordinary character" by Reverend Paris. Perhaps he was considered the ringleader because he was the oldest of the group. On the scaffold, he spoke out when given the opportunity, saying, "I believe my peace is made with God. I did wrong in volunteering after I got to New Berne. I would rather have laid in jail all my life than have done it. I have rendered prayers unto God to forgive my sin."[409]

Armyett ended up suffering more than the rest at the hands of the hangman. The executioner had somehow failed to tie the knot properly around Armyett's neck, and when the trap door was sprung beneath him, the noose did not tighten. It was almost fifteen minutes before strangulation came to put an end to Armyett's thrashing and twisting at the end of the hangman's rope that day. Meanwhile, both soldiers and the public were gathered around to watch the tortured body twist and turn as he slowly faced his final minutes of pain and anguish.[410]

Lewis C. Bryan enlisted in Jones County on May 15, 1862, in Company A, 8th Battalion, North Carolina Partisan Rangers, for the duration of the war. On October 2, 1863, he was transferred to Company F, 66th North Carolina. He did not report for duty to his new regiment but instead enrolled in the 2nd North Carolina Union Volunteers on November 27.[411]

Mitchell Busick enlisted as a private in Company A of the 8th Battalion, North Carolina Partisan Rangers, on June 28, 1862, for the duration of the war. On October 2, 1863, he was transferred to Company F of the 66th Regiment of North Carolina State Troops.[412] At his trial, Busick said he "went to New Bern and they told me if I did not go into their service I should be taken through the lines and shot." He called out, "I was frightened into it."[413]

William J. Hill was born in Beaufort County, where he resided and worked as a farmer. He enlisted on May 16, 1862, in Company K of the 41st Regiment North Carolina Troops (3rd Regiment, North Carolina Cavalry). He deserted on January 1, 1864, and joined the Federal army,

enlisting in Company F of the 2<sup>nd</sup> Regiment of North Carolina Union Infantry on January 2, 1862. When he died, he left his wife and three helpless children.

William Irving enlisted in Jones County on January 21, 1863, for the duration of the war in Company A of the 8<sup>th</sup> Battalion North Carolina Partisan Rangers. He was transferred to Company F, 66<sup>th</sup> Regiment North Carolina State Troops, on October 2, 1863.[414] William Irving's mother asked Isiah Wood, the Kinston jailer, to help her in locating her son's body after his execution. He stated that he was unable to do so because there were three men buried in a common grave and he could not distinguish one body from another.[415]

Elijah Kellum was born in Jones County, where he resided as a teamster or farmer and enlisted at the age of twenty-five on July 16, 1862, for the duration of the war. He enlisted in Company K, 61<sup>st</sup> Regiment. He was listed as sick in the hospital from January to April 1863, by reason of "morbi varii." He enlisted in Company F, 2<sup>nd</sup> Regiment North Carolina Infantry (Federal) on December 1, 1863, and was captured by Confederates. He was hanged as a young man and unable to read.[416]

Kellum attempted to join a number of Confederate units, but no one would accept him in their unit because he was deformed and had no constitution. In the end, he professed to die in peace and received the ordinance of baptism from Reverend Paris.[417]

John L. Stanley enlisted in Jones County on February 9, 1863, for the duration of the war in Company A, 8<sup>th</sup> Battalion of North Carolina Partisan Rangers. He was transferred to Company F, 66<sup>th</sup> North Carolina State Troops, on October 2, 1863.[418]

In looking over the list of men hanged, it is notable that most were from Jones County and most served in Company A, 8<sup>th</sup> Battalion of North Carolina Partisan Rangers. It is obvious they knew one another, deserted together and joined the Federal service. Nethercutt's Battalion was organized at Goldsboro on August 22–23, 1862, with two independent companies. Four other companies were added later. The battalion could either be cavalry or infantry but began as an infantry group. The group operating around Trenton and Core Creek (present-day Cove City) was primarily cavalry. After the battalion was organized, the two companies moved to Trenton in Jones County, which became the center of its operations. Throughout the early part of the war, the battalion remained in front of Kinston to picket the roads between Kinston and New Berne. Nethercutt's partisans were heavily involved with various skirmishes with

the Federals around the Core Creek area as well as along the Dover Road and Sandy Ridge area of western Craven County.

The Kinston hangings turned out to be another low period in Pickett's career. He was haunted for the rest of his life, putting another dark shadow on his career. He was constantly questioned for his actions in the hangings, and there were thoughts of court-martial as well as a congressional inquiry into the matter. With all the problems facing Pickett, he left the country and went to Canada for a while.

# THE BATTLE OF PLYMOUTH

Following his defeat in February 1864, General Pickett returned to Virginia to lick his wounds and attempt to rebuild his reputation. As for General Robert F. Hoke, he was left in North Carolina "in anticipation of another attempt at the Federal strongholds in the state."[419] Hoke wrote to Major Walter Taylor on February 8: "I assure you I found matters more favorable than I expected. The work could have been done, and still can be accomplished."[420]

Immediately upon assuming his new duties, Hoke began to plan his next attack against the Federal forces located in the eastern part of the state. Rather than attack New Berne as expected, Hoke decided to attack Plymouth, the major Federal supply depot located on the Roanoke River. He was sure that a surprise attack would be successful as soon as the Federal gunboats on the river were removed and confident that victory would be assured with the aid of the ironclad *Albemarle*, being built upstream from Plymouth.[421] If Hoke captured Plymouth, then he could move on to Washington and New Berne.

General Foster, military governor of North Carolina in New Berne, had reorganized his army into three divisions. He dispersed his forces among the three major ports of North Carolina: New Berne, Washington and Plymouth. He concentrated his forces in these places for lightning-quick expeditions from time to time. These expeditions would not occupy eastern North Carolina but controlled the Confederate forces in the area.[422]

Plymouth had a civilian population of only 250 people in 1864, yet it was a major supply depot for Federal land forces in eastern North Carolina.[423] At

the same time, Plymouth had become the keystone of naval activities along the Roanoke, Chowan and Cashie Rivers. Approximately two thousand sailors on thirty Federal ships patrolled the waters there under the command of Lieutenant Charles Williamson Flusser.[424]

Plymouth is located on the south side of the Roanoke River approximately three miles inland from the Albemarle Sound. It lies on a small rise between Welch's Creek in the west and Conaby Creek in the east. A half mile to the east is Conaby Creek; to the north of town is the Roanoke River. As a result, the only approach to Plymouth at the time was to the southwest across the broad plain on the Washington Road.[425]

After the American Revolution, Plymouth developed a flourishing trade in naval stores, such as timber, shingles, tar, pitch and turpentine. In addition, there were large quantities of tobacco being shipped out of the port as well as cotton from the local plantations, making Plymouth the fifth-largest port in North Carolina. By 1862, Plymouth had become a thriving community, only to be destroyed during the first Battle of Plymouth. During that engagement, much of Plymouth was burned deliberately by the Confederates to keep the Federals from getting the town, especially important buildings. In addition, many private residences were burned, "from which frantic inhabitants garbed solely in their bed clothing were forced to fall into the frigid early morning air. While running in the streets to escape her burning home, forty-three year old Amanda Phelps was shot and killed. Her daughter was Lieutenant Commander Charles Flusser's special 'lady friend.'"[426]

More than two-thirds of the buildings in Plymouth had been burned during the Confederate attack on Plymouth in December 1862. Since then, Federal troops had burned a few more buildings in town and pulled down others, "including the local Masonic lodge, from which U.S. soldiers had removed jewels and regalia.…This was no longer a town. There were no residences, no shops, no public buildings left standing save the federal customs house. Plymouth was a military installation."[427]

In two years of undisturbed occupation, the Federal forces had turned Plymouth into a formidable stronghold. While there were strong natural defenses surrounding Plymouth already, Brigadier General Henry W. Wessells, who was in charge of the garrison in Plymouth, spent his time wisely building up strong and powerful fortifications to defend against any potential assault.

Approximately two miles west of town was Fort Gray, named for Colonel Charles O. Gray of the 96th New York Infantry, who was killed on December 14, 1862, by a musket shot through his heart in eastern North Carolina.[428]

Lieutenant Charles Williamson Flusser. *Courtesy of the Library of Congress.*

The fort was located on Warrens Neck between two creeks and shaped like a diamond and could only be approached by water. It was armed with several big guns with a range of over a mile and overlooked the Roanoke River, protecting the town from the approach of riverboats. Fort Gray was renamed Fort Warren when taken over by the Confederates at the beginning of the war.[429]

*Right*: Brigadier General Henry W. Wessells. *Courtesy of the Library of Congress.*

*Below*: Fortifications at Plymouth, 1864. *From* Field Armies and Fortifications to the Civil War—The Eastern Campaign, 1861–1864.

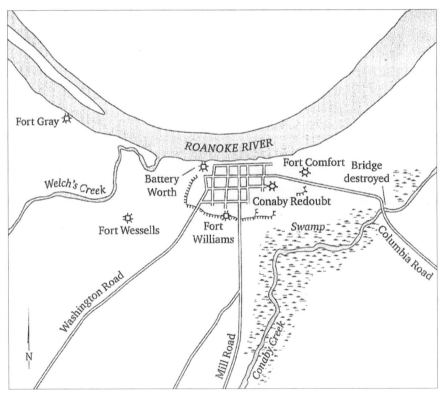

Downstream from Fort Gray on the western side of town at the waterfront fortification was Battery Worth, "one of the numerous redoubts constructed to augment the forts."[430] The fort was built to silence the ram *Albemarle*. Battery Worth was a "35-yard-wide pentagon with open rear protected by a treacherous swamp. A monster 200-pound siege rifle positioned specifically to cover the channel near Boyle's Mill dominated Battery Worth. A field battery forbade any attempt to approach from the west where Boyle's Mill Road cut through the western swamp."[431]

South of Battery Worth was a line of breastworks that extended to the southwest corner of Plymouth, then proceeded to the southwest corner of town and along the southern boundary due east.[432] The Confederates called this installation Fort Hal. Within the town of Plymouth, most of the fortifications were built in the form of a parallelogram, with the longest side parallel to the river.

The strongest and oldest of all the forts in the town of Plymouth was Fort Williams, named for General Thomas Williams. Fort Williams served as the headquarters for General Wessells in addition to guarding the southern approach to the town. The fort was located along "Washington and Lee's Mill roads and projected a half dozen heavy siege guns and three field guns from its commanding elevation. It was enclosed on all sides by a stockade and surrounded by a moat like ditch crossed by a drawbridge."[433]

At first, Fort Williams was surrounded by numerous A-framed tents, used during the warmer seasons, which were placed on elevated wooden platforms two feet off the ground. Later, wooden huts were built for the soldiers for use during the winter. A kitchen and dining room were constructed, streets paved with brick and arbors built to provide shade during the hot summers.[434] Fort Williams "mounted four thirty-two pounder cannons and six-pound brass pieces."[435] It was "nearly 75 yards square, held an array of infantry and artillery and was flanked by strong bomb proofs housing more troops."[436]

Less than a mile to the southwest of Fort Williams was Fort Wessells, or the Eighty-Fifth Redoubt. It was called Fort Wessells because it was one of General Wessells's major projects but it was also called the Eighty-Fifth Redoubt because the 85th New York Infantry occupied it along with twenty-three men from the 2nd Massachusetts Heavy Artillery. The Confederates called it Fort Sanderson because it was built on the Sanderson Farm. Fort Wessells was a smaller fort, similar in design to that of Fort Williams with a moat and a drawbridge, yet it carried only two small guns for defense.

Due to the natural barriers on the eastern side of town, Wessells was not too concerned with the town's defense there, assuming that any attack on

Plymouth would rightly come from the southwest. However, he did establish two small installations, Fort Comfort and Conaby Redoubt, both of which were constructed adjacent to the Columbia Road. The swampy bottomland of Conaby Creek was considered to be enough of an obstruction to protect the town from that direction.

Fort Comfort was named for Captain Alexander Compher, Company D of the 101st Pennsylvania. It was built on a hill in the backyard of a large white house owned by Jackie Dotson. The fort was equipped with two 32-pounders and two 12-pounders. Facing east and octagonal in shape, the fort was located north and midway between Columbia Road and the miry swamp bordering the Roanoke River. After the Confederate victory on April 20, 1864, the fort was renamed Fort Jones in honor of Colonel J.G. Jones of the 35th North Carolina Infantry, who was killed in the siege.[437]

The other redoubt, Conaby Redoubt, was also called Redoubt Latham, as it was built on Latham's farm between Third and Fourth Streets on the eastern end of town. There was another redoubt erected on Bateman's farm, bordering Columbia Road.[438] In addition, General Wessells ordered the bridge through the swamp on the eastern side of town toward Columbia destroyed.

The part of Plymouth's defenses remaining was the Roanoke River, and Wessells felt pretty sure that he had that under control as well. Even with the rumors of a supposed ironclad ram coming down the river, Wessells believed that he had Plymouth well defended against any Confederate attack, even an ironclad ram. Patrolling the Roanoke River were six wooden gunboats, which played a vital role in the defense of Plymouth. Their "absences would open the eastern end of the works to infantry attacks."[439] Four of those gunboats were assigned to Plymouth, while the other two were assigned to the lower Roanoke River and Albemarle Sound. The gunboats assigned to Plymouth were the USS *Miami*, USS *Southfield*, USS *Ceres* and USS *Whitehead*. Commodore C.W. Flusser was in charge of all the gunboats but made the USS *Miami* his flagship.

The USS *Miami* served as the flagship of the fleet, and Commodore Flusser was usually aboard that vessel—although he might be found aboard any of the gunboats. "Built in the Philadelphia Navy Yard, [it] was carrying six 9″ guns, one 100 pounder-Parrott rifle, and one 24-pounder smooth bore howitzer."[440] The other large gunboat, the USS *Southfield*, "carried the same gunnery, except for a slightly smaller howitzer."[441] The *Southfield* was "originally a Staten Island ferryboat, carried five 9″ Dahlgren

Crew of the USS *Miami. Courtesy of the U.S. Naval History Center.*

guns, 100-pounder Parrott, and one 12-pounder howitzer. Both the USS *Ceres* and the USS *Whitehead* carried several 20-pound Parrott guns and howitzers."[442]

On April 17, 1864, the Confederates commissioned the CSS *Albemarle*, an ironclad warship, to do battle with the Federal gunboats in the Albemarle and Pamlico Sounds of North Carolina. The ironclad was 158 feet in length, covered with iron plating and had 150 officers and men. It was under the command of Captain James W. Cooke. Its mission was to clear the Roanoke River of all Union vessels so that General Robert F. Hoke's troops could storm the forts located in Plymouth.

There was one transport attached to Plymouth as well, the USS *Bombshell*. In addition to the various gunboats, Flusser blocked the approach of enemy gunboats by placing mines, sunken vessels and other obstructions in the Roanoke River at Thoroughfare Gap near Warrens Neck.[443] Flusser also lashed the *Southfield* and the *Miami* together with spars and chains in a V formation. His plan was to lure the *Albemarle* into the V, where he could

capture and destroy it. Cautiously confident, Flusser was heard to say, "If I can bring the ram to close quarters, I will sink her, but by Goddamm, I will sink myself." His statement would prove prophetic.[444] Therefore, at the time Hoke was contemplating attacking Plymouth, the Federals there felt confident of their position, for the Federal gunboats were in full command of the Roanoke River.[445]

In late 1863 and early 1864, North Carolina governor Zebulon Vance urged President Davis to do something in regard to the U.S. Army recruiters in eastern North Carolina. There were also numerous Federal raids on local villages and towns, yet the Confederate government was unable to do anything about it. There was a major problem with Confederate soldiers deserting in North Carolina as well as a strong peace movement. Many soldiers were deserting and coming home because they were tired of the war or were needed at home to help with the farming. In addition, there was a strong pro-Union movement in the mountains and the coast that wanted to settle for peace and rejoin the Union. Both of these caused problems for the government by destroying morale and disrupting supplies to the troops. Governor Vance refused to do anything to punish the deserters and would not sanction the use of force against those who were opposed to the war effort. He appealed to President Davis for some relief.

President Davis conferred with General Robert E. Lee and looked at the situation as a military problem, whereas Governor Vance had considered it to be a political one—which the president could take care of himself. As a result, "in March, the Confederate high command determined a last-ditch strategy. Davis could remove three brigades temporarily from Lee's defense of Richmond, strike quickly at the federal outposts in coastal North Carolina hoping to overrun them, and then return the troops to Lee in time to meet the expected onslaught."[446]

Hoke felt that in order to capture Plymouth it was necessary to have both ground and naval support at his disposal. At Edwards Ferry on the Roanoke River, the Confederate navy was constructing an ironclad ram, the *Albemarle*. At White Hall, above Kinston on the Neuse River, it was also constructing another ironclad, the *Neuse*. Hoke appealed to Confederate authorities for use of the two rams in his attack on Plymouth and, later, on New Berne. The Confederate forces granted Hoke the use of the two rams to participate in the attack on Plymouth.[447] Ultimately, the "decision whether to begin the new campaign at Plymouth or New Berne was based upon the completion of the first Confederate ironclads being constructed in the region."

CSS *Albemarle* under construction at Edward's Ferry Shipyard. *Courtesy of Plymouth Museum.*

Hoke directed most of his personal attention to the building of the *Albemarle* and *Neuse* during the month of February 1864. Even so, the CSS *Neuse* was behind schedule. It could not be counted on to attempt to sail down the Neuse River for some time yet and begin to do its job against the Federal forces there.

By March, the Confederates had pinpointed Plymouth as the most logical target for an attack. Hoke traveled to Richmond to confer with President Davis, where he "unveiled his proposed campaign to expel all enemy troops from North Carolina. Davis listened as the General explained that with his brigade and two others, and with the assistance of the *Albemarle*, he believed he could capture Plymouth, Washington, and New Berne."[448] Following the presentation, the president posed many questions about the Federal stronghold in eastern North Carolina and asked about the expedition against Plymouth. "Hoke assured Davis that if he were instructed to attack Plymouth or any other place in his home state, there would be a fight. Davis ended the conference by telling Hoke that he was delighted to know that someone still thought something could be done. Hoke left with assurance that he would be provided with the necessary forces to accomplish his purposes in North Carolina."[449]

While the ironclad CSS *Neuse* was way behind schedule, the CSS *Albemarle* was quickly being readied for duty. The CSS *Albemarle* was being built about thirty-five miles up the Roanoke River in a cornfield near Hamilton. Either way, Hoke depended on one of the ironclads to aid him in his attack on

Plymouth, Washington and, eventually, New Berne. Which town he attacked first depended on the availability of the ironclads.

If the mission was successful, it would eliminate the Federal presence on North Carolina's coastal plain and conciliate the state's disaffected planters as well as intimidate the unionists in the eastern part of the state.[450] Hoke now had a sizable force, "including his own Tar Heel Brigade led by Colonel John T. Mercer, Colonel William R. Terry's Virginia Brigade, Brig. Gen. Matthew W. Ransom's North Carolina Brigade, and Colonel James Dearing's cavalry regiment."[451] More than anything else, Confederate sympathizers in eastern North Carolina wanted the Yankees gone from the east, especially New Berne, the headquarters of the Union's Sub-District of the Albemarle, as well as from Plymouth on the Roanoke River.[452]

Early rumblings of the battle to come could be seen back in February 1864, when General Lee detached an entire corps of more than ten thousand soldiers from his Army of Northern Virginia to Goldsboro for the purpose of conducting a number of "demonstrations" against Federal posts in the eastern part of the state. At the same time, General Henry W. Wessells requested on February 4, that additional soldiers be sent to Plymouth to reinforce his command because of rumors of the impending arrival of the ironclad ram *Albemarle*. Again, on February 7, he requested that three thousand additional soldiers be sent to reinforce his command. When no reinforcements were forthcoming, on March 20, he requested five thousand additional troops. Still, no reinforcements were on the way.

In March, the ram *Albemarle* was floated from Edwards Ferry, where it had been constructed, downriver two miles, where it was to be "mounted with a deadly armament of two eight-inch Brook rifles."[453] At the end of March, General Hoke visited the *Albemarle* for inspection and found that it was in the final stages of completion and would be ready for sail by mid-April.[454]

General Braxton Bragg formulated the plan of attack on Plymouth. He instructed General Hoke to concentrate all his troops at Tarboro, sixty-five miles due west of Plymouth, where they would find five days' rations waiting at the railroad station. From Tarboro, Hoke was to march eastward to Williamston and then to Plymouth in two days. The *Albemarle* would sail downriver toward Plymouth at the same time. This was to be a fast, cheap operation. Bragg stressed that Hoke's preparations and movement must be carried out in the greatest secrecy in order to retain the element of surprise.[455]

The Confederate plan of attack was the worst-kept secret of the battle. Everyone knew that the Confederates were building an ironclad ram at Edwards Ferry. In December 1863, the Federals were aware that the

*Left*: General Braxton Bragg. *Courtesy of the Library of Congress.*

*Below*: CSS *Albemarle* floating down the Roanoke River. *Courtesy of Plymouth Museum.*

Confederates were nearing completion of the ram; it would be ready for action in the early spring. As a result, the garrison in Plymouth went on alert beginning in late February 1864.

On April 12, General Bragg issued marching orders from Richmond for General Hoke to take charge of the expedition, with Brigadier General Matt Ransom assisting, and to march out within two days. On April 14, just before noon, Brigadier General Hoke and his men left camp and marched through Kinston, past the gunboat *Neuse* and on toward the depot. From there, they rode the train to Rocky Mount and then took the Tarboro branch of the Wilmington & Weldon Railroad to Tarboro, arriving at 3:00 a.m.[456] On the same date, Brigadier General Henry W. Wessells, commanding at Plymouth, obtained detailed information of the

Confederate operation against Plymouth. He informed his superiors that a large enemy force of approximately ten to twelve thousand soldiers was headed toward Plymouth.[457]

On Friday, April 15, Brigadier General Hoke assembled his forces at Tarboro.[458] He marched over ten thousand troops along the road through Martin County to the Washington County border over the next two days. They assembled at the depot, where they rested for the next step in their attack on Plymouth. While they did so, Brigadier General Hoke alerted "Commander Cooke that the time had come and the mostly completed CSS *Albemarle* made final arrangements for her maiden voyage from Edwards Ferry."[459] At 10:00 a.m, "with regimental flags flying and bugles blowing, Hoke set his expeditionary force in motion. The Confederate quest to liberate eastern North Carolina was underway."[460]

On Saturday, April 16, the column of Confederate soldiers arose early at dawn and marched for ten miles, nearly to Williamston. Discipline on the march remained lax at first, and the members of the 21st Georgia broke ranks and managed to bag several wild turkeys along the road.[461]

On Sunday, April 17, Hoke's troops arrived outside of Plymouth about midafternoon. Hoke's troops drove in Wessells's pickets and halted before Federal lines outside of artillery range. "Ransom's brigade moved eastward to a plain south of town, while Hoke's brigade moved west toward Fort Wessells. Both sides threw out skirmishers, and the Federals opened fire with their enemy."[462]

At 4:00 p.m., Hoke's troops reached a point five miles from town. He soon captured some of the enemy pickets and scattered a detachment of cavalry. Hoke then proceeded to Plymouth. Here the Federals answered his movement with artillery fire, which lasted until nightfall.[463] The sharp skirmishing kept up until dark on the Washington Road, extending across the fields nearly to the Acre Road, but without any important result, and the night was passed in comparative quiet.[464]

About 2:00 p.m. on Sunday, April 17, the CSS *Albemarle* was placed in commission. An hour later, Captain Cooke ordered, "Cast off all lines!" "With ten portable forges on board for emergencies and numerous sledge hammers simultaneously echoing, the unfinished Confederate ironclad ram slipped her mooring at Hamilton to begin her tenuous journey down the Roanoke River, heading for the port of Plymouth."[465]

Just about the time the sun was beginning to set, Colonels Read and James Dearing opened fire about 1,500 yards from Fort Gray, cutting down its flagstaff. "The fort vigorously returned fire and after a few hours, the Rebels

quieted, listening in vain for the arrival of the already tardy *Albemarle*, whose aid was so desperately needed."[466]

At daybreak on Monday, April 18, Hoke's men were roused from slumber and the line of battle formed. General Hoke was notified that the attack was about to commence with a signal rocket. Skirmishers, under Captain Cicero Durham, the fighting quartermaster of the 49th North Carolina, moved forward and drove the enemy pickets before him and his men. The Confederates advanced at quick time and yelled from the entire line. The Confederate artillery fired on the fortifications ahead, which lay on both sides of the Columbia Road. "At this moment, General Hoke, on the west side of town, opened with his artillery and his men sent up yell after yell as if about to charge."[467] Incessant skirmishing continued throughout the whole of the day "along and between the main approaches in front of the town, at a distance of 1,200 yards from the line of defense."[468]

At the same time, the Confederate forces opened a severe cannonade against Fort Gray, resulting in some casualties, but the garrison remained firm, returning the enemy's fire. Battery Worth began to turn its 200-pounder in that direction without any effect. The Federal transport *Bombshell* received several shots below the waterline and attempted to return to town, but it sank at the dock. "The transport *Massasoit* made two trips to Roanoke Island, carrying away a large number of women, children, contrabands, and other non-combatants. The gunboat *Ceres*, being above Fort Gray at the time of its investment, passed down the river under the destructive fire and rejoined the squadron, with a loss of 9 men killed and wounded."[469] The *Miami*'s logbook indicated that "the *Massasoit* departed on April 18th at 12:05 a.m. and did not return to Plymouth until 5:30 p.m. Two trips were required to transport all of the officers' wives and children, as well as the wounded and other noncombatants, including a number of elderly African Americans and families of 'Buffaloes.'"[470]

After sunset, Brigadier General Hoke unleased a heavy bombardment on Fort Williams and the town itself. The Federal line of skirmishers fell back, and Fort Williams opened a furious cannonade in return, inflicting heavy damage and loss on the Confederates. Finding that the front of Fort Williams was too well prepared for an assault, the Confederates turned their attention to Fort Wessells. Hoke could hear the shrieks and screams of the dying within the fort as he withdrew his forces.

At Fort Wessells, or the Eighty-Fifth Redoubt, heavy fighting ensued. Most of the Federals were safely tucked away within the bombproofs inside the fort. Both sides sent out skirmishers in order to ascertain the enemy's

positions—the Confederates made no general advance. Both they and the Federals waited patiently for the Confederate ironclad to arrive, but the ironclad failed to arrive by midnight.[471] The Confederate gunners fired percussion shells concentrating on the fort's magazine, hoping to blow up the fort and its garrison, but it failed. However, the percussion shells did kill three men inside the fort, without whom "the fort's defense could not be maintained—the garrison's only trained gunners."[472]

> *The capture of Fort Wessells provided General Hoke with a good position for his artillery, but he knew that capture of Plymouth still depended on the cooperation of the Albemarle, which had not arrived. "Bitterly disappointed" that the ram had not made its appearance and fearful that it would not, many of Hoke's men "fell to sleep, deeming it more probably that the morrow would bring orders for Tarboro than for Plymouth." The enemy, however, harbored no such thoughts. Commander Flusser, aboard the* Miami *on the evening of the eighteenth, wrote: "We have been fighting here all day. About sunset the enemy made a general advance along our whole line. They have been repulsed.... The ram will be down to-night or tomorrow. I fear for the protection of the town."*[473]

That night, "as Fort Wessells was reduced, the CSS *Albemarle* descended the Roanoke. One of the best ironclad vessels the Confederacy produced, it broke through a line of obstructions three miles upstream from town at 2:30 a.m. and easily passed Fort Gray."[474]

Later on that morning, about 3:00 a.m., Brigadier General Hoke "ordered his artillery to shell Fort Gray, hoping to divert the attention of U.S. gunners from the river. The general apparently intended that the *Albemarle*'s commander, Captain James W. Cooke, would take notice of the shelling and seize the opportunity. But Hoke sent no communication to Cooke informing the captain of his intentions. Cooke appears to have acted independently and without any knowledge of Hoke's plans, or actions."[475] By 3:15 a.m., the *Albemarle* was poised and ready to strike off of Plymouth.

Hoke's men seemed to be everywhere from the Federals' point of view. Fort Wessells had fallen, the CSS *Albemarle* was now in the Roanoke River off of Plymouth ready to pounce on the Federal forts and Hoke established a battery near Fort Wessells where he could get a better aim at Fort Williams. Having twice failed to breach Plymouth's defenses from the southwest, Brigadier General Hoke conceived a different plan of attack. That evening, Hoke ordered "General Matt Ransom to move

his troops through Conaby Creek Swamp southeast of town to the Columbia Road. There, Ransom was to turn westward toward Plymouth and attempt a crossing of rain-swollen Conaby Creek. If successful, Ransom would find little resistance, this being the only side of Plymouth without entrenchments."[476]

Hoke could not be satisfied with just a duel of artillery, so he threw out two brigades of skirmishers. He wanted to storm the trenches at Fort Williams and drive the Federals back into their entrenchments. In addition to Ransom attacking from the east, Hoke now had the *Albemarle* to support him from the north.

"'All night long,' one man in Ransom's Brigade recalled, the fort's shells 'hurled above and around us, and sometimes exploded in our very midst.' But the rebel soldiers remained motionless and silent, waiting for orders.… Finally at dawn, Ransom's field commander gave the order to advance."[477] Ransom's troops moved across a level plain under a hail of fire. "Then, artillery gunners at forts Comfort and Williams directed an enfilading fire of canister and grapeshot at the advancing rebels. That stopped their forward movement."[478] After a few minutes, "Ransom's main line again raised themselves from the ground and marched forward, straight into the Federal guns. The soldiers moved slowly and silently without firing a shot until nearly standing in the Federal entrenchment. Then, they began a long rebel yell and fired their guns as they ran to surround Fort Comfort and Conaby Redoubt."[479] In a matter of minutes, "Ransom's troops roughly five thousand men, overran and captured the Federal positions—but not before U.S. gunners 'for fifteen murderous minutes' shot down rebels 'like mown grass.' A rebel soldier wounded in the battle estimated that five hundred of his comrades lay dead."[480]

While part of Ransom's Brigade remained to subdue the Federals in Fort Comfort and Conaby Redoubt,

> *another group marched along the river through town to Battery Worth. In a matter of minutes, the rebels overran the entrenchments there. Battery Worth had been built on the assumption that Flusser's gunboats would protect the fortification's rear. Hence, the earthworks did not extend to the east side of the battery, the direction from which Ransom's attack came. The fall of Battery Worth placed in Confederate hands the 200-pounder Parrot gun which the* Albemarle *had dropped downriver to avoid. Rebels soon turned the gun on Fort Williams, while the* Albemarle *made its way upriver in safety and began to shell the town at close range. Finally, Ransom reformed*

*his troops along the Roanoke River so as to march toward Fort Williams and the Federal entrenchments.*[481]

Hoping to avoid further bloodshed, Hoke demanded the surrender of Fort Williams, but General Wessells refused. At that point, the Confederate artillery opened up a terrific fire upon Fort Williams, pounding it into submission.

On the Roanoke River, the *Albemarle* had a tremendous first day on the river. It slipped downriver from Hamilton, where it had been christened, and passed by Fort Gray. There the *Albemarle* was fired on as it floated by the fort but evaded any damage. Shortly after arriving that morning in Plymouth, the *Albemarle* came into contact with the Federal gunboats *Miami* and *Southfield*. These two gunboats had been lashed together with long spars and chains to create a V in which to capture the CSS *Albemarle*. Commodore Charles W. Flusser was in command of the Federal gunboats at Plymouth when *Albemarle* arrived. He was stationed on the USS *Southfield* at the time, rather than the USS *Miami*. He hoped to get the ram caught between the two gunboats and there batter it to pieces with gunfire at close range. Seeing what his opponent had in mind, Commander Cooke ran the *Albemarle* in close to the shore and then suddenly turned into the middle of the river. With throttles wide open, the *Albemarle* dashed its prow into the *Southfield*, making a hole large enough to carry the Union vessel to the bottom of the river. For a brief moment, it looked as if the engagement would take down the *Albemarle* as well. "The chain plates on the forward deck of the *Albemarle* had become entangled in the frame of the *Smithfield*, pulling the ram's bow down until water poured into the portholes. But as the Union vessel touched bottom in the shallow river and turned over on her side, the *Albemarle* was released and came up on an even keel."[482]

As soon as the *Albemarle* was free from the *Southfield*, the ram opened fire on the *Miami*, which was alongside the ram. "They were so close together that a shell with a ten-second fuse fired to the *Miami* rebounded off the ram and landed on the deck of the Union ship. The explosion killed Commander Flusser where he stood, lanyard in hand, by the gun that had fired the shot."[483] Commander Cooke then moved his ram closer to the shore near Plymouth and awaited further orders. The Federal commander, Lieutenant French, seeing that the situation was hopeless, ordered the remaining gunboats to drop down the river and await daylight.[484]

The morning of April 20 broke full of hope and excitement for the Confederates. They were on the verge of victory, and the men could taste it. Ransom attacked first thing that morning, "firing a signal rocket to let

The *Albemarle* ramming the *Southfield*, April 19, 1864. *From* Albemarle: Ironclad of the Roanoke.

Hoke know he was on the move." The guns of the *Albemarle* pounded Fort Comfort, which was shortly taken by the 35th North Carolina, but the Conaby Redoubt proved to be more difficult to take. The 8th North Carolina stormed into the ditch, where it was pelted with hand grenades. The Federals fired on the Confederates through loopholes cut into the palisades at the rear of the work. The Tar Heels surrounding the fort, managed to fire back when the loopholes were empty and broke down the gate in the palisades, forcing the garrison to surrender.[485]

On the right wing, Battery Worth fell, and the Confederates concentrated their artillery fire on Fort Williams in the center of the line. Wessells watched the tremendous pounding from inside the fort. The breast-high ramparts were struck by solid shot on every side, with fragments of shells seeking every interior angle of the work; the whole extent of the parapet was swept by musketry and men killed and wounded even on the banquette slope.[486]

The surrender of the fort began in a gentlemanly manner, with Hoke riding up on his horse into Fort Williams and requesting to speak with General Wessells. There he clasped Wessells's hand, expressed his respect and sympathy and told General Wessells that he ought to "bear the fortune of war without self-reproach" after "such a gallant defense." Wessells offered his sword, but Hoke graciously refused to take it. The U.S. commander then

requested that his men not be "robbed"—specifically, that they be allowed to keep their clothing, overcoats and blankets. Hoke agreed to this. Wessells was later taken prisoner, separated from his troops and, on Saturday, transported with his officers to Libby Prison in Richmond, Virginia.[487]

The Federals lost 2,400 men captured and 200 men killed at Plymouth, while the Confederates forces might have lost as many as 1,800 killed and captured.[488] In his report, Wessells claimed that the losses due to enemy fire were not so heavy because he had sheltered his men in bombproofs hastily constructed along the line. Major General John J. Peck, the master earthwork builder, did not buy that excuse. He bemoaned the loss of Plymouth and blamed it on faulty engineering. The fire delivered by the *Albemarle* was the key to the Confederate victory, for it took the entire Federal position in reverse. Wessells informed Benjamin Butler that had all the works been enclosed, the results would have been very different.[489]

According to the Richmond newspapers, General Wessells surrendered "approximately 2,500 men, 28 pieces of artillery, 500 horses, 5,000 stands of small arms, 700 barrels of flour…'with our commissary and quartermaster supplies, immense ordnance stores,' and most important, the 'strong position of Plymouth.'"[490]

On April 23, President Jefferson Davis telegraphed General Hoke directly: "Accept my thanks and congratulations for the brilliant success which has attended your attack and capture of Plymouth. You are promoted to be a major-general from that date."[491] General Hoke had accomplished his goal. Now it was time to face south and look toward Washington and New Berne: "The Confederate victory at Plymouth reverberated throughout the Confederacy. Victories had not come easily during the preceding year, and Union armies currently threatened the east on four fronts."[492]

With the victory of Plymouth behind him, Hoke now turned his attention to Washington and New Berne. He immediately set about reorganizing his army and getting it ready for their next campaign—Washington, where he looked forward to another victory.

# 12

# THE BURNING OF WASHINGTON

Major General Hoke wasn't able to sit back and rest on his laurels over the big victory at Plymouth. He knew he had work to do and had precious little time in which to do it. To Hoke, Washington and New Berne were the greater prizes, and he was eager to get started. Hoke aimed his sights on his new targets, knowing that if he captured them, the enemy would be banished from eastern North Carolina.[493] Hoke had been operating with strong support from Richmond in his attempt to wrest eastern North Carolina from the Federals. But now, things had changed. He had a new immediate commander—General Pierre G.T. Beauregard—who did not initially approve of the Confederate initiative in eastern North Carolina. On April 22, General Beauregard arrived in Weldon to assume command of the Department of North Carolina and Southern Virginia south of the James and Appomattox Rivers and all of North Carolina east of the mountains.[494] This change in leadership made General Hoke a bit cautious for the future of his venture.

In camp, preparations were being made around Hoke's headquarters to move out. Troops in Kinston were placed on notice to "be prepared to 'march at a moment's warning.'"[495] Unnoticed by almost everyone except a few of the crew of the CSS *Neuse*, the water level of the Neuse River had fallen significantly—at a rate of three-quarters of an inch per hour over the last three days.[496] The ironclad would draw nearly eight feet of water when finished, and the river was rapidly dropping below that level.

At noon, on April 22, firm orders reached Kinston that the CSS *Neuse* had but one hour before heading downriver to support an attack on New Berne. Word spread quickly throughout Kinston of the move, and a large crowd began to gather on the Kinston side of the Neuse River to witness the gunboat's departure. The drawbridge downstream swung open to allow the gunboat through. By four o'clock that afternoon, the gunboat was in full readiness and moved off beautifully. "Hundreds cheered as the low slung monster glided off into what remained of the main channel."[497] The CSS *Neuse* "steamed out her 'cat hole' toward New Berne, despite the fact that the ironclad was not finished."[498]

Ever mindful of the significant role that the navy played in the victory in Plymouth, Major General Hoke was anxious to gain the support of the ironclads in the upcoming assault on New Berne.[499] Hoke would have to make a decision soon whether to attack Washington or New Berne, depending on the availability of the ironclads. He knew that he could not do the job without them to assist.

In New Berne, General Palmer was analyzing the situation as well. He knew that Hoke was planning to attack, and it was no secret that the target was "Little Washington." Palmer considered the Washington garrison to be "of little strategic importance," but it had become a safe haven for many refugees and he intended to protect them.[500]

Navy Lieutenant B.P. Loyall commanded the CSS *Neuse* as it headed down the river toward New Berne to take the city and sink the Federal gunboats. Shortly after the ironclad left its mooring, it ran into a sandbar and was grounded. Loyall and his crew did all they could do to free the vessel, with no luck. As day turned to night, the ironclad stood four feet out of the river, useless to the Confederate war effort. As a result, Hoke's grand strategy was dealt a severe blow.[501]

Shortly after arriving in North Carolina, Beauregard expressed alarm about a possible immediate enemy attack on Petersburg and intimated a lack of readiness for such an assault. He questioned if Hoke should remain in North Carolina and continue his campaign there or if he should return to Virginia, where he was needed more, demonstrating Beauregard's lack of support for Hoke's mission in eastern North Carolina.

On Monday, April 25, Hoke's army began its southern movement toward Washington, thirty-five miles distant. The expeditionary force stopped to camp for the night after eleven miles on the dusty road, near Jamesville, which one of Hoke's officers described as "a dilapidated town."[502] While Hoke was marching south toward Washington for his next round of battles,

big things were happening in New Berne. There, Major General John J. Peck was replaced by Brigadier General Innis N. Palmer, a graduate of the famous West Point class of 1846.[503]

The morning of April 26 was an unseasonably warm one. Hoke's men got up early and resumed their march over dusty roads toward Washington and what was to be their next showdown with the Federals. A good many of the men "fell out" from the heat. As the soldiers bedded down for the night, they continued to enjoy the countenance of Richmond. Earlier in the day, Bragg intimated its importance in a response to Beauregard: "The movement under Major-General Hoke, if prompt and successful, will enable us to concentrate a formidable force to meet Burnside."[504]

Although Hoke was marching as fast as he could toward Washington, he did not know that Palmer had already ordered Brigadier General Edward Harland in Washington to evacuate the place, salvaging what he could, cautioning him to somehow keep up the appearance of resistance.[505]

Washington was a mirror image of Plymouth occupying the north bank of the Pamlico River, the direction from which the Confederate column approached the town. It was ringed with impressive earthworks.[506] The Pamlico River was bristling full of Federal gunboats, "More gunboats than he intended to deal with." On top of that, Hoke could no longer expect help from either the CSS *Albemarle*, which was busy on the Roanoke River, or the CSS *Neuse* in his attempt to take Washington. As a result, Hoke feared making a frontal assault of Washington and its well-aimed guns. Hoke informed General Beauregard that New Berne was a far more important prize, and he chose to lay a half-hearted seize of Washington.[507]

To many of the Federal soldiers, the word "evacuation" meant a license to steal. Everything from small-scale looting to major theft took place, even during the major artillery duel for the city. Looting begun in the regimental stores of the departing 1st North Carolina Volunteers, and outrages during the day became general. "Government stores, sutlers' establishments, dwelling houses, private shops, and stables, suffered alike."[508] Throughout the town, bedlam grew as the citizens joined crewmen and black refugees in driving loyal citizens, mainly women and children, into the woods to wait out the storm.[509]

On the morning of April 27, Major General Hoke, in anticipation of the arrival of both the ironclads, decided to lay siege to the city of Washington. About 8:00 p.m., Hoke decided to move his wagon train back from the town eight miles west toward Greenville.[510] Over the next three days, Hoke grew

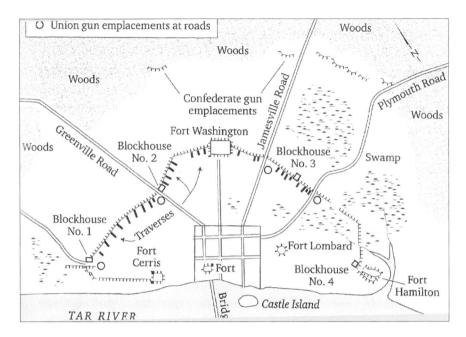

Federal defense of Washington, April 1863. *From* Field and Fortifications in the Civil War.

more confident that his siege would work and Washington would fall into his hands without bloodshed. However, as Hoke waited on the outskirts of Greenville for the fall of Washington, Washington burned. "Federal troops took the time to wantonly burn and pillage the town."[511] Harland was "urged to 'speedily, but as secretly as it is possible' move his garrison, stores, and guns to New Berne. Palmer noted that the decision to evacuate Washington was made because the town was 'not worth the expense which is required to hold it.' None the less, Harland was admonished to 'keep up the idea that there is no intention of evacuating Washington, and even after the guns and stores have all been removed a small force must be kept in the works.'"[512]

By Thursday, April 28, the Confederate infantry had removed to the Greenville Road, joining General Hoke, "drained and ready to leave."

On Friday, April 29, Hoke lifted the siege of Washington and sent his three brigades to follow his wagons. The troops warmed considerably until halting four hours later, three miles east of Greenville, bathed in dusty sweat.[513]

As Hoke's forces were reaching Greenville, Lee specifically appealed to Jefferson Davis to return Hoke's former brigade to his army in Virginia, but Hoke's gains in North Carolina had swayed President Davis to ask Lee to allow Hoke to finish his mission. The president telegraphed General

Lee, "Your wishes will be complied with as soon as possible.…Enemy have evacuated Washington." While General Lee impatiently backed off, he would not be dissuaded for long.[514] Convinced that Richmond was determined to see Hoke's mission through to the end, Beauregard decided to counsel him to attempt to take New Berne.[515]

The morning of April 30 dawned with Washington in flames and Hoke's troops in Greenville. The few remaining Federal troops and even women fought the blaze. For some reason, the Yankees had destroyed all the water pumps; thus, the churches, houses and stores were consumed by flames. One civilian woman even burned to death. Bucket brigades were formed by the women of Washington and succeeded in saving the lower half of town closest to the Pamlico River.[516]

While Washington burned, the last of the Federal troops "boarded ships for the trip to New Berne."[517] As the Federals were boarding the ships, the acting post commander "directed the Union gunboat, *Louisiana*, to burn the bridge across the Tar River."[518]

In Kinston, Bragg issued a directive with dire consequences for Major General Hoke and his upcoming mission in New Berne: "A dispatch from General Lee to the President, just received, reported Burnside certainly moving rapidly to join Meade, and General Lee urged the movement of all assistance practicable to his front. The Secretary of War concurs with me in the following: Urge the expedition of General Hoke to an issue at once, so that his force may join General Lee."[519]

Hoke knew that his days in North Carolina were numbered, but if he worked quickly, he could accomplish his goals in Washington and New Berne. Hoke had several things going for his plan: in New Bern, General Palmer was uncertain what the Confederate army was doing and Palmer was less than confident in requesting reinforcements. The major point in Hoke's favor was the bloodless capture of Washington just a few days earlier.[520]

During the late afternoon of April 30. Hoke's troops began to filter into Washington from the Greenville Road in the west, and what they found was appalling: "Although General Palmer's evacuation orders had directed that not a particle of property of any description be destroyed, hordes of Union soldiers had gone on a lawless rampage throughout the city soon after receiving notice of the evacuation. No building or civilian was safe from the mayhem."[521] This devastation witnessed by the Confederate troops "proved a source of motivation for them to finish their task."[522]

May 1 was Sunday, the Lord's Day. Hoke's men arrived in Washington, but the damage was already done. His arrival was too late, and the town

was in ashes. He set up provost guards and began to assist the citizenry in establishing order. He sent agents to Hyde County to obtain corn for his troops and the starving civilians of Washington.[523] Incensed by the atrocities that he found in Washington, Hoke was more determined than ever before to take New Berne back from Federal control.[524] At the same time, Hoke received disheartening news from General Beauregard concerning the CSS *Neuse* in Kinston. The *Neuse*, which had been grounded since April 22, was still tight aground and thus would not be available for Hoke's upcoming attack on New Berne. Therefore, Hoke communicated with Commander Cooke of the CSS *Albemarle*, who was aware of the difficulties and dangers in a naval mission to New Berne. Cooke promised his aid in any attack that Hoke made on New Berne.[525]

As the sun rose on Washington on May 2, Hoke began to look forward to his next move: New Berne via Kinston. The general knew that his time in North Carolina was running out and he must act quickly. He began to reorganize his army to march to Kinston, where he could regroup and there plan the attack on New Berne from the west. While Hoke had triumphantly taken both Plymouth and Washington, the rank and file within his army dreaded the next objective—New Berne. Many had been there only a few months before and remembered the heavy losses and the near miss.

# THE FOURTH BATTLE OF NEW BERNE

With the glow of Washington burning behind him, Major General Robert F. Hoke led his triumphant army south to what he hoped would be his next victory—New Berne. Yes, he had faced this scenario before, just three months earlier, but that battle was not his battle. It had been led by someone else even though it had been his plan. He knew that had he been the one to lead that expedition in February 1864, it would have been successful. The leadership did not have the gumption to stick with the plan and see it through. They were, in fact, too timid and failed when they were needed the most. Now, Major General Robert Hoke himself was leading the expedition—his expedition—and he knew he could carry it through to the end and to victory. The time was ripe. This time, his plan would succeed.

Major General Hoke was leading his army to Kinston, where he was to confer with General Beauregard and, from there, march on toward New Berne. In Kinston, the first thing Hoke wanted to do was go to see the damage done to the CSS *Neuse*, which had been grounded on a sandbar in the Neuse River. Seeing the CSS *Neuse* grounded confirmed the reports that Hoke had received, and he realized that the *Neuse* would not be available to him for his attack on New Berne.[526]

After assessing the situation of the CSS *Neuse*, Hoke went on to meet with his superior commander, P.G.T. Beauregard. At the meeting, Beauregard handed Hoke two things. The first was Beauregard's appointment of Hoke as overall commander of the Second Military District of North Carolina.

The second was Beauregard's own tactical recommendations for a successful assault on New Berne. This included Bragg's authorizations for Hoke to retain all of the troops he had used successfully at Plymouth to accomplish the upcoming task.[527]

Beauregard's intelligence agents accurately reported the defenses at New Berne and the number of Federal troops manning them. Federal forces occupied four primary fronts, with a canal and strong rifle defenses guarding the right flank to the Neuse River. The major fort, Fort Totten, was almost impregnable.[528] The "mysterious canal" mentioned was "a canal [that] had been cut from one river to the other above the town, completely surrounding the town with water, and there was no way to attack the enemy except to swim."[529]

With the CSS *Neuse* out of commission indefinitely, Beauregard suggested that its sister ship, the CSS *Albemarle*, be used instead to clear Federal sea power from the waters surrounding New Berne. Hoke's infantry would need that support to overcome the six thousand Federal troops now gathered in New Berne.[530] Beauregard went on to suggest that as in the February maneuvers, this attack should be along Batchelder's Creek.[531] He further suggested that the best route to follow was the Trenton Road south of the Trent River to Tar Landing, or Rocky Landing, on the Trent, where the river might be crossed on a pontoon bridge.[532]

On May 1, Major General Palmer in New Berne received word that Washington had been evacuated and General Beauregard was in Kinston.

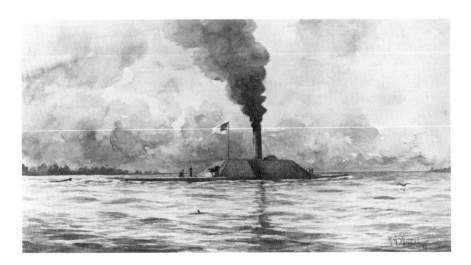

CSS *Neuse. Courtesy of the Ram Neuse Museum.*

He received a report from a deserter that Beauregard was "assembling five brigades there for the attack on New Berne." In his report, Palmer stated, "I may be wrong in my estimate of our abilities, but I think we can make a successful resistance."[533] Clearly, Palmer had no idea of what was in store for him in the next few days.

That same day, General Beauregard forwarded a letter to Major General Hoke outlining his proposals for the assault on New Berne. Beauregard considered three different methods of attacking New Berne: "First, by surprise and assault; second, by assault without surprise; third, by regular approaches."[534] Since it was obvious that the enemy was clearly aware of the Rebels' approach, the first method would not be possible. As for the third method, there was insufficient time to execute that method. Therefore, the second plan was "the only one which can now be carried into effect. It can, however, be made to partake more or less of a surprise, and with the assistance of the ironclad gunboat, *Albemarle,* from Plymouth."[535] However, there was no hope of cooperation with the CSS *Neuse*, as it would not be afloat in time for the assault on New Berne. The attack on New Berne had to be made in such a way as to capture or destroy the separate Federal forces before they could be concentrated into one body. For that purpose, the CSS *Albemarle* must destroy the long bridge across the Trent River so as to isolate the troops now stationed south of the river. The *Albemarle* would also have to sink the two or three gunboats aiding in defense of the town as well as burn the Trent River Bridge. The *Albemarle* would then take up such a position in the Neuse River so as to cut off New Berne from communication from Federal forces from the north side of the river and cooperate with Major General Hoke's attack by taking in flank and rear the works and lines extending from the Neuse to the Trent, defending the direct approach to the city.[536]

Expecting the interview with Major General Hoke, General Beauregard sent General Samuel Cooper a telegram requesting more troops for Hoke. Cooper basically replied that Hoke had all that he was going to get and that he could use all of the troops that were assigned to him.

On May 2, after a difficult twenty-five-mile march, Hoke's army reached the outskirts of Kinston, where rations were issued and the men met with a hard night's rain. In the Shenandoah Valley, Federal armies were on the move: "Three large enemy armies now threatened Richmond and Petersburg, both vital rail centers. At Petersburg, Pickett faced down two Yankee corps with but two and a half brigades. Lee's situation north of Richmond was even more dire, and…he no longer asked, but demanded from Davis and Bragg the return of Hoke and his troops."[537]

Captain Smith, U.S. Navy, sent in a report on May 2: "New Berne is threatened by a large rebel force, and unless the speedy operations on the peninsula should diminish their present numbers, estimated at 15,000, there will be great difficulty in holding the place."[538] Also on May 2, General Beauregard reported that the "enemy in New Berne [is] reported demoralized."[539]

Even though the enemy at New Berne was projected to be far greater than what he had met at Plymouth or Washington, Hoke was greatly confident of success because he was sure he would have naval assistance and felt that would be the deciding factor in the upcoming expedition. In Plymouth, General Martin noted, "The ironclad [Albemarle] will be ready to leave here to join in the attack on New Berne in two or three days."[540]

May 3 was a great day for Major General Hoke. He received a message from Commander Cooke of the CSS Albemarle, which included a report on the Albemarle's recent excursions in the Albemarle Sound and his satisfaction with the Albemarle's ability to withstand rough weather between Plymouth and New Berne.[541] This boosted Hoke's confidence of success tremendously.

Hoke's men resumed their march from Kinston toward New Berne and crossed the Neuse River on a pontoon bridge approximately twelve miles east of Kinston. At the same time, Beauregard made his way to Goldsboro, where he wired Bragg that Hoke had commenced his movement to New Berne the previous day. In the telegram to Bragg, Beauregard warned that it might take Hoke four or five days to finish his mission.[542] Hoke's men made camp Tuesday night some twenty miles west of New Berne along the Trent Road. At 7:25 p.m. that same night, Colonel P.J. Claassen, commander at Batchelder's Creek, reported, "I have the honor to inform you that I have, to me, satisfactory proof that no force of the enemy are now menacing New Berne, either by land or water."[543]

As the sun rose on May 4, Hoke began to implement his grand plan of attack on New Berne, sending his army down the Trent Road: "Once again, there would be a three-pronged attack, which would issue as follows: one portion of his army would strike Fort Anderson and the other Union defenses on the north side of the Neuse above New Berne; a second, more substantial attack force would assault New Berne's inner works after surprising the Federals at Batchelder's Creek northwest of town; and the third prong, led by Dearing's cavalry and some artillery, would cut the railroad and telegraph lines to Morehead City and then work its way north into New Berne on the railroad bridge."[544]

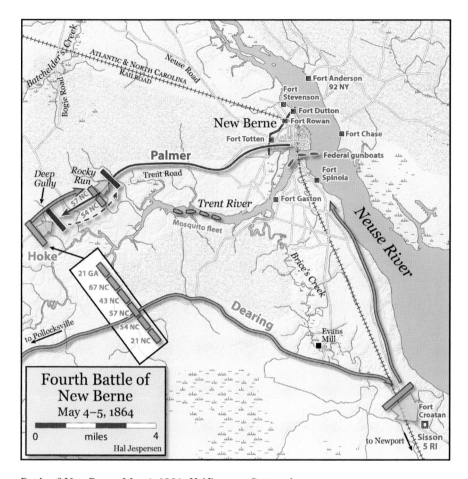

Battle of New Berne, May 4, 1864. *Hal Jespersen, Cartographer.*

The first encounter that Hoke's men had with the Federals came at Deep Gully on the Trent Road, about eight miles west of New Berne on the Craven/Jones County line. Here, Hoke's men were marching from Trenton toward New Berne when they came upon the pickets located at Deep Gully. There Colonel William Gaston Lewis, 43rd North Carolina, faced what Sergeant Samuel C. James, commissary sergeant, termed "strong entrenchments" beyond the creek, which were created by the gully. Lewis had orders to drive in the enemy's pickets, bombard the battery attached to the enemy and take command of the earthworks on the creek about six miles from New Berne, then fall back to Pollocksville on the Trent.[545] Lewis's Brigade "made a dash on the redoubts at Deep Gully, but the enemy fled

to avoid capture." This evicted the small outer defense force rather easily, and the brigade "withdrew some distance to give them a chance to come out today, but they seem clear of doing so."[546] The 67th North Carolina was left at Deep Gully to protect the position there while the remainder of the brigade hurried to catch up with the remainder of Hoke's army.[547]

James Savage reported that the force that drove in the pickets at Deep Gully consisted of "two companies of cavalry, about 150 infantry, and two 10-pounder Parrott guns."[548] He went on in his report to say that his forces had stopped the enemy Confederates at Rocky Run.

While Hoke's men achieved their first victory, the real blow to the campaign was delivered without his knowing it. At Kinston, Beauregard received an urgent message from President Davis: "Unless New Berne can be captured by *coup de main* [surprise] the attempt must be abandoned, and gather troops returned with all possible dispatch to unite in operation in North Virginia. There is not an hour to lose. Had the expedition not started I would say it would not go. Have all practicable arrangement made to transport the troops to this place with dispatch."[549] Beauregard had no choice but to recall Hoke. By 4:00 p.m., he had issued the order to recall Hoke, have him turn his army around and return to Kinston immediately. "Beauregard dispatched no fewer than five couriers with the communiqué."[550]

As Thursday night transitioned into day, Major General Hoke had matured his plans for the capture of New Berne, confident that he would capture the city by Sunday with or without the ironclad. "Once again, he

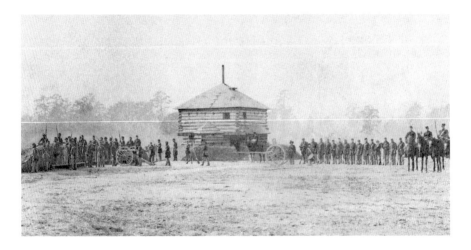

Evans Mill Blockhouse. *Courtesy of Wisconsin Public Library, Reedsburg, Wisconsin.*

knew that the town was almost in his grasp."[551] Early that morning, the Confederates crossed the Trent River to the south side near Evan's Mill on Brice's Creek. The Federals at Evan's Mill were barracked at a blockhouse and supported by a redoubt with one heavy gun at an elevated point. This allowed them to keep a large force at a distance. As Hoke rode up toward the blockhouse to reconnoiter the area, he attracted the attention of the Federals there. A journalist reported what happened: "Very soon a puff of smoke announced the salute intended for us, and almost instantaneously a twelve pound solid shot ricocheted in front, and sped at a few feet above our heads, to seek the earth some distance in the rear."[552] Hoke immediately ordered skirmishers deployed under the command of Colonel John A. Baker of the 3rd North Carolina Cavalry to protect the artillerymen. The artillerymen rushed two Napoleons forward into an open field several hundred yards in front of the blockhouse and unleased a steady barrage of well-directed fire. As soon as the skirmishers made their way through a nearly impassable bog, the Federals "took to their heels." Soon afterward, Hoke's troops poured across the bridge spanning Brice's Creek and headed in the direction of New Berne.[553]

Hoke wasn't the only one having a good day. Dearing was doing well too. He marched his men south down the Atlantic and North Carolina Railroad to the Croatan Fort about eight miles south of New Bern. The fort was a small, earthen fort on the railroad and not intended to be held against a large force. Captain Aigan, commanding the fort, heard rumors of Rebels in the area. He went out looking for them and was quickly surrounded by about twenty such Rebels. "Wheeling suddenly, he put spurs to his horse and escaped to the fort. The tents were at once struck, taken to the fort, the drawbridge was taken up, the magazine opened, ammunition distributed, and every preparation made for action."[554] Rapid fire continued between the Confederates and the Federals until the Confederates disappeared into the woods. Colonel Aigan told Chaplain White that he "had never before been under such close and accurate shelling."[555]

Gradually, the Confederates extended their lines right and left until they completely surrounded the small fort. "The return fire from the fort was as rapid and as heavy as [the fort] could make it. Solid shot, shell and canister were thrown first in one direction and then in another, and, as our gun was a field piece, mounted on an elevated platform, it commanded the approach in every direction."[556] At about 2:30 p.m., a flag of truce appeared down the railroad tracks. The fort ceased firing, and Captain Aigan went out to see what the Confederates wanted. The

captain returned and stated that the Rebels wanted the surrender of the fort, but he told them that "he could not surrender the fort."[557]

Aigan then called Lieutenant Dupree and Chaplain White together to discuss the matter, asking them their opinions. They realized that the capture of the fort was only a question of time, and "the only question aside from the lack of water was the sacrifice of the men. From the new position which the enemy had obtained during the truce [they] saw that [they] could hardly hope to work the gun for any length of time. The only course then seemed to be the surrender of the fort. A white flag was then raised, and soon the officers who came before returned."[558] The firing at the fort ended before 3:00 p.m., and the surrender of the fort was completed shortly thereafter.

In struggling to reach the Croatan earthworks, Dearing and his men just missed another important prize: "the train making its way from New Berne to Morehead City. Nonetheless, he promptly set about his primary mission, destroying the rail and telegraphy lines between the two cities. Soon dense columns of dark smoke signaled that Dearing had accomplished his purpose."[559]

Hoke made his way to the Trent River and there made "a personal reconnaissance of the Federal defense works and pronounced them 'pretty strong.' In the process, he was slightly wounded in the arm. A nearby soldier promptly produced a silk handkerchief from his pocket and handed it to the general to bind his arm. Despite his wound, all had gone well for Hoke during the day. He now commanded the outer works, and the town was under siege."[560] But where was the *Albemarle*?

Hoke had encircled and isolated and prepared to demand New Berne's surrender. Hoke told an aide that even though New Berne was perhaps the best fortified place he had ever seen, he finally had the enemy where they should have been back on February 2. His men could enter the city and Union works at any time virtually unchallenged.[561] But where was the *Albemarle*?

The morning of Thursday, May 5 dawned bright in Plymouth, just as it did in New Berne with promise of success. The morning was spent getting the CSS *Albemarle* ready to set sail for New Berne. At noon, the ironclad left its moorings at Plymouth and began to sail down the Roanoke River escorted by two steamers, the *Bombshell* and the *Cotton Plant*. Even though the day was bright and all was quiet and peaceful on the Roanoke, Commander Cooke knew "the mission was fraught with peril." Before Cooke could reach Hoke's battleground and New Berne and the Federal vessels waiting there, he would be forced to negotiate not only the Roanoke

River but also Albemarle, Croatan and Pamlico Sounds as well. Once he reached the Neuse River, he would find obstructions in the river as well as the Federal gunboats. In addition, he was sure to encounter Federal warships on the way to New Berne.[562]

At 2:00 p.m., the *Albemarle* entered the Albemarle Sound. Dead ahead were the Federal ships "*Ceres, Commodore Hull, Whitehead,* and transport *Ida May.* Their intended mission had been to place two lines of torpedoes across the river, but the unexpected appearance of Cooke's flotilla cancelled their plans."[563] They turned around and withdrew from the area. Cooke followed the Federal ships downriver and noticed they set a course east–northeast, generally in the direction of Sandy Point. He had followed the Federal ships for about ten miles when he saw three large double-ended gunboats. "Cooke recognized they were of a more formidable class than those he had followed. He estimated they carried from ten to twelve guns each. Perceiving that an unequal contest was imminent, Cooke immediately prepared the *Albemarle* for action."[564] By now, it was about five o'clock in the afternoon.

Cooke signaled the *Cotton Plant* and *Bombshell* to turn around and return to the Roanoke River, but only the *Cotton Plant* did so. All too quickly the *Albemarle* was surrounded by the *Wyalusing* and *Sassacus*, "the latter having given the ironclad a broadside in passing. Moments later the *Mattabesett* was on her quarter with engines stopped. Cook described what happened next:

> Sassacus *struck the ram abreast her beam at a good speed which "jarred and careened her so much that the water flowed freely over her decks and gave her so great a list that* [Lieutenant Commander Roe] *thought it would sink."* The Sassacus *then kept the engine going and retained* [its] *position there, forcing her broadside to, for some ten minutes, hoping soon, one of our gunboats might get up alongside, opposite to me, as she was unable to harm them by ramming. Finding this could not be, and she starting ahead, the* Sassacus *slued obliquely toward her starboard side, when she fired, raking us, putting 100-pounder rifle shot clear throughout starboard boiler, fore and aft. We then fired the pivot rifle, striking her port sill, and a fragment of this shot flew back upon my deck. This shot was broken into fragments. I fired again with similar results. I put three rifle shot into her port, and the muzzles of two of her guns were badly broken.*[565]

Lieutenant Commander Francis A. Roe stated in his report that after that, he rammed the ironclad, and "the collision was pretty heavy and the ram careened a good deal, so much so that the water washed over her deck

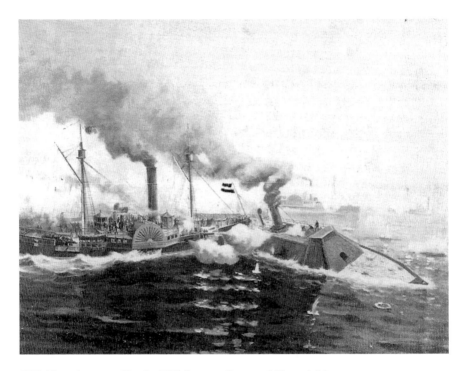

CSS *Albemarle* rammed by the USS *Sassacus*. *Courtesy of Plymouth Museum.*

forward and aft the casemate. At one time I thought she was going down. I kept the engine going…deeper and deeper into her.…I retained this position full ten minutes, throwing grenades down her deck hatch and trying in vain to get powder into her smokestack and receiving volleys of musketry."[566]

The *Albemarle*'s smokestack was shot up so badly it was almost impossible for the ship to build up any pressure at all in the boiler. "Reaching New Berne now was not feasible and Cooke wasn't even sure he would be able to return to Plymouth. He pulled out and headed back toward Plymouth full of holes and after having been rammed."[567]

Cooke knew his ship was dead in the water and felt for sure that he would be rammed and sunk. He ordered his crew to dismantle all wooden structures to feed the furnace, including the "bulkheads, doors, cabin furniture, and interior casemate planking." The fuel was all piled into the furnace, but it was not hot enough to build up steam to get the ironclad off the sandbar. One of the crew decided to add a large quantity of bacon, ham and lard on board the gunboat, which created a fire hot enough to produce the steam to release the ironclad: "Steam pressure rose, the propellers turned, and the

*Albemarle* steamed toward the Roanoke. The CSS *Albemarle* would not make it to New Berne to assist Hoke in his attempt to retake New Berne from the Federals. It was just lucky to have survived this round with the Federal gunships in Albemarle Sound." At 2:00 a.m. on May 6, the *Albemarle* docked at Plymouth "in rather dilapidated condition."[568]

Hoke woke early on the morning of Friday, May 6 , looking forward to his triumphant entry into New Berne. But that was not to be. By 10:00 a.m., Beauregard's courier had finally caught up with Hoke and given him his orders to end the expedition. He was to turn around immediately and head back to Kinston and then Richmond. The two victories he had just attained meant nothing. His conquests had to be abandoned. "The news stunned Hoke. Ending his campaign, of which he had no doubt of its success," making his recall "one of the greatest disappointments I ever had." But as a good soldier, the general readied his men to go to the defense of the capital.[569] The old brigade "was ordered to be ready to march at 10 a.m. on Friday, May 6. Most of his soldiers, anxious to drive the Federals from New Berne, were dismayed when their commanders sent them in the direction of Kinston, rather than into the face of the enemy."[570]

But before turning his back on New Berne one last time, Hoke decided to play "one round for the game." Hoke sent a flag of truce demanding that General Palmer surrender New Berne. Palmer immediately summoned his officers to discuss the matter, after which Palmer declined to surrender. The following day, Palmer described the event in his official report: "Yesterday morning under a flag of truce came in with Major Read who stated verbally that he had come by direction of General Hoke, to demand the surrender of the place, as they had possession of the Neuse River, the railroad, etc. I directed one of my aids-de-camp to go to Major Read and say to him that his delicate jest was duly appreciated by me, but that he must leave in one-half hour, or we should fire upon him. He left immediately, and I have heard nothing from him since."[571]

By Saturday, May 7, most of Hoke's men were already in Kinston, where Beauregard had collected trains to transport them to the battlefields of Virginia via the Wilmington and Weldon Railroad. Hoke had inspired his men to make one of the hardest marches of the war. During a twelve-hour period, the distance covered by the 43rd North Carolina, including the running fight toward New Berne and the retreat to Kinston, was thirty-seven miles. "Plagued by a lack of drinking water, dusty roads, and blistered feet, the soldiers endured great suffering and fatigue 'without scarce a murmur.' Most expressed but one regret—that they have not been permitted to 'finish

the job.' Not only was the march one of the hardest during the war, but it was long taught at the United States Military Academy as one of the most rapid troop movements on record."[572] For Hoke, the expedition was obviously one of what might have been. What would have happened if the CSS *Albemarle* and the CSS *Neuse* had been available? What would have happened if the Confederate powers that be would have let Hoke have one or two more days to finish his job? What would have happened if Hoke had captured New Berne and thrown the Yankees out?

Following the Battle of Batchelder's Creek and the Confederate attempts to retake New Berne in early 1864, the Federal authorities began making plans to prevent the Rebels from making another such attack down the Neuse River by boat by stretching a chain across the river near Batchelder's Creek with mines to prevent such ships or gunboats from descending the river. On May 26, 1864, much progress had been made, and nine such torpedoes consisting of 250 pounds of powder had been placed in the river, with more on the way. On that date, the last four torpedoes were being delivered to the station at Batchelder's Creek to be taken to the river and thus placed along with the other nine to complete the blockade of the river.

The last four torpedoes were being unloaded from the train on May 26 when something went terribly wrong. Three of the torpedoes had already been unloaded and were at the bottom of the ramp when the fourth torpedo was rolled down the ramp. When it hit the other three torpedoes, it caused a deadly chain of explosions. The fourth torpedo hit the third torpedo, and it exploded, which in turn caused the second and the first torpedoes to explode: "Like the crash of a thousand pieces of artillery."[573]

The commissary building was shattered. The watchtower was shot into the air eight hundred feet. Newspaper accounts list thirty-five men killed instantly and thirty-two more mortally injured, later dying from their wounds. The death toll was heaviest with the 132nd New York Infantry, which lost twenty-eight men killed. Twenty-five or more of the dead were contrabands, or free African Americans. And one civilian, Hezekiah Davis, "an old citizen of that neighborhood," was killed.

Fragments of men and debris were scattered for hundreds of yards. The sound of the explosion could be heard as far away as New Berne, where it sparked a "Scene of wild confusion." The wounded were taken back to New Berne to Foster General Hospital, but there was little that could be done for most of them.

While this is the accepted version of the events that happened at Batchelder's Creek, there is another version of those events. While doing

Sergeant William Ennever, killed during the explosion. *Courtesy of Joy Swensen.*

research on this particular chapter, I discovered a transcript of an interview I conducted with Hervey Ipock of the Asbury community of western Craven County on October 6, 1978. I had forgotten about that interview and found its contents surprising, considering the material it contained regarding the events of May 26, 1864.

In the interview, Ipock asserted that during the Civil War, his father, Brice Ipock, served in Nethercutt's Partisan Rangers in the Clarks–Batchelder's Creek area. At the time of the explosion, Brice had laid a mine under the railroad at Clarks, and when the train stopped there and began unloading the torpedoes, he detonated it, blowing up the train. Hervey Ipock would have had no knowledge of the explosion other than through his father, as he was not one who would have done research or have read the Official Records. In addition, he claimed that his uncle Hezekiah Davis was also killed in the explosion—the only civilian killed. Davis was there that day selling vegetables to the Union troops.

Again, Major General Hoke's attempt to capture New Berne and evict the Federal troops there was thwarted by his superiors. It was General George Pickett who had his doubts about the feasibility of the expedition in the first place. This time, Hoke's expedition was stymied by Robert E. Lee himself because of threats to the Confederate capital in Richmond. Had Hoke only two more days, the city of New Berne might have been his. The garrison in New Berne was heavily outnumbered and surrounded. Hoke was again on the outskirts of the town, and all he had to do was go in and take it. But being the professional military man he was, he followed orders and immediately turned around and headed toward Richmond via Kinston, double quick—abandoning the last hope to free New Berne from Federal occupation.

# Notes

## Chapter 1

1. New Bern has been spelled a number of ways throughout its history, including Newbern, Newberne, New Berne and, today, New Bern. I chose to use New Berne because that is the way it was spelled in official records at the time of the Civil War.
2. Barrett, *Civil War in North Carolina*, 33.
3. Note, the Outer Banks are called the Barrier Islands from Virginia to Cape Lookout.
4. Carbone, *Civil War in Coastal*, 6.
5. Barrett, *Civil War in North Carolina*, 33.
6. Trotter, *Ironclads and Columbiads*, 16.
7. Barrett, *Civil War in North Carolina*, 73.
8. Mallison, *Civil War on the Outer Banks*, 34.
9. Carbone, *Civil War in Coastal*, 6.
10. Barrett, *Civil War in North Carolina*, 36.
11. *Official Records of the Union and Confederate Armies of the War of the Rebellion* (hereafter listed as OR), 4:585.
12. Ibid.
13. Trotter, *Ironclads and Columbiads*, 21.
14. Carbone, *Civil War in Coastal*, 7.
15. Ibid.
16. Barrett, *Civil War in North Carolina*, 39.
17. Trotter, *Ironclads and Columbiads*, 36.
18. Ibid., 18.
19. Barrett, *Civil War in North Carolina*, 42.

20. Trotter, *Ironclads and Columbiads*, 35.

21. Barrett, *Civil War in North Carolina*, 43.

22. Trotter, *Ironclads and Columbiads*, 37–38.

23. Carbone, *Civil War in Coastal*, 12–13.

24. Barrett, *Civil War in North Carolina*, 43.

25. Mallison, *Civil War on the Outer Banks*, 42.

26. Trotter, *Ironclads and Columbiads*, 37.

27. Von Eberstein Papers, 129.

28. Manarin, *North Carolina Troops*, 582.

29. Von Eberstein Papers, 129.

30. Ibid.

31. Ibid.

32. (Washington, NC) *Dispatch*, n.d.

## *Chapter 2*

33. Mallison, *Civil War on the Outer Banks*, 51.

34. Ibid., 63.

35. Trotter, *Ironclads and Columbiads*, 56–57.

36. Carbone, *Civil War in Coastal*, 6.

37. Barrett, *Civil War in North Carolina*, 66–67.

38. OR, 9:352–53.

39. Mallison, *Civil War on the Outer Banks*, 72.

40. Osborne, *Private Osborne*, 44.

41. Ibid., 51.

42. Mallison, *Civil War on the Outer Banks*, 71.

43. Ibid.

44. Ibid.

45. Ibid., 70–71.

46. Ibid., 66.

47. OR, 9:363–64.

48. Barrett, *Civil War in North Carolina*, 74.

49. Trotter, *Ironclads and Columbiads*, 81.

50. Osborne, *Private Osborne*, 56.

51. Trotter, *Ironclads and Columbiads*, 84.

52. Ibid.

53. Barrett, *Civil War in North Carolina*, 80–81.

54. Trotter, *Ironclads and Columbiads*, 80.

55. Osborne, *Private Osborne*, 56–57.

56. Barrett, *Civil War in North Carolina*, 83.

57. Ibid.

58. Ibid.
59. Trotter, *Ironclads and Columbiads*, 86–87.
60. Mallison, *Civil War on the Outer Banks*, 77–78.
61. Trotter, *Ironclads and Columbiads*, 19.
62. Barrett, *Civil War in North Carolina*, 87.

## *Chapter 3*

63. Osborne, *Private Osborne*, 63.
64. Ibid., 63–64.
65. Mallison, *Civil War on the Outer Banks*, 93.
66. Ibid.
67. Barrett, *Civil War in North Carolina*, 96.
68. Mallison, *Civil War on the Outer Banks*, 89–90.
69. Ibid.
70. Ibid., 93–94.
71. Barrett, *Civil War in North Carolina*, 98.
72. Slocum Creek is located on the military base of Cherry Point at Havelock, North Carolina, today.
73. Henry K. White Papers, #5013-Z.
74. Sauers, *Civil War Journal*, March 14, 1862, 30–36, 73.
75. Barrett, *Civil War in North Carolina*, 99.
76. Ibid.
77. Mallison, *Civil War on the Outer Banks*, 91.
78. Carbone, *Civil War in Coastal*, 52.
79. Ibid.
80. Barrett, *Civil War in North Carolina*, 9–10.
81. OR, 9:243.
82. Trotter, *Ironclads and Columbiads*, 114.
83. Ibid., 115.
84. Ibid.
85. Barrett, *Civil War in North Carolina*, 100–101.
86. Ibid., 102.
87. Barrett, *Civil War in North Carolina*, 53.
88. Carbone, *Civil War in Coastal*, 97.
89. Barrett, *Civil War in North Carolina*, 103–4.
90. Ibid., 103.
91. Osborne, *Private Osborne*, 65.
92. Mallison, *Civil War on the Outer Banks*, 96.
93. Barrett, *Civil War in North Carolina*, 104.
94. Ibid.

95. OR, 9:226.

96. Ibid., 380.

97. Mallison, *Civil War on the Outer Banks*, 102.

98. OR, 9:207.

99. Carbone, *Civil War in Coastal*, 65.

100. Ibid.

101. Ibid., 56.

102. Mallison, *Civil War on the Outer Banks*, 103.

103. Carbone, *Civil War in Coastal*, 60–61.

104. Mallison, *Civil War on the Outer Banks*, 104.

105. Carbone, *Civil War in Coastal*, 59–60.

106. Ibid.

107. Barrett, *Civil War in North Carolina*, 114.

108. Mallison, *Civil War on the Outer Banks*, 104.

109. Barrett, *Civil War in North Carolina*, 115.

110. Trotter, *Ironclads and Columbiads*, 140.

111. Barrett, *Civil War in North Carolina*, 116.

112. Mallison, *Civil War on the Outer Banks*, 107.

113. Barrett, *Civil War in North Carolina*, 117.

114. Ibid., 117–18.

115. Mallison, *Civil War on the Outer Banks*, 108.

116. Barrett, *Civil War in North Carolina*, 118.

117. Mallison, *Civil War on the Outer Banks*, 108–9.

118. Barrett, *Civil War in North Carolina*, 118.

119. Mallison, *Civil War on the Outer Banks*, 109–10.

120. Frank V. Adams Papers, letter to his sister Elizabeth, #1224.1.b.

121. Ibid.

122. Ibid.

## *Chapter 4*

123. Browning, *Shifting Loyalties*, 58.

124. Ibid.

125. OR, 9:199.

126. Barden, *Letters*, xxvi–xxvii.

127. Browning, *Shifting Loyalties*, 124.

128. Ibid., xxvi.

129. Sherrill, *21ˢᵗ North Carolina Infantry*, 295.

130. Ibid.

131. Barefoot, *General Robert F. Hoke*, 108.

132. Ibid., 181.

133. Ibid., 189.

134. OR, 33:824–25.

135. Barden, *Letters*, 64, note 12.

136. OR, 33:824–25.

137. Ibid.

138. Ibid.

139. Ibid.

140. OR, 33:293.

141. Ibid.

142. Diagram of Fort Chase, Eng. Dept., December 7, 1863, transmitted with St. Farquhar's letter, of December 3, 1863, in possession of Pat McCullough.

143. Ibid., 193.

144. OR, 33:824–25.

145. Charles H. Tournier Papers, #283.1.

146. Frank W. Adams Papers, letter to Elizabeth, #1224.1.b.

147. OR, 33:824–25.

148. Ibid.

149. Ibid., 576.

150. Ibid.

151. Ibid.

152. Ibid.

153. Ibid.

154. Ibid.

155. Ibid.

156. Ibid.

## *Chapter 5*

157. Barden, *Letters*, 159–60.

158. OR, 18:190.

159. Ibid.

160. Ibid.

161. Ibid., 197–98.

162. Ibid.

163. Ibid.

164. Ibid., 192–93.

165. Ibid.

166. Ibid.

167. Ibid.

168. Ibid.

169. Ibid.

170. Ibid., 188.

171. Ibid.

172. McSween, *Confederate Incognito*, 115.

173. OR, 18:186.

174. Captain William J. Riggs, Battery H, Third New York Artillery, and Captain James Belger, Battery F, First Rhode Island Artillery.

175. OR, 18:186.

176. Ibid., 188–89.

177. Ibid.

178. Burlingame, *History of the Fifth*, 136. There never were that many troops to go through Kinston. Their intelligence was wrong.

179. On May 23, 1863, as Colonel J. Richter Jones was returning to Batchelder Creek from an expedition from Gum Swamp, he was shot through the heart by a sniper from the window of a nearby house. The sniper was not apprehended, and the entire Federal force went into deep mourning for the loss of their beloved leader. In an interview conducted by the author in 1976 with Mr. Hervey Ipock of the Asbury Community of Craven County, Ipock stated that his father, Brice Ipock, was the one who shot and killed Richter Jones. Brice was a member of the Partisan Rangers, operating in western Craven County. Ipock described the event in detail as if he were there and stated that his father had fired the shot from the upper-story window of the Richardson House. He also stated that his father had aimed his rifle at the breastplate that Jones was wearing on his chest, thus being able to shoot him in his heart.

180. OR, 8:559–60.

181. Ibid. It is interesting to note that Colonel Hiram J. Anderson, who fought so bravely here defending Fort Anderson, was killed a year later on June 1, 1864, at the Battle of Cold Harbor.

182. *Official Records of Navies the Rebellion* (hereafter listed as ORN), 7:609.

183. Burlingame, *History of the Fifth*, 4.

184. ORN, 8:603–4.

185. Ibid.

186. Ibid., 193.

187. McSween, *Confederate Incognito*, April 8, 1863.

188. OR, 18:184.

189. Ibid.

190. Ibid.

191. De Kalb, New York Historical Office, Chemung County Historical Society, Elmira, NY; John, Letter to Friends, from New Berne, NC, March 27, 1862.

192. Ibid.

193. OR, 18:185.

194. Ibid., 193–94.

195. Ibid.

196. ORN, 8:610.
197. Letter to friends from John, Chemung County Historical Society.

## *Chapter 6*

198. Patterson, *Justice or Atrocity*, 18.
199. Ibid., 21.
200. Ibid.
201. Ibid.
202. Sherrill, *21ˢᵗ North Carolina*, 292.
203. Barefoot, *General Robert F. Hoke*, 105.
204. OR, 33:1061.
205. Ibid.
206. Ibid.
207. Ibid.
208. Ibid.
209. Lindblade, *Fight as Long*, 7.
210. Patterson, *Justice or Atrocity*, 21.
211. Lindblade, *Fight as Long*, 7.
212. Ibid., 2.
213. Ibid.
214. Barefoot, *General Robert F. Hoke*, 106.
215. Sherrill, *21ˢᵗ North Carolina*, 293.
216. Lindblade, *Fight as Long*, 9.
217. Patterson, *Justice or Atrocity*, 24.
218. Lindblade, *Fight as Long*, 9.
219. Barefoot, *General Robert F. Hoke*, 110.
220. Sherrill, *21ˢᵗ North Carolina Infantry*, 296.
221. Patterson, *Justice or Atrocity*, 26.
222. OR, 33:1119.
223. Ibid., 1102.
224. Sherrill, *21ˢᵗ North Carolina*, 296.
225. OR, 33:1102.
226. Ibid.
227. OR, 33:93.
228. Barefoot, *General Robert F. Hoke*, 108–9.
229. OR, 33:1102.
230. Patterson, *Justice or Atrocity*, 24–25.
231. Lindblade, *Fight as Long*, 12.
232. OR, 33:1099.
233. Ibid.
234. Ibid., 1099, 1100.

235. Sherrill, *21ˢᵗ North Carolina*, 293.
236. OR, 33:1101.
237. Barefoot, *General Robert F. Hoke*, 111.
238. Sherrill, *21ˢᵗ North Carolina*, 294.
239. Patterson, *Justice or Atrocity*, 40.
240. Barefoot, *General Robert F. Hoke*, 112.

## Chapter 7

241. Today, Batchelder's Creek is spelled Batchelor's Creek.
242. Burlingame, *History of the Fifth*, 187–88.
243. Sherrill, *21ˢᵗ North Carolina*, 295.
244. Ibid.
245. Ibid.
246. Barefoot, *General Robert F. Hoke*, 112.
247. Sherrill, *21ˢᵗ North Carolina*, 298.
248. OR, 33:62.
249. Ibid.
250. Ibid., 57.
251. Ibid., 62.
252. Ibid., 57.
253. Ibid.
254. Ibid.
255. Sherrill, *21ˢᵗ North Carolina*, 298.
256. Henry A. Chambers, Diary: January 1 through December 31, 1864, Manuscript, Raleigh, North Carolina, Department of Archives and History, unpublished manuscript, January 31, 1864.
257. OR, 33:71.
258. Sherrill, *21ˢᵗ North Carolina*, 298.
259. Ibid.
260. Ibid.
261. Ibid.
262. Burlingame, *History of the Fifth*, 188.
263. Ibid.
264. Sherrill, *21ˢᵗ North Carolina*, 298.
265. Ibid., 299.
266. Ibid.
267. Ibid.
268. Burlingame, *History of the Fifth*, 188.
269. OR, 33:70.
270. Ibid., 65.

271. Ibid., 70

272. Ibid.

273. Ibid., 65.

274. Ibid.

275. Sherrill, *21ˢᵗ North Carolina*, 300.

276. Barefoot, *General Robert F. Hoke*, 114.

277. Sherrill, *21ˢᵗ North Carolina*, 300.

278. OR, 33:93.

279. Sherrill, *21ˢᵗ North Carolina*, 300.

280. OR, 33:57.

281. Burlingame, *History of the Fifth*, 188.

282. OR, 33:65–66.

283. Ibid., 72.

284. Barefoot, *General Robert F. Hoke*, 112–13.

285. Ibid.

286. Sherrill, *21ˢᵗ North Carolina*, 299.

287. Barefoot, *General Robert F. Hoke*, 113.

288. OR, 33:49.

289. Ibid., 1145.

290. Ibid.

291. Sherrill, *21ˢᵗ North Carolina*, 300–301.

## *Chapter 8*

292. OR, 33:54–55.

293. Ibid., 95.

294. Ibid., 61.

295. Lee, *Civil War Diary*, 71.

296. Ibid.

297. Sherrill, *21ˢᵗ North Carolina*, 296.

298. Ibid.

299. OR, 33:58.

300. Ibid., 501.

301. Sherrill, *21ˢᵗ North Carolina*, 302.

302. OR, 33:58.

303. Ibid.

304. Sherrill, *21ˢᵗ North Carolina*, 295.

305. Patterson, *Justice or Atrocity*, 43–44.

306. Ibid., 43; James A. Wicks, one of John Taylor Woods's crew, led an illustrious life of his own, worthy of his own biography. Two weeks after the raid on New

Bern, Wicks left North Carolina and went to Charleston, where on February 17, 1864, he served on the ill-fated voyage of the CSS *Hunley*.

307. Barefoot, *General Robert F. Hoke*, 115.
308. Patterson, *Justice or Atrocity*, 43–44.
309. Barefoot, *General Robert F. Hoke*, 116.
310. Ibid.
311. Burlingame, *History of the Fifth Regiment*, 191–92.
312. Ibid.
313. OR, 33:56.
314. Barefoot, *General Robert F. Hoke*, 116.
315. Shingleton, *John Taylor Wood*, 97.
316. Ibid., 101.
317. Ibid.
318. Ibid.
319. Ibid, 102.
320. Ibid., 103.
321. Barefoot, *General Robert F. Hoke*, 116.
322. OR, 33:50.
323. Ibid., 58.
324. Barefoot, *General Robert F. Hoke*, 193.
325. Shingleton, *John Taylor Wood*, 103.
326. Ibid.
327. Burlingame, *History of the Fifth*, 193.
328. Ibid.
329. Ibid., 104.
330. Ibid.
331. Ibid., 105.
332. Ibid.
333. Shingleton, *John Taylor Wood*, 105–6.
334. Ibid.
335. Ibid., 105–6.
336. Ibid.
337. Sherrill, *21st North Carolina*, 301.
338. Lee, *Civil War Diary*, 101.
339. Shingleton, *John Taylor Wood*, 106.
340. Ibid.

## Chapter 9

341. Lindblade, *Fight as Long*, 13.
342. Ibid., 27.
343. Ibid., 50–51.

344. Ibid., 53.

345. Ibid., 58–59.

346. OR, 33:77.

347. Ibid., 72.

348. OR, 33:81.

349. Lindblade, *Fight as Long*, 96.

350. Ibid., 62.

351. OR, 33:85.

352. Ibid.

353. Lindblade, *Fight as Long*, 32–33.

354. Ibid., 98.

355. Ibid., 33–34.

356. Ibid., 40.

357. Ibid.

358. Ibid., 33.

359. OR, 33:77.

360. Lindblade, *Fight as Long*, 98.

361. OR, 33:78.

362. Lindblade, *Fight as Long*, 90.

363. Ibid.

364. Eric Lindblade, "The Battle of Newport Barracks: February 2, 1864," last modified May 18, 2011, http://newportbarracks.blogspot.com.

365. Lindblade, *Fight as Long*, 104.

366. Ibid.

367. Ibid., 104–5.

368. Ibid., 107.

369. Ibid., 107–8.

370. Ibid., 109.

371. Ibid.

372. Ibid., 113.

373. Ibid., 114.

374. OR, 33:83.

375. Ibid., 86.

## *Chapter 10*

376. Longacre, *Pickett*, 140.

377. Patterson, *Justice or Atrocity*, 49.

378. Ibid.

379. Weymouth, Brown and Coffey, eds. *North Carolina Troops* (hereafter *NCS Troops*), 1:56.

380. Ibid., 57.

381. Patterson, *Justice or Atrocity*, 53–54.

382. Perry, *Civil War Courts-Martial*, 298.

383. Patterson, *Justice or Atrocity*, 50–55.

384. Perry, *Civil War Courts-Martial*, 55.

385. Patterson, *Justice or Atrocity*, 60.

386. Ibid., 62.

387. Ibid., 64.

388. *NCSTroops*, 15:84.

389. Ibid., 362.

390. Ibid., 346.

391 Patterson, *Justice or Atrocity*, 64.

392. *NCSTroops*, 1:468.

393. Perry, *Civil War Courts-Martial*, 229.

394. Patterson, *Justice or Atrocity*, 227.

395. Ibid., 225.

396. *NCSTroops*, 15:364.

397. Perry, *Civil War Courts-Martial*, 225–26.

398. Patterson, *Justice or Atrocity*, 66.

399. Ibid., 60.

400. *NCSTroops*, 15:365.

401. Ibid., 349.

402. Patterson, *Justice or Atrocity*, 66.

403. *NCSTroops*, 9:25.

404. Patterson, *Justice or Atrocity*, 66–67.

405. *NCSTroops*, 15:351.

406. Ibid., 368.

407. Patterson, *Justice or Atrocity*, 64–65.

408. Ibid., 65.

409. Ibid., 70–72.

410. Ibid.

411. *NCSTroops*, 15:362.

412. Ibid., 363.

413. Patterson, *Justice or Atrocity*, 70–71.

414. *NCSTroops*, 2:257.

415. Perry, *Civil War Courts-Martial*, 222–23.

416. *NCSTroops*, 14:755.

417. Patterson, *Justice or Atrocity*, 70.

418. *NCSTroops*, 15:368.

## Chapter 11

419. Burlingame, *History of the Fifth*, 119.

420. Ibid.

421. Moss, *Battle of Plymouth*, 104.

422. Perry, *Civil War Courts-Martial*, 175.

423. Barrett, *Civil War in North Carolina*, 213.

424. Moss, *Battle of Plymouth*, 29.

425. Durrill, *War of Another Kind*, 191.

426. Moss, *Battle of Plymouth*, 43.

427. Durrill, *War of Another Kind*, 176–77.

428. Moss, *Battle of Plymouth*, 47.

429. Barefoot, *General Robert F. Hoke*, 131–32.

430. Ibid.

431. Sherrill, *21ˢᵗ North Carolina*, 317.

432. Barefoot, *General Robert F. Hoke*, 131–32.

433. Ibid.

434. Moss, *Battle of Plymouth*, 44.

435. Ibid.

436. Sherrill, *21ˢᵗ North Carolina*, 317.

437. Moss, *Battle of Plymouth*, 47.

438. Ibid.

439. Sherrill, *21ˢᵗ North Carolina*, 317.

440. Moss, *Battle of Plymouth*, 48.

441. Durrill, *War of Another Kind*, 191.

442. Moss, *Battle of Plymouth*, 48.

443. Barefoot, *General Robert F. Hoke*, 182.

444. Ibid., 133.

445. Moss, *Battle of Plymouth*, 48.

446. Durrill, *War of Another Kind*, 187.

447. Ibid., 124–25.

448. Barefoot, *General Robert F. Hoke*, 125.

449. Ibid.

450. Durrill, *War of Another Kind*, 187–88.

451. Hess, *Field Armies*, 302–3.

452. Moss, *Battle of Plymouth*, 103.

453. Barefoot, *General Robert F. Hoke*, 128.

454. Ibid., 127.

455. Durrill, *War of Another Kind*, 188–89.

456. Sherrill, *21ˢᵗ North Carolina*, 316.

457. Durrill, *War of Another Kind*, 190.

458. Ibid., 190.

459. Sherrill, *21ˢᵗ North Carolina*, 316.

460. Barefoot, *General Robert F. Hoke*, 134.

461. Sherrill, *21ˢᵗ North Carolina*, 316.

462. Durrill, *War of Another Kind*, 194.

463. Barrett, *Civil War in North Carolina*, 215–16.

464. OR, 33:297–98.

465. Moss, *Battle of Plymouth*, 81.

466. Ibid., 116.

467. Barrett, *Civil War in North Carolina*, 219.

468. OR, 33:298.

469. Ibid.

470. Moss, *Battle of Plymouth*, 115.

471. Durrill, *War of Another Kind*, 194–95.

472. Ibid., 196–97.

473. Barrett, *Civil War in North Carolina*, 216–17.

474. Hess, *Field Armies*, 303–4.

475. Durrill, *War of Another Kind*, 197.

476. Ibid., 200.

477. Ibid., 201.

478. Ibid.

479. Ibid.

480. Ibid., 201–2.

481. Ibid., 202.

482. Barrett, *Civil War in North Carolina*, 217–18.

483. Ibid., 218.

484. Ibid.

485. Hess, *Field Armies*, 305.

486. Ibid.

487. Durrill, *War of Another Kind*, 204.

488. Barefoot, *General Robert F. Hoke*, 152.

489. Hess, *Field Armies*, 305–6.

490. Barrett, *Civil War in North Carolina*, 220.

491. Sherrill, *21st North Carolina*, 326.

492. Ibid.

## *Chapter 12*

493. Barefoot, *General Robert F. Hoke*, 152.

494. Ibid., 155.

495. Sherrill, *21st North Carolina*, 327.

496. Ibid., 327.

497. Ibid.

498. Bright, Rowland and Bardon, *CSS Neuse*, 14.

499. Barefoot, *General Robert F. Hoke*, 160.

500. Sherrill, *21st North Carolina*, 329.

501. Barefoot, *General Robert F. Hoke*, 157.

502. Ibid., 155.

503. Barefoot, *General Robert F. Hoke*, 155–56.

504. Ibid., 156.

505. Sherrill, *21ˢᵗ North Carolina*, 329.

506. Ibid.

507. Ibid.

508. Ibid., 330.

509. Ibid.

510. Barefoot, *General Robert F. Hoke*, 157.

511. Ibid., 157–58.

512. Ibid., 156.

513. Sherrill, *21ˢᵗ North Carolina*, 329.

514. Ibid., 330.

515. Barefoot, *General Robert F. Hoke*, 158.

516. Sherrill, *21ˢᵗ North Carolina*, 330.

517. Ibid.

518. Ibid.

519. Barefoot, *General Robert F. Hoke*, 158–59.

520. Ibid., 159.

521. Ibid.

522. Ibid.

523. Ibid., 160.

524. Ibid.

525. Ibid.

## *Chapter 13*

526. Elliott, *Ironclad of the Roanoke*, 330.

527. Ibid.

528. Ibid., 331.

529. Ibid.

530. Ibid.

531. Ibid.

532. Ibid., 88.

533. OR, vol. 37, part 2, 328.

534. ORN, 9:810.

535. Ibid.

536. Ibid.

537. Elliott, *Ironclad of the Roanoke*, 332.

538. ORN, 36:715.

539. Ibid., 942.

540. Elliott, *Ironclad of the Roanoke*, 190.

541. Ibid.

542. Barefoot, *General Robert F. Hoke*, 161.

543. OR, 36:369.

544. Barefoot, *General Robert F. Hoke*, 161–62.

545. Sherrill, *21st North Carolina*, 331.

546. Ibid.

547. Barefoot, *General Robert F. Hoke*, 162.

548. OR, 36:397.

549. Barefoot, *General Robert F. Hoke*, 162.

550. Ibid.

551. Ibid., 164.

552. Ibid., 162–63.

553. Ibid.

554. Chaplain Henry S. White, quoted in Burlingame, *History of the Fifth*, 209.

555. Ibid.

556. Ibid., 210.

557. Ibid.

558. Ibid., 211–12.

559. Barefoot, *General Robert F. Hoke*, 163.

560. Ibid., 164.

561. Elliott, *Ironclad of the Roanoke*, 332.

562. Barefoot, *General Robert F. Hoke*, 164.

563. Elliott, *Ironclad of the Roanoke*, 194.

564. Ibid., 195.

565. ORN, 9:737.

566. Ibid., 9:738–39.

567. Ibid.

568. Elliott, *Ironclad of the Roanoke*, 211.

569. Ibid., 332–33.

570. Barefoot, *General Robert F. Hoke*, 166.

571. Ibid.

572. Ibid., 166–67.

573. David A. Norris, "Like the Crash of a Thousand Pieces of Artillery," The Cape Fear Round Table (Wilmington, NC), n.d.

# BIBLIOGRAPHY

## Published Works

Barefoot, Daniel W. *General Robert F. Hoke: Lee's Modest Warrior*. Winston-Salem, NC: John F. Blair, 1996.

Barrett, John G. *The Civil War in North Carolina*. Chapel Hill: University of North Carolina Press, 1963.

Bright, Leslie S., William H. Rowland and James C. Bardon. *CSS Neuse: A Question of Iron and Time*. Raleigh, NC: Division of Archives and History, 1981.

Browning, Judkin. *Shifting Loyalties: The Union Occupation of Eastern North Carolina*. Chapel Hill: University of North Carolina Press, 2011.

Burlingame, John K. *History of the Fifth Regiment of Rhode Heavy Artillery, During Three Years and a Half of Service in North Carolina, January 1862–June 1865*. Providence, RI: Snow and Farnham, 1892.

Carbone, John C. *The Civil War in Coastal North Carolina*. Raleigh, NC: Division of Archives and History, 2001.

Durrill, Wayne K. *War of Another Kind: A Southern Community in the Great Rebellion*. New York: Oxford University Press, 1990.

Elliott, Robert G. *Ironclad of the Roanoke*. Shippensburg, PA: White Mane Publishing, 1999.

Harrell, Roger H. *The 2nd North Carolina Cavalry*. Jefferson, NC: McFarland & Company, 2004.

Hess, Earl J. *Field Armies and Fortifications in the Civil War—The Eastern Campaigns 1861–1864*. Chapel Hill: University of North Carolina Press, 2005.

Lindblade, Eric A. *Fight as Long as Possible: The Battle of Newport Barracks, North Carolina, February 2, 1864*. Gettysburg, PA: Ten Roads Publishing, 2010.

Longacre, Edward G. *Pickett: A Biography of General George E. Pickett, C.S.A. Leader of the Charge*. Shippensburg, PA: White Mane Publishing, 1998.

Malanowski, Jamie. *Commander Will Cushing: Daredevil Hero of the Civil War*. New York: W.W. Norton and Company, 2014.

Mallison, Fred M. *The Civil War on the Outer Banks: A History of the Late Rebellion Along the Coast of North Carolina from Carteret County to Currituck*. Jefferson, NC: McFarland & Company, 1998.

Manarin, Louis H. *North Carolina Troops 1861–1865, A Roster*. Vol. 1, *Artillery*. Raleigh: North Carolina Archives, 1966.

Morrill, Dan. *The Civil War in the Carolinas*. Charleston, SC: Nautical and Aviation Publishing, 2002.

Mose, Juanita Patience. *Battle of Plymouth, North Carolina (April 17–20, 1864): The Last Confederate Victory*. Bowie, MD: Heritage Books, 2003.

Norris, David A. "Like the Crash of a Thousand Pieces of Artillery." Wilmington, NC: Cape Fear Round Table, n.d.

Patterson, Gerald A. *Justice or Atrocity: General George E. Pickett and the Kinston, N.C. Hangings*. Gettysburg, PA: Thomas Publications, 1998.

Perry, Aldo S. *Civil War Courts-Martial of North Carolina Troops*. Jefferson, NC: McFarland and Company, 2012.

Sauers, Richard A. *"A Succession of Honorable Victories": The Burnside Expedition in North Carolina*. Dayton, OH: Morningside House, 1996.

Sherrill, Lee W., Jr. *The 21st North Carolina Infantry: A Civil War History with a Roster of Officers*. Jefferson, NC: McFarland and Company, 2015.

Shingleton, Royce Gordon. *John Taylor Wood: Sea Ghosts of the Confederacy*. Athens: University of Georgia Press, 1979.

Trotter, William R. *Ironclads and Columbiads: The Civil War in North Carolina, the Coast*. Winston-Salem, NC: John F. Blair, 1989.

Weymouth, Jordan, Jr., Matthew M. Brown and Michael W. Coffey, eds. *North Carolina Troops 1861–1865*: A Roster. 20 vols. Raleigh, NC: State Department of Archives and History, 1966–2017.

Womble, Frank. *Confederate States Ship Albemarle: Photography, Official Naval Records from the War of Rebellion and Eyewitness Accounts*. Privately published, 2015.

Zatarga, Michael P. *The Battle of Roanoke Island: Burnside and the Fight for North Carolina*. Charleston, SC: The History Press, 2015.

## *Published Diaries, Letters and So Forth*

Amory, Charles B. *A Brief Record of the Army Life of Charles B. Amory*. London: Forgotten Books, 2015.

Barden, John R., ed. *Letters to the Home Circle: The North Carolina Service of Pvt. Henry A. Clapp Company F Forty-Fourth Massachusetts, Volunteer Militia, 1862–1863*. Raleigh, NC: Division of Archives and History, 1998.

Edmondson, Catherine Ann Devereux. *"Journal of a Secesh Lady": The Diary of Catherine Ann Devereux Edmondson*. Edited by Beth G. Crabtree and James W. Patton. Raleigh: North Carolina Department of History, 1979.

Davidson, C.T., ed. *Dear Transcript Letters from Windham County Soldiers During the Civil War 1861–1865*. Danielson, CT: Killingby Historical & Genealogical Society, n.d.

Hauptman, Laurence M. *A Seneca Indian in the Union Army: The Civil War Letters of Sergeant Isaac Newton Parker 1861–1865*. Shippensburg, PA: Burd Street Press, 1995.

Howe, W.W. *Kinston, Whitehall and Goldsboro (North Carolina) Expedition, December, 1862*. New York, 1890. Nabu Public Domain reprints.

Lee, Henry S. *A Civil War Diary*. Edited by John Dixon Davis. Black Mountain, NC: Craggy Mountain Press, 1997.

Loving, Jerome M. *George Washington Whitman, Civil War Letters of*. Durham, NC: Duke University Press, 1975.

Lowery, Thomas P., ed. *Swamp Doctor: The Diary of a Union Surgeon in the Virginia and North Carolina Marshes*. Mechanicsburg, PA: Stackpiles Books, 2001.

McSween, Murdoch John. *Confederate Incognito: The Civil War Reports of "Long Grab," a.k.a. Murdoch John McSween, 26th and 37th North Carolina Infantry*. Jefferson, NC: McFarland & Company, 2013.

*Official Records of the Union and Confederate Armies of the War of the Rebellion*. Series I. Washington, D.C.: Government Printing Office, 1898. Reprint, Harrisburg, PA: National Historical Society, 1987.

*Official Records of the Union and Confederate Navies of the War of the Rebellion*. Series I. Washington, D.C.: Government Printing Office, 1898. Reprint, Harrisburg, PA: National Historical Society, 1987.

Osborne, Frederick M. *Private Osborne: Massachusetts 23rd Volunteers Burnside Expedition, Roanoke Island, Second Front Against Richmond*. Gretna, LA: Pelican Publishing Company, 2002.

Priest, John Michael, ed. *New Bern to Fredericksburg: Captain James Wren's Diary*. Shippensburg, PA: White Mane Publishing Company, 1990.

Sauers, Richard A., ed. *The Civil War Journal of Colonel Bolton 51st Pennsylvania April 20, 1861–August 2, 1865*. LaVergne, TN: Da Capo Press, 2000.

Splaine, Henry. *Memorial History of the Seventeenth Regiment, Massachusetts Volunteer Infantry in the Civil War from 1861–1865*. Salem, MA: Salem Press, 1911.

Yearns, W. Buck, and John G. Barrett, eds. *North Carolina Civil War Documentary*. Chapel Hill: University of North Carolina Press, 2002.

## *Unpublished Manuscripts, Letters and Diaries*

Adams, Frank W. 51st Mass Reg, to Elizabeth Dec 1862, East Carolina University, Joyner Library, Manuscript Collection, Letters, Greenville, North Carolina, #1224.1.b.

———. 51st Mass Reg, to Elizabeth Dec 1862, East Carolina University, Joyner Library, Manuscript Collection, Greenville, North Carolina, #1224.1.c.

Alexander, William B. Letters, March–May 1862. East Carolina University, Joyner Library, Manuscript Collection, Greenville, North Carolina, #5197.2.

Barden, John R., ed. *Letters to the Home Circle: The North Carolina Service of Pvt. Henry A. Clapp Company F. Forty-fourth Massachusetts, Volunteer Militia 1862–1863.* Raleigh, NC: Division of Archives and History, 1998.

Brackett, William Davis, Jr. Papers & Diary, East Carolina University, Joyner Library, Manuscript Collection, Greenville, North Carolina, #1007.1.a.

Branch, L.O. Letter from James B. Hoke, Chapel Hill, North Carolina, Southern Historical Collection. March 15, 1862.

———. Letter to Governor of North Carolina, Raleigh, North Carolina. North Carolina State Archives. March 23, 1862.

Brentlinger, John. Diary, 1862–1863, Greenville, North Carolina. East Carolina University, Joyner Library, Manuscript Collection, #438.

Bryan, James H. Bryan Collection, Raleigh, North Carolina. North Carolina State Archives. March 20, 1862

Calton, John Washington. Letter to Brother and Sister, Raleigh, North Carolina. North Carolina State Archives. April 20, 1863.

Calvin Papers, Letter from Jimmie to Brock, Raleigh, North Carolina. North Carolina State Archives. September 12, 1862.

Calvin Papers, Letter to Brock, Raleigh, North Carolina. North Carolina State Archives. July 30, 1862.

Carey, Pvt. Thomas J. Co. E. 15th Conn. Vol. Infantry, Personal Diary, Chapel Hill, North Carolina, Southern Historical Collection.

Chambers, Henry A. Unpublished Diary. January 1–December 31, 1864, Raleigh, North Carolina. North Carolina State Archives.

Clewell, Augusts. Letter to Sister, Raleigh, North Carolina. North Carolina State Archives. May 15, 1864.

De Kalb, New York Historical Office, Chemung County Historical Society, Elmira, NY: John, Letter to Friends, from New Berne, NC, March 27, 1862.

Evans, Media. Unpublished diary, Raleigh, North Carolina. North Carolina State Archives.

Foster, Gen. John G. Foster's Goldsboro Expedition, 1862, Draft Report, Greenville, North Carolina. East Carolina University, Joyner Library, Manuscript Collection, #816.1.b.

Foster, General John G. Foster's Goldsboro Expedition, 1862, Draft Report, Greenville, North Carolina. East Carolina University, Joyner Library, Manuscript Collection, #816.1.a.

Hill, D. H. Letter to Wife, Raleigh, North Carolina. North Carolina State Archives. March 8, 1863.

Hooker, William Howard. Collection, George H. Hitchcock Papers, Correspondence. Greenville, North Carolina. East Carolina University, Joyner Library, Manuscript Collection, #472.3.a.

Hooker, William Howard. Collection, George H.S. Driver Papers, 1861–1863. Greenville, North Carolina. East Carolina University, Joyner Library, Manuscript Collection, #472.2.b.

Johnson, John H. Unpublished diary, Raleigh, North Carolina. North Carolina State Archives.

Jones, Abraham G. Jones Papers, Miscellaneous Items, Greenville, North Carolina. East Carolina University, Joyner Library, Manuscript Collection,

Jones, Abraham G. Jones Papers, Miscellaneous Items, Greenville, North Carolina. East Carolina University, Joyner Library, Manuscript Collection, Correspondence, 1856–September 1863.

Kinsley, Alford. Letters to Ed. Greenville, North Carolina. East Carolina University, Joyner Library, Manuscript Collection, #1222.1.a.

Kinsley, Thomas. Letters to Edward Kinsley. Greenville, North Carolina. East Carolina University, Joyner Library, Manuscript Collection, #1222.1.b.

Myers, A.C. Myers Collection, 1862–1864, Raleigh, North Carolina. North Carolina State Archives.

Osbourne, Frederick M. *Private Osborne: Massachusetts 23rd Volunteers Burnside Expedition, Roanoke Island, Second Front Against Richmond.* Gretna, LA: Pelican Publishing, 2002.

Patrick, Henry M. Letter to wife Sue, Raleigh, North Carolina. North Carolina State Archives, February 8, 1864.

Riggs, Captain William J., Battery H, Third New York Artillery, and Captain James Belger, Battery F, First Rhode Island Artillery.

Stetson, Jeremiah. Stetson Papers, Chapel Hill, North Carolina, Southern Historical Collection, #5028-Z.

Steven. Letters to Maggie, Chapel Hill, North Carolina, Southern Historical Collection. December 24, 1862.

St. Fragahar, U.S. Engineer Department. Diagram of Various Forts in New Berne, December 7, 1863, originals in possession of Patrick McCullough, New Bern, NC.

Taylor, Herman W. Papers, Various Letters, Raleigh, North Carolina. North Carolina State Archives. Lucius Thomas Papers, Correspondence, 1862. Greenville, North Carolina. East Carolina University, Joyner Library, Manuscript Collection, #366.1.a.a.

Thomas, Lucius. Thomas Papers, Correspondence, 1863. Greenville, North Carolina. East Carolina University, Joyner Library, Manuscript Collection, #366.1.b.

Tournier, Charles H. Diary, 8-29-1864-7-3-1865, New Bern Historical Society Collection, Greenville, North Carolina. East Carolina University, Joyner Library, Manuscript Collection, #283.1.

Von Eberstein. Papers, Greenville, North Carolina. East Carolina University, Joyner Library, Manuscript Collection.

White, Henry K. White Papers, Diary, Chapel Hill, North Carolina, Southern Historical Collection, #5013-Z.

Whitehurst. Family Papers, Correspondence 1841–1889. Greenville, North Carolina. East Carolina University, Joyner Library, Manuscript Collection, #617.1.a.

Whitford, John D. Whitford Papers, Letter. Raleigh, North Carolina. North Carolina State Archives. March 6, 1862, PC 89.y.

Young, Johnny Graig. Young Collection 1862–1865. Greenville, North Carolina. East Carolina University, Joyner Library, Manuscript Collection, #419.1.